CLINT EASTWOOD

THE ICONIC FILMMAKER AND HIS WORK

IAN NATHAN

Quarto

First published in 2023 by White Lion Publishing,
an imprint of The Quarto Group.
1 Triptych Place
London, SE1 9SH
T (0)20 7700 6700
www.Quarto.com

A catalogue record for this book is available from the British Library.

ISBN 978-0-7112-8365-7
Ebook ISBN 978-0-7112-8880-5

10 9 8 7 6 5 4 3 2 1

Designed by Sue Pressley and Paul Turner, Stonecastle Graphics

Printed in China

CLINT EASTWOOD

THE ICONIC FILMMAKER AND HIS WORK

IAN NATHAN

UNOFFICIAL AND UNAUTHORISED

WHITE
LION
PUBLISHING

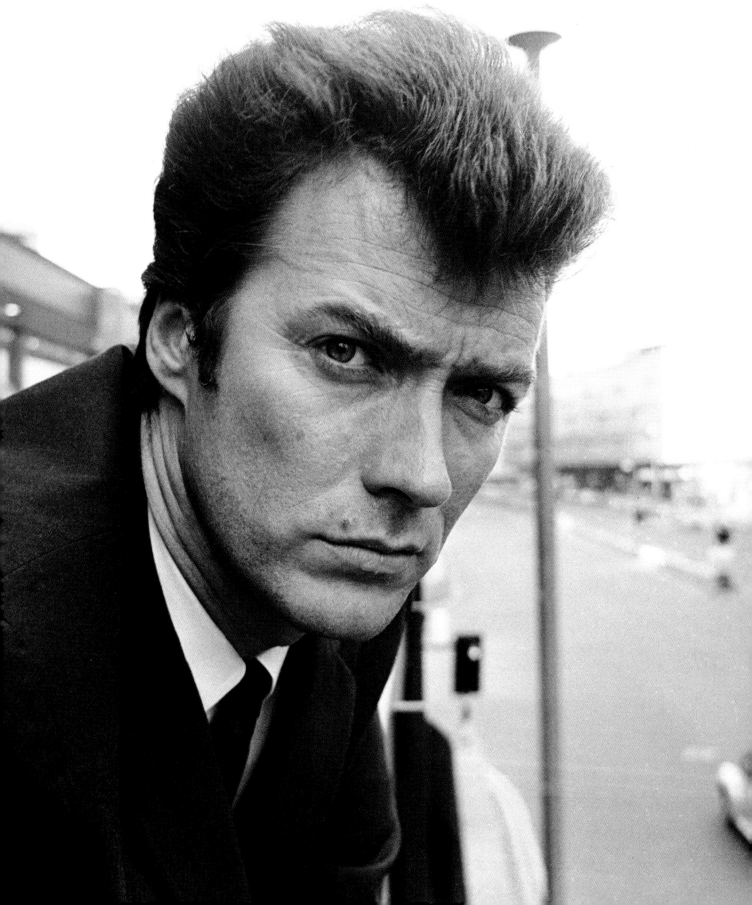

CONTENTS

Opposite: Portrait of the artist as a youngish man
– Eastwood in 1967, on the cusp of superstardom,
a certain scepticism toward fame already evident.

INTRODUCTION

'Deserve's got nothin' to do with it.'
William Munny, *Unforgiven*

Tom Hanks does a fine impression of Clint Eastwood. They worked together in *Sully*, on first appearances an airplane disaster movie, but in truth a complex enquiry into heroism. What we have come to understand as classic Eastwood material. It was a great honour, of course, to work for an icon of American cinema, he suggested, but Eastwood doesn't direct in the conventional way. For one thing, he treats his actors like horses. Hanks smiles, and explains himself. During Eastwood's tenure on the Western serial *Rawhide* in the late fifties and early sixties, he had noticed that whenever the director shouted 'Action!' the horses bolted. The actors had to quell much the same impulse. So when he began directing feature films, Eastwood saw to it that his sets remained calm. Instead of yelling 'Action!', he always keeps his voice quiet and level. This is when Hanks slips into a pitch-perfect rendition of Eastwood's smoky baritone tuned to a whisper: 'All right, go ahead.'[1] Nor does he shout 'Cut!' in the traditional manner, adds Hanks. He will sidle up behind the actor, lean over their shoulder, and say (he's back in that voice): 'That's enough of that.'[2]

The voice, the presence, the aura of total command and control, the wisdom of years in the business, and the deceptive simplicity – there really is no need to spook the actors – make Eastwood a singular director. And what endurance. In 2022, he celebrated his ninety-second birthday. He has barely stopped working for over seventy years, defying Hollywood gravity.

The point of Hanks' story, apart from capturing how even someone of his stature was in awe of the old man, is that Eastwood has always done it his way. Softly, yet determinedly. He knows his own mind. He is the least 'Hollywood' of Hollywood figures. He doesn't partake in test screenings, or any other industry malarky. 'If they're so interested in the opinion of a grocery-store clerk in Reseda, let them hire him to make the movie,'[3] he once growled. He doesn't suffer fools. Yes, there have been marriages and gossip, the statutory scandals that attach themselves to fame, and he enjoys his wealth. But also his isolation: mainly living in Carmel, far from the furore of Los Angeles.

Eastwood is Hollywood's conscience, the standard by which other filmmakers are judged. The one they look to in order to remind themselves that the business has still got a heart and a soul and a backbone. He carries the same kind of mythological bandwidth as a Tim Burton or Quentin Tarantino or a Martin Scorsese, a cult figure, but plays to a wider, more diverse and populist fanbase. There is a whisper of classical Hollywood about him – one of the greats in front of the camera. Indeed, one of the most famous people on the planet: The Man with No Name, *Dirty Harry*, *Unforgiven's* William Munny, *Gran Torino's* Walt Kowalski.

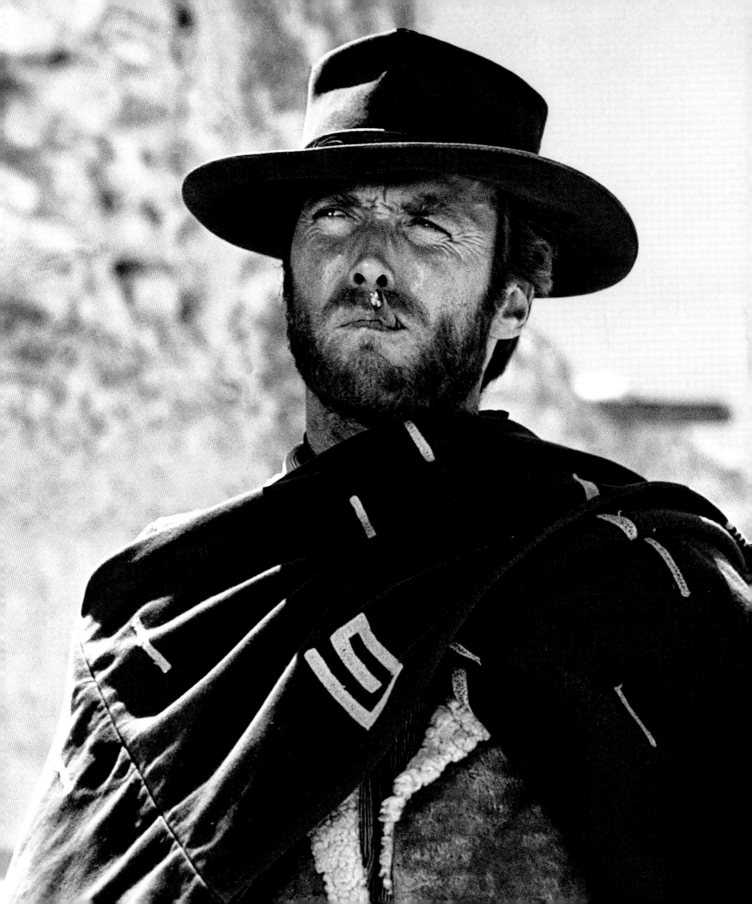

We have adored him as an enigmatic cowboy, or a grouchy cop, or a grouchy anything: the rugged, unyielding, yet introspective face of American machismo. The colloquial 'Clint' embodies the movies for legions of fans. But he is also an auteur fashioning uncompromising, fascinating, intellectual films about his country, about life, about whatever the hell takes his fancy.

The term 'cultural figure' gets bandied around a lot, but Eastwood, or simply Clint, has become an adjective – a collective idea. In time-travelling yarn *Back to the Future Part III,* with Marty McFly transported back to the Old West, he assumes the name Clint Eastwood (the filmmakers sought the star's bemused permission for the gag). This isn't simply a reflection of his stature as a figurehead of Westerns, it is a mantle Marty assumes, a coat of armour. Clintness.

Separation of actor and director is almost impossible. They are intimately related, cross-pollinating, and in this synthesis he has, in the latter half of his career, come to be viewed as one of the great American artists, no matter how much that makes him wince. He also composes many of his scores. As film historian David Thomson said, he is 'one of the few Americans admired and respected at home and abroad, without qualification or irony.'[4] Not even his good friend Steven Spielberg operates so freely outside of the strictures of commercial pressure. And yet, or perhaps because of that, he makes hit after hit.

While drawing connections from his wider work as an actor, and those who have influenced him, it is Eastwood's identity as a director that this book will explore. But at heart it goes in search of an artist. I'm not sure there is a better subject: when you travel alongside Eastwood, you chart a map of post-war Hollywood and the changing moods of an entire nation. Eastwood illustrates how cinema has defined America, and vice versa.

In interview he is wry, grounded, still a little perplexed at the attention, full of warm detail, uncomfortable with psychological readings of his work, but aware of them all the same ('If

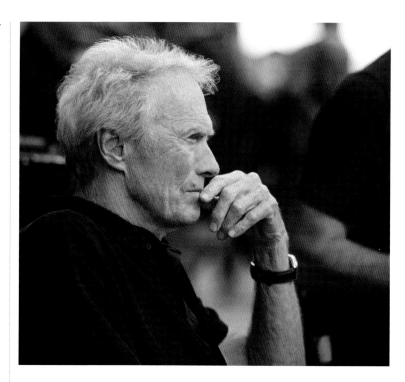

you want to go with that psychobabble bullshit, then *Unforgiven* sort of said something about my career'[5]), and with a determination to look forward rather than back. Retirement simply doesn't figure. When we spoke, he paused at one point to reflect that if we were in London (rather than California) then we 'would be doing this in a pub.'[6] He meant it, but the idea was insane. Eastwood isn't simply famous: he is like a living monument, hewn from rock and weathered with the ages.

'He is the most unhurried of men,'[7] the writer Tom Junod said of him: taking his time in coming to the point, not wanting to spook the horses. Yet he makes films at a gallop. Forty of them, as things stand.

Above: First of two studies of a man in his creative element – as director, Eastwood calmly observes the filming of *Sully* in 2016, one of his many enquiries into the nature of heroism...

"He is the most unhurried of men"
Tom Junod, writer

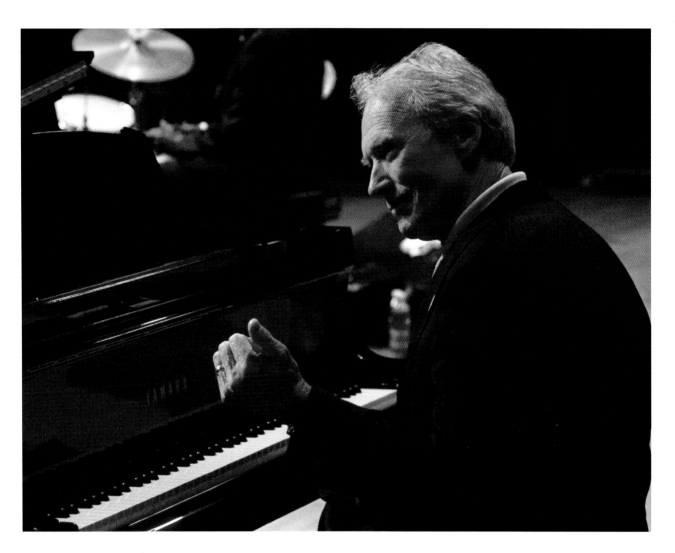

This is not a career – it is a landscape. The subject may change, and while synonymous with the Western and cop movie he has experimented with many genres, made films on many different scales. Pick an adjective, pick as many as you want: real, human, observant, wry, blackly comic, tragic, violent, American, political, unpolitical, folksy, emotional, lean, detailed, methodical, thrilling, and profound. They all apply. But there is something unshakeably Eastwoodian about them all.

Above: ...and second, as musician – Eastwood, the great jazz aficionado, is never more at home than when seated at a piano. Here, he's performing at the Monterey Jazz Festival near his base in Carmel.

THE MAGNIFICENT STRANGER

The early years (1930–1971)

It began in a stampede. The idea that he might one day be a director. As it would turn out, not just any director but *Clint Eastwood*, one of the most revered figures in film, a two-time Academy Award winner, director of forty feature films (forty-five with television episodes and documentaries). At the time, he was only Clint Eastwood, actor, in the guise of jejune cattle hand Rowdy Yates, a recurring character on *Rawhide*, the CBS network's serial Western – the genre with which his career would always be associated.

Currently, Rowdy was surrounded by three thousand head of cattle. Dust was flying. The noise intense. It was real dramatic looking from where he was standing. He sensed the visual opportunities, the drama of it all. This being formulaic television, the cameramen were situated at a safe distance from the action, like tourists in the Old West. During a halt in filming, Eastwood went to the director. 'Look there's some great stuff in there that you're not getting because you're way out here on the periphery.'[1]

There came the usual carping about union rules, the pressures of time and money: the basic blunt resistance of a risk-averse industry. Something he would have to learn to negotiate. 'Finally, they threw me a bone,'[2] he recalled, easing into a natural storytelling mode. They gave him a camera, and he returned with vivid footage from the thick of things. From there, they let him direct some trailers, have an input on scripts (certainly, where Rowdy was concerned), but allowed him no further. He was just an actor. He would have to bide his time, until he had the influence and the material to tell his own stories. Until Clint Eastwood, superstar, became Clint Eastwood, superstar director.

But you could say it began long before *Rawhide*. Those storytelling instincts were with him from the very start, when the son of an unsettled family, who had no particular notion of what to do with his life, set out on the journey to becoming an American icon.

Clinton Eastwood Jr was born in San Francisco on 30 May 1930, and was still residing in his mother Ruth's womb when the stock market crashed. Alongside his younger sister Jeanne, it was upbringing in the shadow of the Depression. Work was hard to come by. As his father and namesake Clinton Sr hunted for jobs, they drove town-to-town in an old Pontiac, the landscapes of Northern California and Washington state unfolding before them. 'We weren't itinerant: it wasn't *The Grapes of Wrath*,' insisted Eastwood, 'but it wasn't uptown either.'[3] The thirties were a very different America: unyielding, demanding, not yet formed, closer in time and lifestyle to the frontier days of Wyatt Earp.

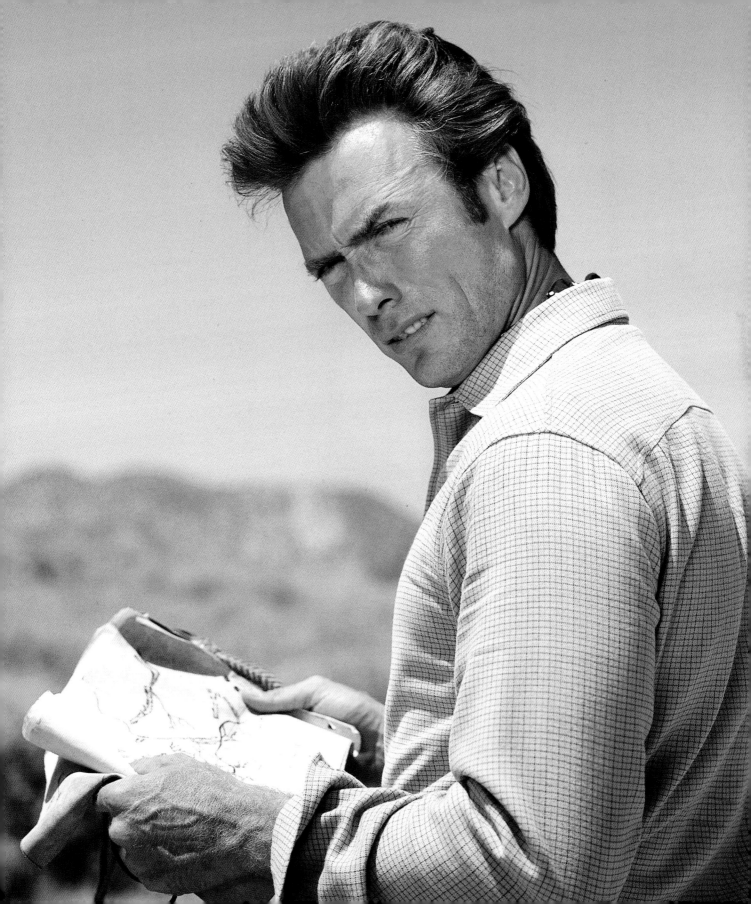

His father was variously a bond salesman and a manufacturing executive, but he was also willing to pump gas by the Los Angeles roadside. Clinton Sr dispensed a brand of solid, practical axioms on life. 'You always progress,' he instructed his eldest, 'otherwise you decay.'[4] We can see, looking back, the influence his father had on him. That dedication to provide for his family. But always being the new boy at school was rough. Always, said Eastwood, 'having to find his way.'[5] Is this where the actor was forged? Having to make an impression? He recalled an English teacher who mounted a one-act play and cast him because 'he was the one kid in class who had no interest.'[6] His reluctance, he was told, would be the making of him. For a second on that stage, he felt a spark.

While an average student at best, Eastwood had a great ear for music. He got that from his mother, Ruth. She was a homemaker, and later took a clerical role at IBM when the family settled for nearly a decade in middle-class Piedmont, California. She would play jazz records in the house, filling the air with melody. Like his mother, he revealed a precocious gift, teaching himself to play from the age of eight by imitating those tunes on Grandma Andy's piano (in actuality, his great-grandmother), the only piece of furniture that travelled with them in the early days. Jazz, blues and a little country are his true loves, and were to play their part in the films to come. But there is deeper influence. Jazz provides an inner music, at once experimental and laid back.

Movies don't figure highly at this time. What a remote possibility they must have seemed. He liked classic-era Hollywood as much as anyone, and a family outing to the pictures was a real treat. The first thing he can remember seeing was Gary Cooper in *Sergeant York* with his father in 1941. He liked Coop, the 'great minimalist.'[7] But he cites James Cagney as his favourite star. He saw him a year later in *Yankee Doodle Dandy*: all that jazzy, voluble energy, so different from the stilled presence of Eastwood to come. Maybe he imagined directing him. There were other film favourites

Above: A very early publicity shot of Eastwood from 1955, when he was enrolled in Universal's young actors' program, a vestige of an ageing studio system looking for the next generation of stars.

1955 **Revenge of the Creature**
Actor (uncredited)

1955 **Francis in the Navy**
Actor

– the noir of *Double Indemnity*, the social comedy of *Sullivan's Travels* – and those statutory tales of sneaking into picture houses with his friends and crawling through the 'gum and popcorn and spilled cola'[8] to find a seat.

No, he dreamed of being a professional musician. Not yet out of high school, he played local jazz joints in Oakland like The Omar Club, where he'd been tinkering away casually, imitating Fats Waller, when the owner offered him a slot. He got free beer and pizza, and the girls liked a guy who played piano. But he knew he could never aspire to the heights of Dizzy Gillespie or Charlie 'Bird' Parker.

There were jobs, but no direction. He worked in the parts department of Boeing Aircraft, in a steel forge, and as a lifeguard at Renton Beach. He took off for a while, working as a lumberjack in Oregon. During these 'lost years'[9] as he called them, he got to see ordinary life first-hand, shaping his fabled instinct away from the pretensions of artists.

These were the contradictions of Eastwood: sculpted by labour and liberated by jazz. When he enrolled as a music major at Seattle University, he received his military papers for the Korean war and that was that. But he has always been lucky. Stationed at Fort Ord on the California coast, he never saw any action. He administered swimming tests and, with a prophetic touch, became the projector operator for training films.

If we're divining for life-changing moments, the spark of epiphany, surviving a plane crash would certainly count. After visiting his parents in Seattle, Eastwood hitched a ride back to Fort Ord in a military Douglas AD Skyraider. With just a single seat for the pilot in the cockpit, he was crammed into the small compartment in the tail used by radar operators. Not long after take-off, he found that his door wouldn't shut properly and had to jerry-rig it closed with some cable. The air was so thin and cold he almost lost consciousness. That was only the start of his troubles: a combination

Below left and right: Eastwood's cited influences, or at least favourites, include Preston Sturges' *Sullivan's Travels* (1941), a screwball comedy about a director in search of meaning, with Joel McCrea and Veronica Lake; and *Sergeant York* (also 1941), Howard Hawks' tale of heroism under fire, starring Gary Cooper.

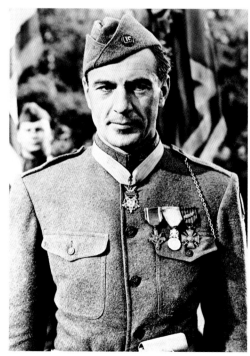

1955 Lady Godiva of Coventry
Actor (uncredited)

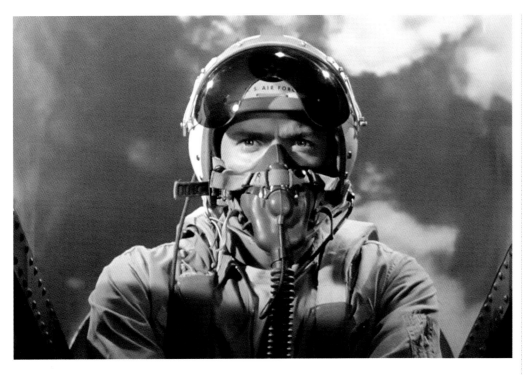

Left: Every great career has its collection of early curios and minor embarrassments, and Eastwood's is no exception. These include playing a squadron leader in giant spider fable *Tarantula!* (1955)…

of bad weather, faulty oxygen supply, and comms failure convinced the pilot to backtrack for repairs, but they ran out of fuel, ditching three or four miles off the coast. There was nothing else for it: he and the pilot had to swim towards the shore, but the currents kept pushing them north. As darkness fell, they became separated. Orientating himself toward the lights of houses, Eastwood negotiated schools of luminescent jellyfish. 'It was like some science-fiction deal,'[10] he remembered. He wondered if he was hallucinating. Eventually, he heaved his exhausted body onto the Californian rocks not far from his beloved Carmel. His brush with death left him appreciative of his small place in the universe. 'You get a break, you're here, you do the best you can with it,'[11] he reflected, though he was a reluctant flyer for a few years.

Coming out of the army, buoyed by his payout from the G.I. Bill, Eastwood set his course for Los Angeles, where he began a business administration degree at the Los Angeles City College for want of

anything better. Some combination of the inner music and the desire for more led him to the acting classes run out of the college's excellent drama program. It was serious stuff: they taught the rival schools of Michael Chekhov and Konstantin Stanislavsky. He learned about method, and the idea of finding a truth. In later career, his approach would be based around Chekhov's honed instincts. What was it Cagney had said? 'Plant your feet and speak the truth.'[12]

After a few false starts, and odd jobs, he got lucky again, when a cinematographer landed him an audition for the Universal's young actors' training program. This was his first taste of studio life. He looked the part, at least. Tall and well-toned, from a dedication to daily exercise that would endure into old age, and those blue-green eyes staring intently from a fine-boned face. A Gary Cooper or Joel McCrea type, his teachers would have thought. A relic of the old studio system, the program offered a regular wage as the

1955 **Tarantula**
Actor (uncredited)

1956 **TV Reader's Digest** (TV Series)
Actor (1 episode)

studio built up an array of young contract players. Eastwood committed himself for a year and a half, taking dance, diction, and riding lessons between acting classes. 'I wasn't afraid to try anything,'[13] he said. Later stalwarts David Janssen, John Saxon, and Mamie Van Doren were in the same intake. But it was going nowhere.

Hollywood was experiencing its own slump. This was the early fifties, and television was transforming a nation. Soon there was a set glowing in every living room. The glory days of the studios were on the wane. Movies were in decline. After Universal there was no guarantee of work. The roles, such as they were, came in fits and starts. B-movie bit parts that would haunt his later career. Is that Clint Eastwood stiffly performing in *Tarantula* and *Revenge of the Creature*? Sure is. He hated the audition process, and would

avoid putting actors through it as a director. All that sweat and effort for four hours on the Rock Hudson romance *Never Say Goodbye*.

He was close to quitting altogether when he dropped in to see a friend at CBS Television. As he sat drinking coffee in the studio cafeteria, an executive took a good look at him, strolled over, and asked him to test for a new Western serial they were planning called *Rawhide*. 'It was a fluke,'[14] he admitted. One that lasted for years. Westerns were big in the nascent world of television: *Gunsmoke* and *Bonanza* ruled the roost, but trail-herding drama *Rawhide* found its audience every Friday night. From 1959 to 1965, Eastwood became Rowdy Yates, the most earnest part he has ever played – the cloddish, youthful spirit (though he was thirty) of the perpetual cattle drive overseen by Eric Fleming's

Right: ...as well as uncredited bit parts in the Rock Hudson romance *Never Say Goodbye* (1956) – a sum total of four hours on set – and playing a comic lab technician in *Revenge of the Creature* (1955), 3D sequel to the classic *Creature from the Black Lagoon*.

1956 **Never Say Goodbye**
Actor (uncredited)

1956 **Highway Patrol** (TV Series)
Actor (1 episode)

1956 **Star in the Dust**
Actor (uncredited)

fatherly trail boss. 'Rowdy Yates, idiot of the plains,[15]' as Eastwood took to calling him. And that meant a gruelling schedule of filming six days a week, twelve hours a day. Here was the first realization that he wanted to direct. In the stampedes and around campfires, and in the mild, soapy dramatics of a weekly show, he could see how tame it all was. 'In TV, I saw so much that I *wouldn't* do as director,'[16] he said. But in every sense, he learned how to shoot fast.

Eastwood was already in his thirties, established but cornered on television, when the gateway to greatness crept open. In broad terms, his relationships with two, distinctive directors were to shape the artist to come. Two directors entwined with the Eastwood myth. And it began with an enquiry from the Rome branch of the William Morris Agency, who represented him. The international producers of a low-budget Western

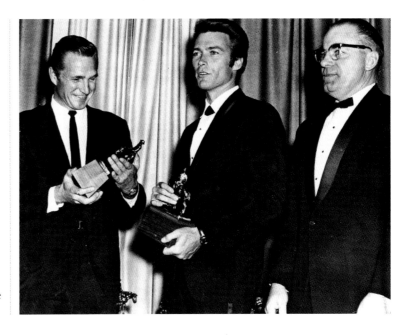

Above: *Rawhide* was the break Eastwood needed, becoming a huge hit on the emerging medium of television. Here Eastwood (centre) picks up an award with series lead Eric Fleming (left). It wouldn't be the last time we saw Eastwood in a tuxedo clutching a trophy.

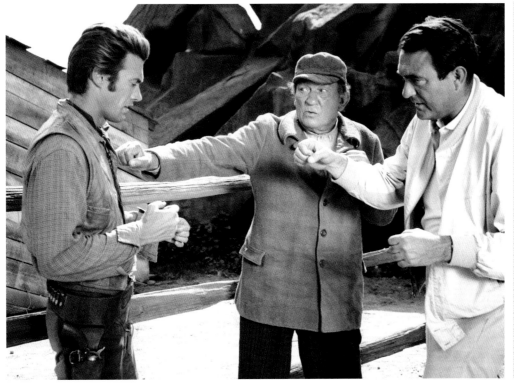

Left: Eastwood on the MGM Studios set of *Rawhide* in 1959, rehearsing a fist fight with guest star Victor McLaglen (centre), under the guiding eye of McLaglen's son and director Andrew (right).

1956 **The First Traveling Saleslady**
Actor

1956 **Away All Boats**
Actor (uncredited)

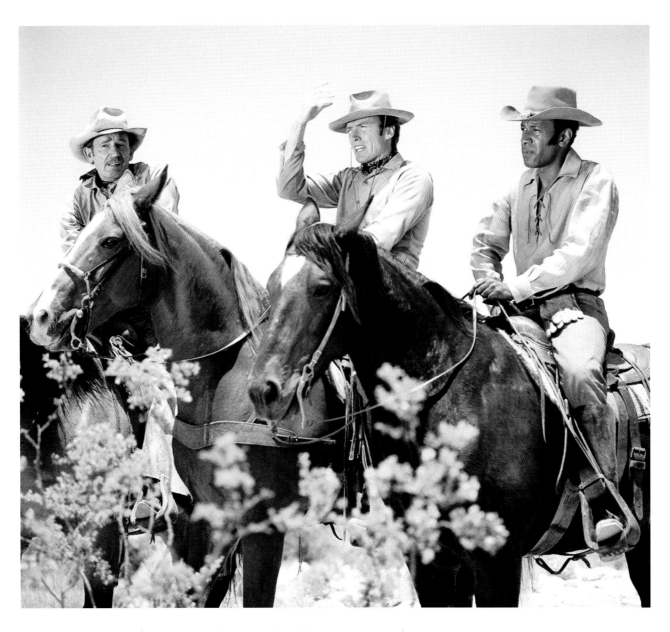

Above: By the final season of *Rawhide* in 1966, after Fleming had left, Eastwood's Rowdy Yates was promoted to trail boss. Here Eastwood's Rowdy issues instructions to regulars Steve Raines (left) and Raymond St. Jacques (right).

1956 **Death Valley Days** (TV Series)
Actor (1 episode)

1956 **West Point** (TV Series)
Actor (1 episode)

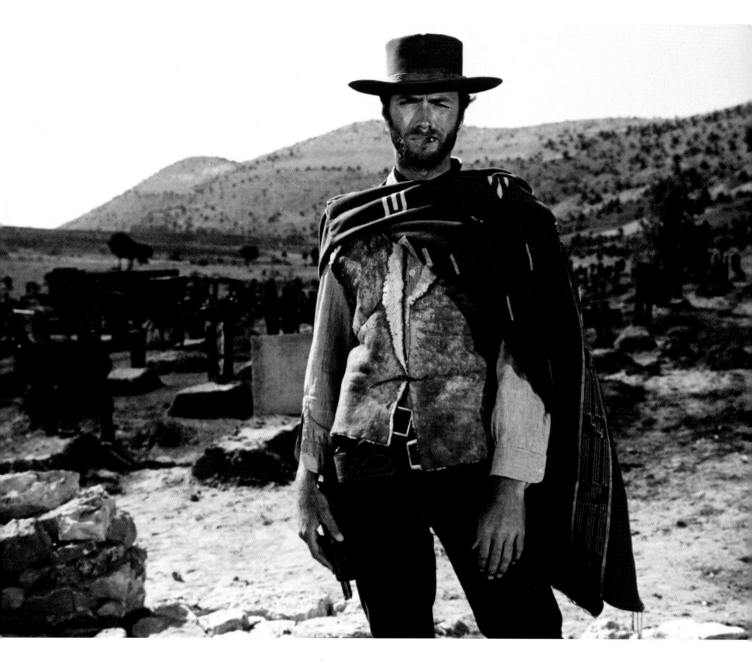

Above: Eastwood's The Man with No Name (in fact, Blondie) strikes an iconic pose in *The Good, the Bad and the Ugly* (1966) – cynical, posed to draw, his expression fixed in a world-weary wince as he chews on a cheroot.

1957 **Escapade in Japan**
Actor (uncredited)

1958 **Navy Log** (TV Series)
Actor (1 episode)

1958 **Ambush at Cimarron Pass**
Actor

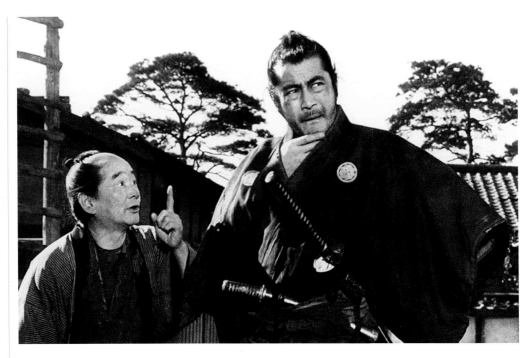

Right: One of the main reasons Eastwood agreed to star in the first of his Spaghettis, *A Fistful of Dollars* (1964), was that it was clearly an unofficial remake of a film he greatly admired – Akira Kurosawa's Samurai classic *Yojimbo* (1961), with Toshiro Mifune (right).

going by the name of *The Magnificent Stranger*, to be directed by someone called Sergio Leone, were in the market for an American lead. And given the limitations of their budget, they were keen on an *inexpensive* American lead. Now at this time (1963-1964), the thought of leaping into Italian movies was not entirely appetizing. They had a reputation for wily producers, threadbare productions, and unreliable remuneration. And the films were likely to never be heard of again. What, Eastwood might have thought, was the upside? He should politely decline and press on with his career in Hollywood.

"...The moment I got into it I recognized something – the chance to design another type of character." *Clint Eastwood*

History, or destiny, or instinct decided otherwise. He was persuaded to read the script, an unwieldy thing written in clumsily translated English, with what the Italian writers considered Western slang. '...The moment I got into it,' he recalled, 'I recognized something – the chance to design another type of character.'[17] He was beginning to find *Rawhide* constricting, and this was the first serious feature offer he had had in years. He saw a chance to capsize the image of Rowdy Yates. And it struck him quite quickly that this script was a free (and unofficial) adaptation of Akira Kurosawa's *Yojimbo*, a film he greatly admired. The money wasn't great, but at that stage of his career it was something. Plus, he had never been to Europe. 'So I felt, "Why not?"'[18] he said.

The *Yojimbo*-like plot has Eastwood's gun-slinging stranger arrive by mule in the remote town of San Miguel, where he will play two rival, criminal families against the middle. There's gold, and weapons, and all sizes of betrayal. And a swathe of absurdly violent confrontations.

1958 Hell Bent for Glory
Actor

1959 Maverick (TV Series)
Actor (1 episode)

Much to his frustration, the voluble, testy, brilliant Leone, born in Rome and raised in cinema (his father was a director, his mother a leading lady), was priced out of Henry Fonda, or James Coburn, or even Charles Bronson. The great coup with which to surprise his audience. He was appalled by the suggestion of a television star, walking out of the lone episode of *Rawhide* his producers tried to show him. But not without noticing the almost lazy way this clean-cut, thirty-four-year-old actor 'came on and effortlessly stole every single scene.'[19]

So in his summer hiatus from *Rawhide*, Eastwood flew to Almería in southern Spain – where the Italian-German-Spanish co-production was to cost-effectively reimagine the Tex-Mex border country – and shoot what would come to be called *A Fistful of Dollars*, first in a trilogy of magnificently bizarre, on a certain level realistic Westerns that would become their own legend. 'The West was made by violent, uncomplicated men, and it is that strength and simplicity I want to recapture,'[20] claimed Leone as he set out on his revisionist quest to liberate a genre from the 'cruel, puritan fairy tale.'[21] This sure wasn't *Rawhide*.

As part of his contract, Eastwood had an influence over things – the script for *A Fistful of Dollars* was, he said, far more 'expository'[22] than the finished film, with his wandering gunslinger far more verbose. He rewrote scenes the night before shooting them. Less a case of adding than subtracting. He cleaned out the dialogue and left the stare. Ten pages of dialogue could get reduced to a single sentence. 'It was an outrageous story, and I thought there should be much more mystery to the person. I kept telling a perplexed Leone, "In a real A picture, you let the audience think along with the movie; in a B picture, you explain everything."'[23] He had faith that the audience would reach into the story.

He had a hand in the immortal look and props of his character: the light grain of beard that consciously aged him, the poncho, the sheepskin waistcoat, the cheroot cigars (which he found in

a Beverly Hills cigar store and despised), and the same suede boots he wore on *Rawhide*. He became a presence, squinting into the dusty wind, the fastest draw and slowest drawl. His character has no past or future, and little motivation beyond money and a faint notion of cosmic justice. He is a wry ghost, a materialistic myth, a gothic avenger, and an ironic redefinition of all the square-jawed prefects of old. Rowdy Yates was transformed into a nihilistic yet compelling bounty hunter known as The Man with No Name (in fact, a marketing gimmick – Eastwood plays Joe, Manco, and Blondie in the three films).

Above: Communicating in the language of film – maestro Sergio Leone directs Eastwood in *A Fistful of Dollars*, despite the fact the director spoke no English and the star spoke no Italian.

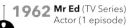

1959 **Alfred Hitchcock Presents** (TV Series)
Actor (uncredited, 1 episode)

1962 **Mr Ed** (TV Series)
Actor (1 episode)

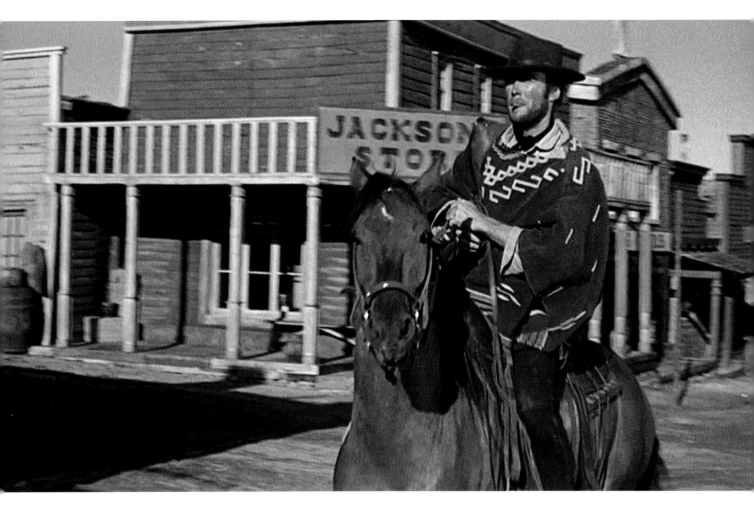

Above: *For a Few Dollars More* (1965) – the signature look of Eastwood's roving bounty hunter, with his poncho, jeans, and *Rawhide* boots, was largely concocted by the star, who hated the ever-present cigars, even though they were his idea.

Take nothing away from Leone, he was a cinéaste with a vast affection for the 'religion'[24] of American movies, especially the Western. He brought a glorious, operatic irony to the genre, a form of warped adoration, redefining the conventions in playful, self-aware, yet always epic terms. The bluntly overdubbed dialogue seems to come from some other dimension, but Ennio Morricone's whip-cracking scores are as much a setting as the landscape. 'I also learned from watching the Italians how to make only a few dollars look like ten times that much on the screen,'[25] said Eastwood.

It was never easy. The fussy Leone didn't speak a word of English, apart from 'goodbye', and Eastwood had no Italian, apart from *'arrivederci.'* The barrel-shaped, Cagney-like Italian directed with extravagant hand signals or by simply showing the actors what he wanted. There was something amusingly childlike about him. 'I spun off Sergio, and he spun off me,'[26] recalled Eastwood. But he felt stranded amid all these strangers, a loner playing a loner. While the actors around him launched into arias of Western exaggeration, he did less and less, scowling, chewing on his cigar, and delivering his remaining

1964 **A Fistful of Dollars**
Actor

1959-1965 **Rawhide** (TV Series)
Actor (217 episodes)

lines dry as a bone. Beneath the languid Spanish sun, that fabled minimalism was discovered. Leone loved a close-up – these magnificent faces as rugged a terrain as the Spanish desert. He made Eastwood's features iconic.

A sensation across Europe, *A Fistful of Dollars* would expand – in budget and scope and plot – through *For a Few Dollars More* and *The Good, the Bad and the Ugly*. Three lightly interwoven Westerns in which Eastwood's similarly guised character (whether it is the same man is left up to us) chased down his bounties, released to ever-increasing popularity and profit. By *The Good, the Bad and the Ugly* in 1966, Eastwood demanded $250,000 of a $1.3 million budget, a Ferrari, and ten per cent of the profits. He was learning fast.

It took a while for their wild success in Europe to filter through to America, with United Artists finally releasing the films back-to-back in 1967 and 1968. American audiences were equally enthralled

by these raucous fever-dreams. To say these pantheon-bound Spaghetti Westerns – as the sub-genre became known – made Eastwood a star is to vastly undersell the effect they had on him as star and director. Leone's trilogy defined his persona. We see the Man with No Name stare out at us from every Western he would make, as well as from the San Francisco streets of *Dirty Harry*, and even from Walt Kowalski's porch in *Gran Torino*.

Eastwood would finally say *arrivederci* to Leone when he (wrongly) turned down Leone's masterpiece *Once Upon a Time in the West*; his signature role, the cynical gunfighter, going somewhat ironically to Bronson. 'I guess, selfishly, because I am an actor, I wanted to do something with more character study,'[27] was Eastwood's excuse. American stardom beckoned, and a second pivotal mentor.

Having signed a deal at Universal, Eastwood was keen on a fish-out-of-water thriller called

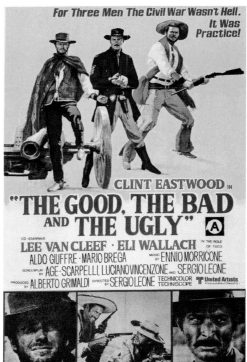

Left: Unsure of what they had, studio United Artists delayed the U.S. release of the *Dollars* trilogy until 1967, by which time the ironic Westerns were a sensation in Europe. They became instant hits in the home of the genre they deconstructed, elevating Eastwood to stardom.

1965 **For a Few Dollars More**
Actor

1966 **The Good, the Bad and the Ugly**
Actor

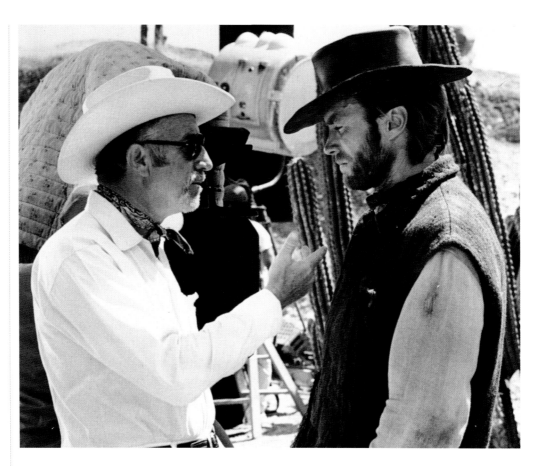

Right: Deconstructing a deconstruction – Eastwood on the set of homegrown Western *Two Mules for Sister Sara* (1970) with director and mentor Don Siegel, deliberately maintaining a similar look to his celebrated Spaghetti anti-hero.

Coogan's Bluff in which an Arizona sheriff comes to New York to escort a fugitive to trial. When he loses his charge, he must use country guile in the big city to track him down. It is almost a transitional genre piece: a combination of Western and cop movie. And after director Alex Segal dropped out, Eastwood needed a director who could add some charm to his Western cynicism, handle action, and be ready in a month. Born in Chicago, Don Siegel had come out of the studio system, supervising montages for Warner (including *Casablanca* and *Yankee Doodle Dandy*), before progressing to directing. He had a track record for bringing an edgy realism to genre pieces like *Invasion of the Body Snatchers* and *Riot in Cell Block 11*.

Another ready appeal: Siegel went about his trade with a staunch pragmatism. He knew what he needed, why hang around for more? 'Don always said, "I'm never trying for the second time. I'm always trying to make it right the first time,"'[28] said Eastwood. They met up in Carmel, had a couple of drinks, and, as Siegel recalled, 'discussed dames, golf, dames, the glorious weather etc.'[29] That about did it.

'I think I learned more about directing from him than from anybody else,' said Eastwood. 'He taught me to put myself on the line.'[30] And always to have forward momentum. They looked like a comedy duo: the tall, lean, slow-talking star and the compact director with a thick moustache, dressed in tweeds and an ever-present cravat,

1967 **The Witches**
Actor

1968 **Hang 'Em High**
Actor/Executive Producer (uncredited)

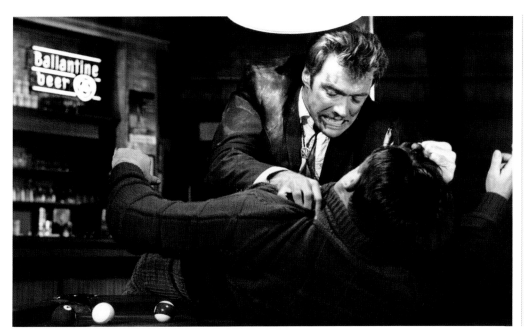

Left: *Coogan's Bluff* (1968), Eastwood's first studio lead, smartly mixed Western tropes with a contemporary cop thriller, as Arizona sheriff Coogan comes to New York to get his man, using old-fashioned policing techniques.

Below: Eastwood on the set of *Escape from Alcatraz* (1979) with director Siegel. This excellent prison-break drama, much of it shot on location, was the final film he would make with his great creative foil.

with a quick, witty, scabrous tongue. Siegel was content to take suggestions, and across five films a shorthand developed between them. He also knew never to give Eastwood too much direction. There were jibes, even flare-ups between them, but Siegel pushed Eastwood as an actor, setting the seal on the next phase of his career with *Coogan's Bluff, Two Mules for Sister Sara*, and *The Beguiled*. And it was Siegel who directed Eastwood in *Dirty Harry*. He had a cool, precise eye, with which, claimed film historian David Thomson, he 'observed action without brutality, treachery without dismay, and romance without glamour.'[31] Their final collaboration is arguably their finest. *Escape from Alcatraz* (1979) is a prison-break saga told with minimalist force, based on the true story of Frank Lee Morris (Eastwood), who made it to the water but was never seen again. 'By this time in their collaboration,' noted Quentin Tarantino, who worships the film almost as much as he does Leone's trilogy, 'many of the creative decisions are the joint decisions of two simpatico minds.'[32] There is something in the measured ingenuity and

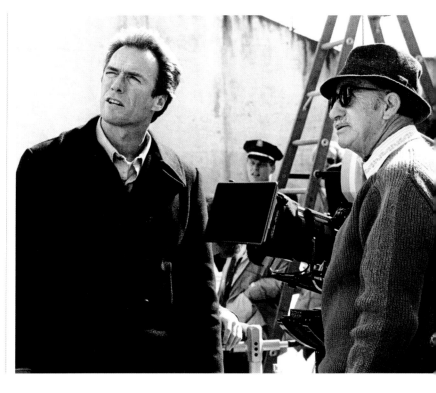

1968 **Coogan's Bluff**
Actor/ Executive Producer (uncredited)

1968 **Where Eagles Dare**
Actor

1969 **Paint Your Wagon**
Actor

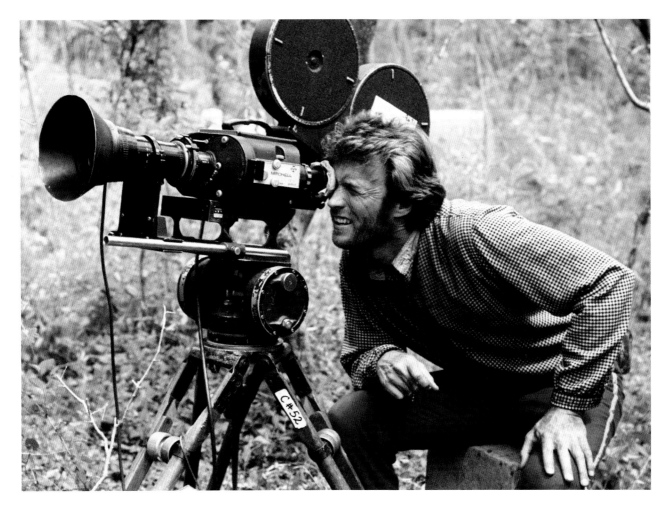

Above: Itching to direct, Eastwood checks the frame on the set of *The Beguiled* (1971), the highly provocative Southern Gothic directed by Siegel. Proof also that Eastwood was drawn to daring material.

practicality of Morris's escape plan that reflects Siegel as director – as it does Eastwood.

One more thing, before Eastwood the director emerges. A distinction needs to be drawn between the two sides of his career. A distinction that will be less apparent to Eastwood himself, who resists the wide view, reluctant to analyze the wherefores of his success. The idea of design, books such as this. But there is 'Clint' and then there is 'Eastwood.' Clint is the popular, genre star: the cool, brusque, steely-eyed, endlessly quoted legend of *Dirty Harry* or *In the Line of Fire*. Eastwood is the considered storyteller, the American artist

keen to remain anonymous behind his story. Now Eastwood has made a few, commercial Clint movies in his time: *The Gauntlet, Sudden Impact, The Rookie*. But in the great masterpieces to come – *The Outlaw Josey Wales, Unforgiven, Million Dollar Baby* – Eastwood has found himself exploring the mythology of Clint.

1970 **Kelly's Heroes**
Actor

1970 **Two Mules for Sister Sara**
Actor/Executive Producer (uncredited)

THE DIRECTOR EMERGES

Play Misty for Me (1971), Dirty Harry (scene) (1971), High Plains Drifter (1973),
Breezy (1973), The Eiger Sanction (1975)

With the arrival of the seventies, Clint Eastwood was on his way to becoming the biggest star in America. The odd *Paint Your Wagon* notwithstanding, an excellent barometer for projects had taken him from television second fiddle to marquee name. He claimed to be driven by no more than a nose for a good story, but the belated success of the Spaghetti Westerns had been consolidated in *Coogan's Bluff, Where Eagles Dare, Kelly's Heroes,* and *Two Mules for Sister Sara. Dirty Harry* was just around the corner.

Take me or leave me, his manner seemed to say. He didn't aim to please. The brand known simply as 'Clint' projected a masculine ideal: an alloy of mysterious authority, coolly amoral, at once ambiguous and attractive. And he knew exactly what he was doing. 'Some books – even Stanislavsky's people – discuss the fact that sometimes less can be best,' he said. 'Sometimes you can tell more with economy than you can with excess gyration.'[1]

Audiences were buying into his minimalist force. He stood in contrast to the zeal of the method gang: the Dustin Hoffmans, Al Pacinos, and Jack Nicholsons. So much more aloof than the stoic models of the past to which he was compared: a Gary Cooper, a Clark Gable, or a John Wayne. His icy blue eyes were more threatening than the glow of Paul Newman or Robert Redford. Clint had a tough bark. But there was a humour there too, dry as a gulch – an ironic aura that hinted we were not to take any of this too seriously. He didn't. It remains his secret gift (both as actor and director). The thing that humanizes him. He sees the world for what it is.

Fame was a burden he would have to carry. He has remained an intensely private man at the eye of global stardom. Keeping his distance from Hollywood, he made his home up the warm California coast in Carmel-by-the-Sea, a haven glimpsed years before while completing his basic Army training at Fort Ord. One day, he thought, I will live there. With his haven achieved, box office success was a means to a different end: creative freedom, the chance to express himself. He knew in his bones that you could tell stories without the waste and fuss he witnessed with studio productions. He called it realism: in his acting, directing, and producing.

"Sometimes less can be best ... sometimes you can tell more with economy than you can with excess gyration.." *Clint Eastwood*

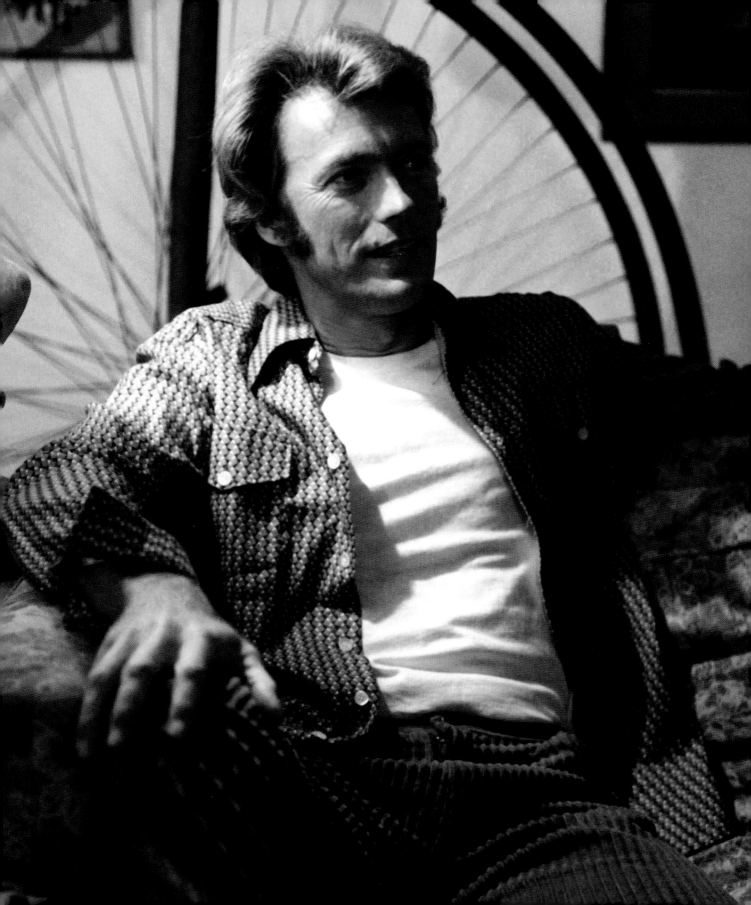

He had launched Malpaso Productions in 1967. Named after a creek that ran through his Carmel estate (and, ironically, the Spanish expression for 'bad step'), his ambition at first was simply to use the company to foster projects in which he could star and have a say in script and casting, while taking advantage of certain tax benefits. It was a good step toward controlling his own destiny. Commencing with *Hang 'Em High*, every film he has made is in part a Malpaso production.

The original sixty-page treatment of *Play Misty for Me*, written by Jo Heims, a former model and fashion illustrator pushing to become a screenwriter, had piqued his interest even before he went off to make *Where Eagles Dare* in 1967. For a few thousand dollars, Malpaso took an option on the thriller about a psychotic fan tormenting a local DJ, and Heims preferred to wait for Eastwood – but when the option lapsed, a larger offer from Universal was too good to turn down.

Fortuitously, with the hopes of regular material, Eastwood (through Malpaso) had signed a deal with Universal in 1969. A commitment to a series of films that might also provide him with an opportunity to direct one day. And that day had come. He asked after 'this little property'[2] they had, which had lain dormant. It's always a little movie with Eastwood. Don't get too big for your britches. Don't let ego get in the way.

There had been several attempts at a full screenplay, but nothing close to a green light, and Eastwood began again with Heims and Dean Riesner, taking a personal interest in developing the central character. Dave Garver really struck a chord. He jockeys at a small-time radio station specializing in jazz, that Eastwood predilection. Every night, a smoky female voice calls in to request the Erroll Garner classic *Misty*, and Garver obliges. Soon enough, the caller tracks him down to his favourite bar, and turns out to be the attractive, if uneasy Evelyn Draper (Jessica Walter). A one-night stand with Evelyn will turn into an increasingly violent struggle with a deranged woman, who does not take rejection well.

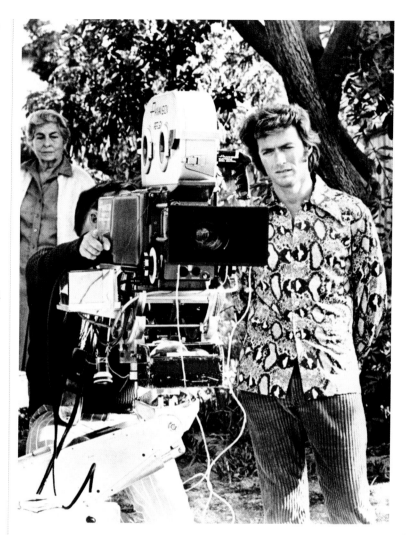

Above: Shooting on the Carmel set of *Play Misty for Me*. Universal had finally given Eastwood leave to direct this inexpensive thriller as a sop to a star's vanity. Little could they know it would launch one of the most celebrated and successful directorial careers in Hollywood history.

1971 **The Beguiled**
 Actor/Executive Producer (uncredited)

Unassumingly, *Play Misty for Me* is a momentous occasion. With this decent little thriller in the Hitchcockian vein (though he would resist comparisons with *Psycho*), Eastwood begins his directorial journey.

The urge to direct was as much an urge simply to be able to tell a story his way. He had seen too many good scripts be short-changed not only by a director's poor choices, but by the control the studio exerted over the material. The narrow-minded contortions of commercialism. He wanted autonomy *within* the system.

The elevation from actor to director (and the lack of female stars even to get a look in is a scandalous indictment of the era) was still an unusual progression in the Hollywood hierarchy. John Wayne had made the transition twice, fruitlessly, with *The Alamo* and *The Green Berets*.

For Laurence Olivier it was more an extension of his experience as a theatrical director. Charles Laughton tried it only once with *The Night of the Hunter*, a wonderful film but a commercial disaster, and he couldn't face it again. Paul Newman and Marlon Brando only directed once apiece, while Jack Nicholson summoned the energy just three times in fifty years. Among Eastwood's peers, only Warren Beatty and Robert Redford have really had comparable careers. But while they dally and fret, mulling over a project for years, Eastwood makes one film after another as if mounting up and riding on to the next town. From the very beginning, he was a director who happened to be in possession of a star's photogenic features. Or at least the two impulses, acting and directing, were entwined in his imagination like the strands of DNA. He simply considered it a 'natural progression.'[3]

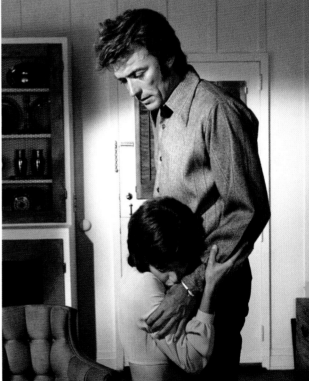

Above and right: A film ahead of its time – what remains so resonant about *Play Misty for Me* is that disc jockey Dave Garver (Eastwood) is a victim of his own flawed nature, as embodied by his one-night stand with Jessica Walter's aggrieved, highly unstable Evelyn Draper.

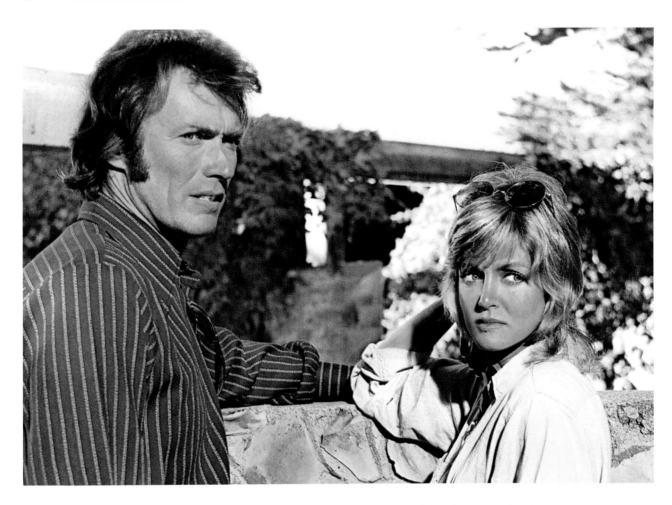

What kind of filmmaker would he make? Would his films necessarily be an extension of the granite presence of the actor? Was there such a thing as a Clint movie? As it will turn out, across the years and the following pages, the answer is a director of far more range than anyone could have realized. One quite capable of confounding choices. Indeed, the very American masculinity he appeared to embody was laid open for inspection. And this begins with *Play Misty for Me*.

The themes resonated with him. Garver's womanizing and fear of commitment – he could hold his hands up to those faults. The witty line, 'He who lives by the sword shall die by the sword,'[4]

was his addition. You can read the plot as a parable about fame. He related, he said, to the 'idea of suffocation.'[5] It was also based on actual incidents. Heims had a female friend she knew to be a stalker, providing her story with a realistic core. There was no murder involved: but the wigs and disguises, the suicide attempt, and the slashing of Garver's clothes were drawn from life. Tied in with this were Eastwood's memories of women who had struggled to let go of him, and he had heard obsessional stories of both sexes. 'It was a very important part of the film,' he maintained, 'because that's the thing that made it personal to the audience as opposed to just a horror movie.'[6]

Above: Eastwood as Garver with estranged and imperilled girlfriend Tobie (Donna Mills) in *Play Misty for Me*. The film would be perceived in some quarters as a feminist piece, with Eastwood drawn from the beginning to complex material.

Eastwood had recently shot *The Beguiled* for Don Siegel – a heated Civil War drama about a mansion of abandoned Confederate women who turn on the Union soldier who has fallen into their midst, and spreads discord and sexual jealousy among them. Its clammy air of male misanthropy had clearly stuck with him. Swapping genres from Southern Gothic to modern thriller, he was still perfectly willing to play tainted – it was more realistic that way. '[The] hero in each case is a careless opportunist who refuses to take responsibility for the havoc he creates,'[7] noted David Denby in the *New Yorker*. Flawed characters became a fixation. And in concert with this deconstruction of the American male was a reactionary view of the female. In its West Coast microcosm, *Play Misty for Me* is a film that foretold *Fatal Attraction*.

The *Los Angeles Times* noted that women in his movies have always been strong, both as heroes and villains, and that 'Eastwood may be not only one of the best, but the most important and influential (because of the size of his audience) feminist filmmaker working in America today.'[8] It's a contentious view, but reveals the complexity that's within the Eastwood touch.

Another attraction was the scale of the story. It was a tight and relatively inexpensive piece, making it less of a gamble for the studio and more manageable as a first film. As written, he could easily transplant the story to Carmel, right on his doorstep, tailoring that sleepy, coastal landscape he knew well to the mood of the film. Marrying theme and topography is one of his great skills. He would effectively be working from home (adding

Right: Eastwood saw the film in the Hitchcockian tradition of violent shocks only reversing genders – here the psychotic Evelyn (Jessica Walter) takes a familiar-looking kitchen knife to Garver's innocent housekeeper Birdie (Clarice Taylor).

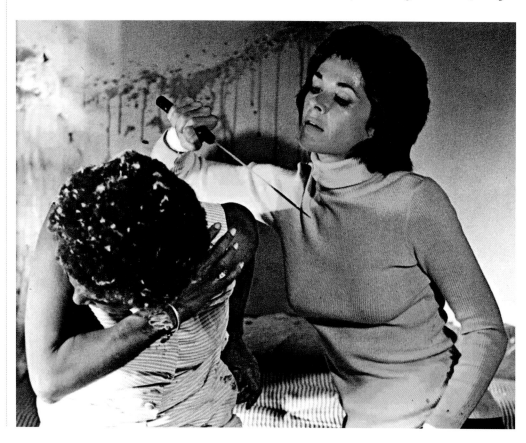

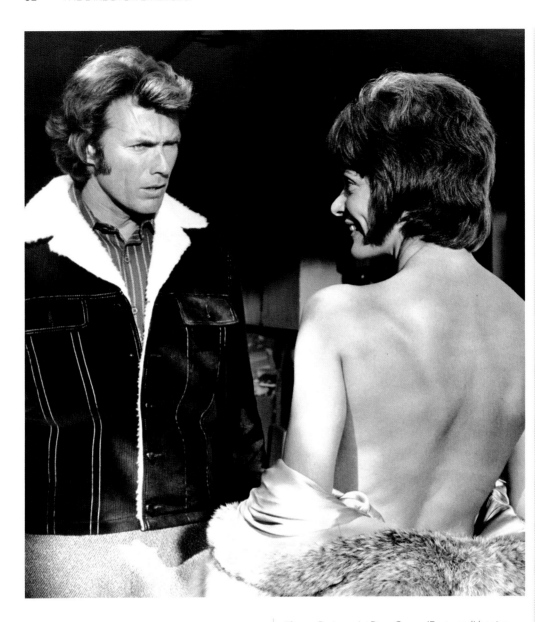

Above: Protagonist Dave Garver (Eastwood) begins to realize the error of his ways as Evelyn (Jessica Walter) refuses to accept that their night together was no more than a casual hook-up. *Play Misty for Me* actually features one of Eastwood's most telling and vulnerable performances.

1971 **Dirty Harry**
Actor/Director/Executive Producer (uncredited)

another thread of reality to the weft). 'I'm gonna do it for zip,'[9] he assured Universal (which meant for under $1 million). How could they argue? Though studio head Lew Wasserman was baffled by why he saw anything in such unpleasant material. Eastwood suspected that they agreed to this 'vanity project' mostly to keep him happy – let him fool around a little behind the camera and he'll be more agreeable to something commercial down the line. But this was a vanity project from a man without vanity, who was only paid for his acting duties.

When it came to the pivotal role of Evelyn, as ever Eastwood followed a hunch. At an agent's suggestion, he watched Walter in *The Group* from 1966, about college friends who reunite to compare woes, featuring eight relatively unknown actresses. He had liked how, in her words, her character 'was on the edge.'[10] There was something threatening in the tight line of her mouth. Besides, they got on well when they met, and as they strolled

around the lot, he encouraged Walter to give her opinion on the script. She pushed to remove a backstory that Evelyn had been in a mental asylum. Eastwood went even further, eradicating any trace of a normal life. Which makes her far more believable: this terrifying force of nature. Naturally, the studio pushed for a bigger name, but his hunch was proved right. With eyes as wide as golf balls, her face a rictus of betrayal, Walter gives an outstanding performance, which, as *TV Guide* said, 'somehow manages to be chilling while at the same time sympathetic.'[11]

Eastwood's directing career officially began on 4 August 1971, and his working method was fully formed. The pace of it. No one runs on an Eastwood production. 'Nobody runs in a hospital, and they're saving lives,'[12] he once said. Equally, there is no indulgence. He gives the actor all the time they need, and mostly just the one take. 'Let's move on,' he says, instead of 'cut.'[13] He prefers that first time you see the situation in an actor's eyes.

The crew, who would soon become regulars – 'his family'[14] – had to learn to decipher quick hand movements. A subtle semaphore that got the job done twice as quickly, and without the director having to show who was boss. Much later, Meryl Streep (and what an Evelyn she might have made) saw the effect first-hand on *The Bridges of Madison County*: 'He's very humble. But he is, in a sense, savvy about his effect on people. And it's a useful, useful thing.'[15] After five weeks of shooting, he finished two and a half days ahead of schedule.

Nonetheless, this was his first film, and he brought his mentor Siegel along as a lucky charm, knowingly cast in a cameo as Dave's bartending counsellor. They share salty exchanges on life and women, with Siegel's Murphy wryly reviewing Dave's irresponsible ways. These were the first scenes they shot. Eastwood laughed: 'I tell everybody I did it that way because it was first day on set, and I wanted somebody to be more nervous than I was…'[16]

While not a stellar hit, *Play Misty for Me* made good money ($10 million in America). Though Eastwood would grumble about the studio's poor handling of the project, he had proved himself and his filmmaking philosophy. The reviews concurred. *Newsday* praised the fact that Eastwood 'keeps his cool on both sides of the camera.'[17]

Below: In art as in life – Eastwood's directing friend Don Siegel was persuaded to take a cameo in *Play Misty for Me* as Dave Garver's bartending confidant Murphy, dispensing wisdom on- and off-screen. Meanwhile, Evelyn (Jessica Walter) lurks at the other end of the bar.

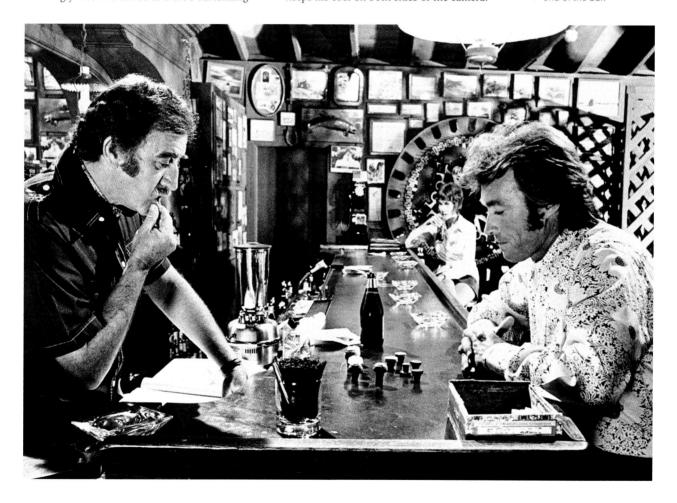

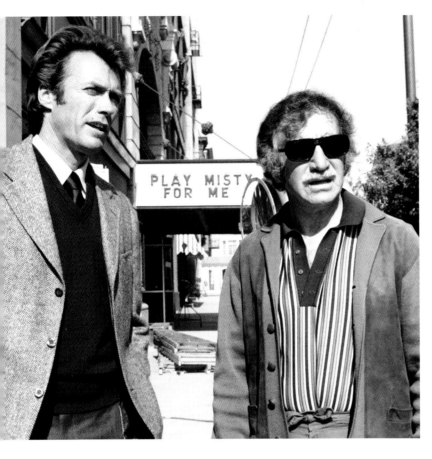

Above left and right:
While shooting *Dirty Harry* (1971), director Don Siegel and star Eastwood weren't above a little self-referential touch by having *Play Misty for Me* show at a passing San Francisco cinema. While not the smash hit his iconic cop thriller would become, *Play Misty for Me* made good money, and Eastwood was in business as director.

What is often forgotten is that Eastwood gives one of the best performances of his early career as this smug man thrown into crisis. The film stands as a herald of so much to come: a naturalism with genre, strong themes, personal touches (including scenes at the real Monterey Jazz Festival), and from the very start, proof that director and leading man were made for one another.

Eastwood didn't direct *Dirty Harry,* the smash-hit thriller by which he is still defined. That was Siegel, of course. But we should pause to consider the impact of his next movie. Also the fact that Eastwood was vital in driving its creation, choosing Siegel, shaping the original script (by Harry Julian Fink and Rita M. Fink), and the sheer presence of weary San

Francisco detective Harry Callahan on the trail of a serial killer calling himself Scorpio (Andy Robinson). And there was one scene in which he did, by necessity, take the reins.

Dirty Harry came about because Frank Sinatra sprained his wrist on *The Manchurian Candidate*. He had signed on to star in the film, under the title *Dead Right*, and when injury disqualified Sinatra (for surely a very different film) Warner Brothers eventually offered it to Eastwood. Perusing the mess of screenplays, he brought in his regular fix-it man Dean Riesner and relocated the story to San Francisco from a New York too synonymous with *The French Connection* and the previous Eastwood-Siegel unconventional cop collaboration *Coogan's Bluff*.

1971 **The Beguiled: The Storyteller** (Short)
Director

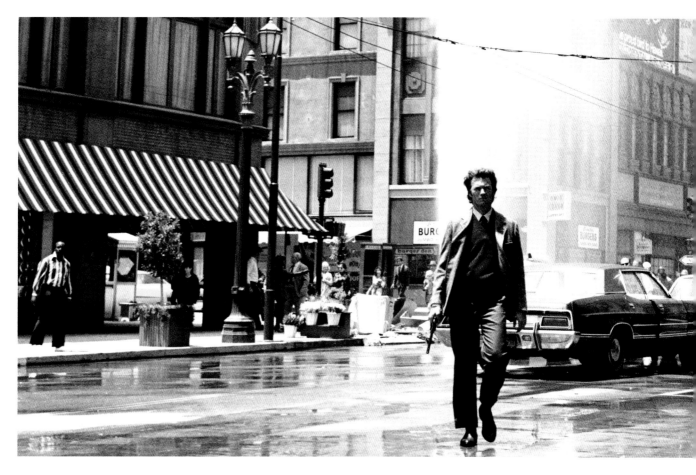

What stirred such delight in audiences and the accompanying controversy is how easily we are drawn into Harry's disaffected perspective. Unbridled by the rulebook, he takes the path of least resistance, his trusty .44 Magnum looming down the lens of the camera. We buy into the scowl and withering commentary, the birth of the one-liner delivered in that sandpaper snarl, all the sangfroid magnetism, halfway funny, that belong only to Eastwood.

Dirty Harry has been read many ways. Many of them, as Richard Schickel contends, 'overheated political metaphors of the moment.'[18] Harry was a reassuring counterpoint to Vietnam. Harry was an exercise in covert fascism (denying the perp his rights, the cop as judge and jury): the overreaching opinion the *New Yorker's* Pauline Kael used as a banner in her career-long crusade against Eastwood. Counter-arguments rage that Harry, if anything, is anti-authoritarian, this lone force against systemic corruption. That was one of the things Eastwood thought so effective – Harry does what he has to do, but behind the curled lip was a cost.

'You know, *Dirty Harry* is a guy who really didn't get any pleasure out of it. I played him for a certain sadness because I believe that if you really did kill all those people, there would be an effect on your soul or your psyche or whatever your beliefs are, however you want to phrase it.'[19]

Above: The scene that made *Dirty Harry* a controversial sensation and Eastwood a superstar has imperturbable Detective Harry Callahan persuading a bank robber not to attempt to flee the scene of the crime – aided by his trusty Smith & Wesson Model 29, loaded with a .44 Magnum cartridge.

1972 **Joe Kidd**
Actor/Executive Producer (uncredited)

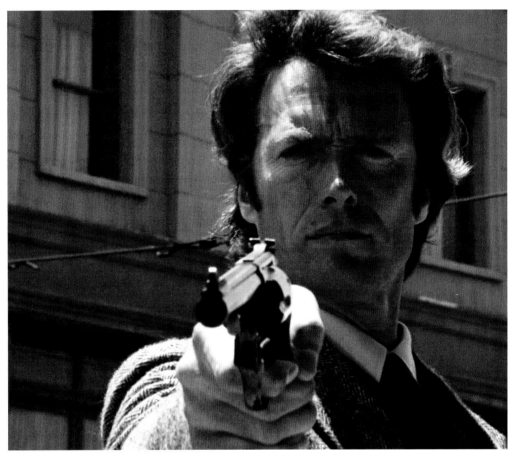

Above right: Harry's emblematic gun (several were used in the movie) had been procured by the star direct from Smith & Wesson.

Right: The scene where Harry deals with a potential suicide (Bill Couch) was directed by Eastwood himself, as the actors and camera operator had taken up all the available space on the ledge where it was filmed.

Over an arduous eight-week shoot, Siegel crafted an excellent, provocative duel between obsessive cop and psycho in which Eastwood and Harry essentially became one. The exception being the scene where Harry deals with a potential suicide by simply knocking him out – a snapshot of his no-nonsense approach to civic duty – when it was Eastwood who called the shots in the confines of a cherry picker and a narrow sixth-floor balcony. Shoot it like they do on the news, he told the crew.

Whichever way you cut it, *Dirty Harry* is a landmark in American cinema. Siegel disciple Quentin Tarantino noted how it was 'the most imitated action film of the next two decades.'[20]

1973 **High Plains Drifter**
Actor/Director

The shadow it cast over Eastwood's career (there were four sequels, one of which he directed) is hugely significant. The character was indelibly imprinted on the moviegoing consciousness. Throughout his directing career, Eastwood has sought to explore, satirize, oppose, and repeat the cultural event of one of the most famous (and infamous) films ever made. On its release, *Dirty Harry* simply became a sensation, making $36 million, whereupon theatre owners in America would name Eastwood their top money-making star of 1972-1973.

High Plains Drifter is so starkly amoral it could have been directed by Siegel, but fully reveals Eastwood's own lack of sentiment. This is a cold cut of vengeance with no redeeming characters, including his own, and the first of the Westerns in which he essays an avenging angel. Riding out of the wilderness, Eastwood's Stranger (a man with no name) has come to settle a score with the townsfolk of Lago, who had heartlessly looked on as their sheriff was whipped to death by outlaws (led by future regular Geoffrey Lewis).

It was born of a nine-page treatment called *Mesa*, which Ernest Tidyman expanded into a near-gothic rendition of a classic formula. 'I just saw the film clearly,' recalled Eastwood. 'That's why I decided to direct it.'[21] There are elements of Leone's irony, certainly, but it is far more visceral, striking out against convention with a vibrant contrast of sun-bright exteriors and sullen, barely illuminated interiors. A mythic texture consciously shorn of glamour. Unusually, Lago sits waterside, and they filmed on the barren shores of Mono Lake where the saline water evokes otherworldly colours as the daylight shifts.

As the Stranger gradually turns on the corrupt citizens, the film ignites into a scathing report on a venal America. '*High Plains Drifter* is funny in a more dread-inducing key,' observed *Slant*

Above left and right:
High Plains Drifter (1973), the first Western that Eastwood directed, showed straightaway that, borrowing from Sergio Leone, he would not be approaching the genre conventionally. Eastwood's unnamed stranger is an almost surreal angel of vengeance, who has returned to bring justice to a corrupt town.

1973 **Breezy**
Actor (uncredited)/Director

magazine, 'offering a lingering visit in purgatory while revealing notions of "society" to be a sham.'[22] What is so startling is Eastwood's willingness to descend to such depths at the height of his box office appeal.

A shock hit (with $15 million), there is an aura of Japanese ghost story as this twist on *High Noon* approaches the surreal. Might the Stranger indeed be the reincarnation of the sheriff? Eastwood accepted you could read it metaphysically, but preferred a more rational take: 'The way the whole town was, no children, kind of strange: it's a weird situation. As far as me justifying the role, he was the brother. But as far as the audience is concerned, if they want to draw him as something a little more than that, that's fine.'[23] He was now the force of nature.

Breezy was a move to lighten things up, plus a chance to direct for the first time without the burden of starring as well. In any case, Eastwood was too young for Frank Harmon, a cynical, fifty-something Los Angeles divorcee, plump with real-estate money, drifting rather than living. Another pleasure the film offered was landing the legend William Holden as his lead, who 'was just a prince to work with,'[24] he recalled.

Once again written by Heims, it was an inversion of *Play Misty for Me* (and a rebuttal to the anti-hippy accusations thrown at *Dirty Harry*), this unconventional love story in which free-spirited teen Breezy (the discovery Kay Lenz) wafts into Frank's life by chance (she thumbs a lift) to stir his clotted heart. Nonetheless, it has its satirical vein in Eastwood's barbed portrayal of L.A.'s *nouveau riche*.

God knows, it wasn't commercial (and Universal despaired). 'It won't make a dime,'[25] accepted Eastwood, which was proved right.

Right: Working with Hollywood legend William Holden was one of the great pleasures of quirky May-December romance *Breezy* (1973), a conscious change of pace, and a chance to prove Eastwood's versatility – not least to himself.

1973 **Magnum Force**
Actor

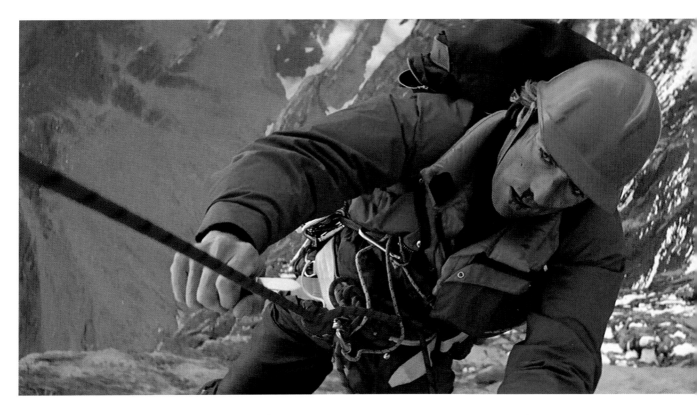

But on a budget of $750,000 the risks were low. He liked the characters, and the change of pace, simple as that. It might be his most forgotten film, and it has dated (not least in the age gap between the leads), but shifting to an ersatz father-daughter context, Lenz's bright-eyed Breezy will be reborn in Hilary Swank's Maggie in *Million Dollar Baby*.

The Eiger Sanction was an out-and-out commercial swing, but one with a distinctly Eastwood slant. Based on the first of a series of pulpy James Bond send-up spy thrillers by Trevanian (pen name for Texas film professor Rodney William Whitaker), it had come Eastwood's way after Paul Newman had passed, considering it too violent. The implausible plot follows Eastwood's Jonathan Hemlock, an art professor stroke assassin-for-hire (undertaking political killings known as 'sanctions') stroke expert climber tasked with flushing out a Russian agent from a team attempting the North Face of the Eiger.

The script needed serious work, but he was drawn to the physicality it offered, and the isolation. He saw a chance to shoot on location with a small crew and be tested to his athletic limits, admitting that he 'got wrapped up in wanting to be the first guy to shoot totally on the side of a mountain…'[26] It would also fulfil an increasingly constricting deal with Universal.

Filmed across the summer of 1974, an already strenuous shoot was darkened by the death of experienced climber David Knowles (who was part of the stunt crew), struck by a falling boulder on only their second day on the Eiger. Eastwood considered shutting down the entire production, but was encouraged to keep going by Knowles' fellow climbers. A finished film, they insisted, would give his death some kind of meaning.

Above: *Cinéma Vérité* taken to the extreme – driven by realism, Eastwood was drawn to spy thriller *The Eiger Sanction* (1975) by the challenge of shooting the mountain-climbing sequences on the Swiss mountain in question. Thus he had to learn to climb to a professional standard.

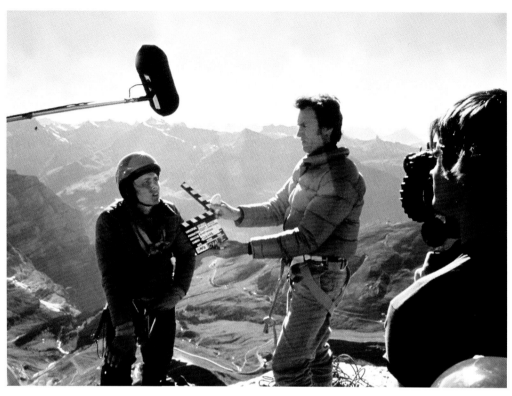

Above right: While it may not wholly convince as an espionage adventure, the views are extraordinary, and *The Eiger Sanction* is a monument to Eastwood's uncompromising approach to his craft.

A box office of $14 million returned Eastwood to profitability, but *The Eiger Sanction* is a film caught in two minds. The cartoonish derring-do of the genre is not a good fit for Eastwood's rugged American realism. As a climbing movie, however, the verisimilitude is unquestionable – that really is superstar Eastwood dangling on the end of a line, 1,000 feet above Swiss pasture. He remembered the distant cowbells. Critics made much the same point. We don't believe the plot for more than fifteen seconds, reported Roger Ebert in the *Chicago Sun-Times*, 'but its action sequences are so absorbing and its mountaintop photography so compelling that we don't care.'[27]

The training sequences in Monument Valley leave the biggest impression. This was the holy backdrop to John Ford's great Westerns. American iconography. As Hemlock strives to get back in shape, he free-climbs the Totem Pole, a flat-topped pillar of orange rock sacred to the Navajo Nation. The production were granted permission to film there on the proviso that they cleared the 640-foot spindle of climbing debris – old pitons and the like. Not skilled enough to make the climb – that was professionals Eric Bjørnstad and Ken Wyrick – Eastwood was lowered onto the 18-foot square summit by helicopter, along with co-star George Kennedy, and a slender crew equipped with lightweight cameras. As the sun set over Monument Valley, there were few more perfect days in all the fifty years he has spent behind or in front of the camera.

1975 **The Eiger Sanction**
Actor/Director

WAY OUT WESTERN

The strange tale of *The Outlaw Josey Wales (1976)*

Clint Eastwood's foremost film to date, and still one of the great Westerns of any era, began life with a strange book and a change of address. It was a defining moment. He cut his ties with Universal, where he had directed four films, and signed a development deal with Warner Brothers, a business move that would shape his entire career. Beyond the contract system of classical Hollywood, no director has been so synonymous with a single studio. Only three of Eastwood's films across the next fifty years, as director and star, didn't involve Warner.

His reasoning was twofold. Firstly, there was the disturbance. Universal had given him a bungalow on the lot, real comfortable, but every day the studio tour would pass by his door, with the tourists yelling for him to come out and take a bow like some performing monkey. No tours, he iterated to the Warner hierarchy. No tours, they assured him. Furthermore, he reported, his new studio 'had a bigger lot, more resources, and their promotions department was pretty good.'[1]

Which was the second, more pertinent reason for the move. He had no faith in Universal's marketeers, who treated his conventional and unconventional choices much the same. He blamed them for the underwhelming performance of *Breezy*. Warner had people who would listen to him. Who knew how to treat a film with care. And, not for the first or last time, he had an unusual Western in mind.

By the mid-seventies, Eastwood was the genre's custodian, refusing to pay heed to Hollywood trends that suggested cowboys were bad for business. Some stories needed to be told. And this was the American genre, its great exploration of selfhood and a foundational folklore for a young nation. The genre, as critic J. Hoberman said, wherein America stared itself in the face as it asked some big questions. What is justice? What is progress? What is civilization?

In Eastwood's hands, the noble countenance of the Old West had drifted into irony. He had learned from Sergio Leone. In the operatic Spaghettis, distinctions became blurred – the hero shoots his foes in the back as readily as the villain. The Man with No Name amassed a body count of fifty in *A Fistful of Dollars*. 'You have to try for realism,' noted Eastwood. 'So, yeah, I used to shoot them in the back all the time.'[2] This was the revisionist way. What does it take to survive?

'I do all the stuff Wayne would never do,'[3] he laughed.

"You have to try for realism. So, yeah, I used to shoot them in the back all the time ... I do all the stuff Wayne would never do." *Clint Eastwood*

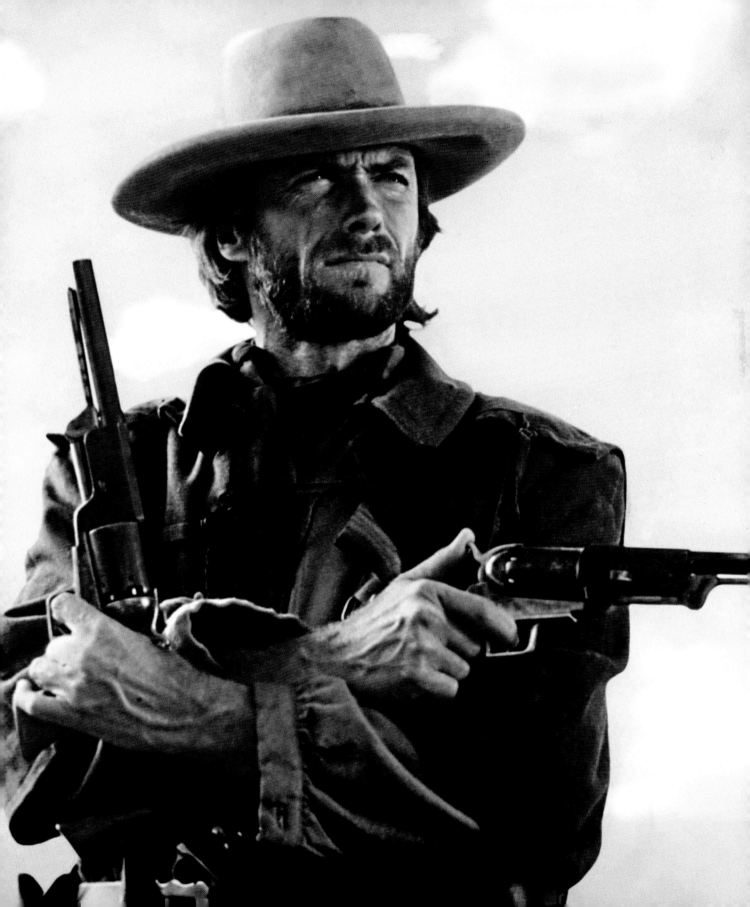

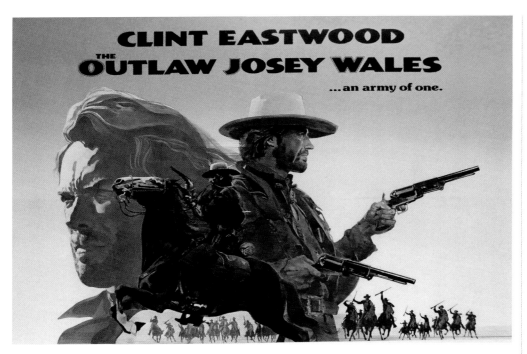

CLINT EASTWOOD
THE OUTLAW JOSEY WALES
...an army of one.

Left: Beginning a career-wide exploration of the wages of violence, *The Outlaw Josey Wales* is in a sense a war movie, portraying the aftermath of Josey's conscription into the Civil War and his journey towards redemption. The seeds of *Unforgiven* (1992) were planted.

The Outlaw Josey Wales is an even more canny operator: a Western that combines these two opposing takes on the genre with great brio and heart. On the one hand, it appears to be a classic Eastwood show – with the lone gunfighter lighting out for the frontier, legend lingering in his wake, the ironic truth in his saddle bag. Shades of the persona he had cultivated in the *Dollars* trilogy, *Two Mules for Sister Sara, Hang 'Em High, High Plains Drifter* and to an extent *Joe Kidd*. The terse, darkly witty archetype audiences and studios had come to expect.

On the other hand, it bears hallmarks of the old school – the tale of a good man thwarted by tragedy, who heads West in search of solace, uniting a family of eccentric souls around him. Traversing epic landscapes and epic emotions, the saga of Josey Wales takes some inspiration from those old wagon-trail pictures where characters follow their destinies West. As the *Chicago Sun-Times said*, 'it was as if *Jeremiah Johnson* were crossed with *Stagecoach*.'[4]

Biographer Richard Schickel saw it as a 'reconciliatory'[5] film, both in terms of the storyline as Josey unites his disparate family of followers, and 'in the way it blended the manners and morals of the traditional Western with those of the revisionist school.'[6] It reconciled eras too. Post-Leone, the Western served as a barometer for the present as much as the past, particularly the sharply attenuated political rivalries of the Cold War. In a rare admission of subtext, Eastwood acknowledged that *The Outlaw Josey Wales* was a Western channelling the ambiguities and rage of Vietnam. Not directly, he added, but depicting what he called the 'futility of war'[7] – its collateral damage on lives. He often cited Watergate too, that other great American betrayal. Josey Wales rages against a corrupt state.

Amy Taubin, writing in *Sight & Sound*, described it as 'the first film of Eastwood's old age.'[8] He was still a vigorous forty-six and making only his fifth film as director, but already probing the surface of his trademark antiheroism. 'I like reality,'[9] he

reflected. He was interested in a certain frailty in mankind, no matter how quick the draw, or how bloody the reputation.

So where did it all begin? The answer is an uninviting novel entitled *The Rebel Outlaw: Josey Wales* that lay buried on Eastwood's desk. One of numerous blind submissions, the author was a figure named Forrest Carter, who would turn out to be a wild card to say the least. As far as Eastwood and his team could tell, the unknown Whipporwill Publishers, based out of Gantt, Alabama, had issued no more than seventy-five copies. 'It had such a bad cover on it, I didn't read it right away,'[10] recalled Eastwood.

When they found him, Carter might well have been a character of his own making: an inveterate drunk, wilful opportunist, and potential schizophrenic, he was liable to draw a knife at dinner or head out into the Alabama woods for days. He was also liable to start demanding more money, due to an unending stream of grievances. Only after the film was released did it emerge that Carter – real name Asa Earl Carter (who died in 1979) – had been a paid-up Klan member, dedicated segregationist, and antisemitic radio broadcaster, though he claimed to have relinquished politics to write this story of transformation. Over the coming years, articles looking to denounce Eastwood would cite Carter as a friend. The truth is, they met only once, and Eastwood's adaption of his book effectively turned Carter's racism on its head.

Below: Unwittingly, Josey will attract a family of strays, including itinerant former chief Lone Watie. Irrepressible, not to say unpredictable actor Chief Dan George would prove a wonderful comic foil for the taciturn Eastwood.

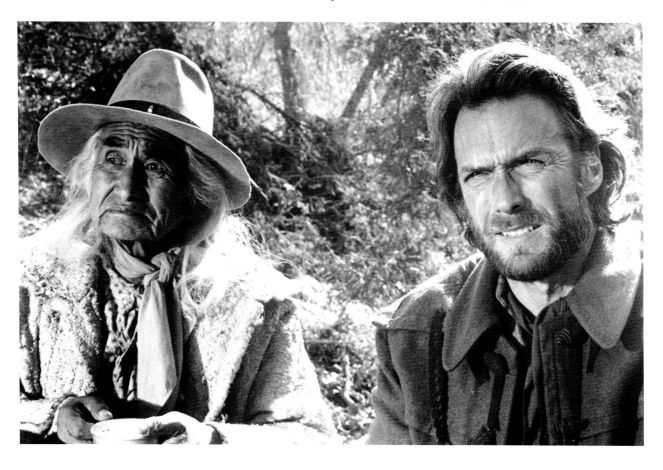

At the time, Eastwood's producing partner Robert Daley was really taken with the story. He read it in one sitting, and was on the phone to Eastwood that night. Catching Daley's enthusiasm, he read it straightaway and saw the possibilities. 'It just read beautifully,' he said, 'even the dialogue jumped off the page.'[11]

Before the opening credits roll, we glimpse Eastwood's Josey as a peaceful farmer, living with his family in rustic Missouri just as the Civil War lands at his door – when Redleg Union raiders burn him out of hearth and home, murdering his wife and his son (played by Kyle Eastwood). For the first time, we witness a motif that would haunt Eastwood's career: his character kneeling at his wife's graveside. Cause and effect: in short order, the embittered Josey is recruited by Confederate bushwhackers, the Missouri Raiders, to 'set things right.'[12] A montage of wartime slaughter later, the war over, Josey refuses to surrender honourably. A wise choice, as it turns out, for his comrades are all but wiped out in a Redleg ambush. Carter's novel knowingly paints a picture of injustices perpetrated by the Blues, and Eastwood would become well versed in the historical complexities of the Civil War.

The film shifts again in tone and location as the ungovernable Josey heads west then south, with a price on his head, and a growing reputation as a ruthless gunfighter. Josey's distaste for fame was matched by the star wearing his hat. On his trail come those same Redlegs, led by the vituperative Captain Terrill (Bill McKinney) and Wales's turncoat Bushwhacker commander Captain Fletcher (a memorable, barrel-voiced John Vernon).

The landscape changes with Josey's emotional state; we can almost chart his spiritual wellbeing by the weather. Missouri to southern Texas: grim and overcast, with those furious Eastwood-rainstorms, a turbid river to cross, and on to a hard but warm desert sun. The journey is internal as well as external, a true saga of a man who loses himself and regains his soul as he unwittingly

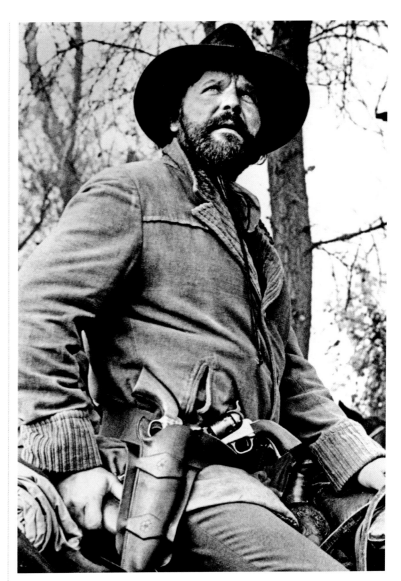

Above: The complex villains of the piece – John Vernon gives a wonderfully considered performance as the conflicted Captain Fletcher, hired to give chase to his former soldier Josey...

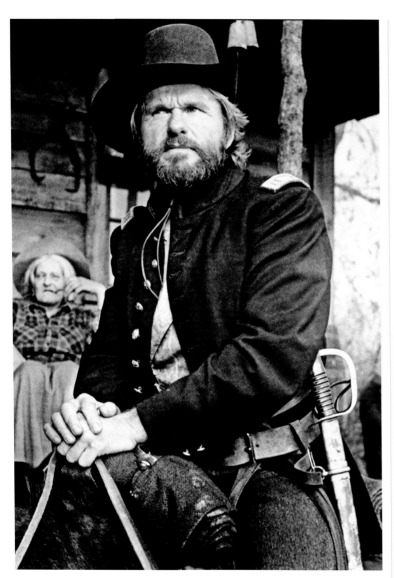

Above: ...and Eastwood regular Bill McKinney plays the brutal Captain Terrill, ironically a Union soldier. *The Outlaw Josey Wales* is unusual in placing the Confederates on the heroic side of the story.

becomes father figure to a company of waifs and strays in search of somewhere to call home.

First though, was the matter of who exactly was directing the film. After his struggles on *The Eiger Sanction*, Eastwood had every intention of taking a break from directing, remaining as star and producer on the $3.7 million project. The task of extracting a workable screenplay from the eccentric novel fell first to Sonia Chernus, then Dean Riesner, and finally Philip Kaufman, an intellectual type who had trained to be a lawyer before becoming enamoured by European film. It was Kaufman's idea to have the Redlegs pursue Wales to the bitter end (they fade out of the book), giving the film its dramatic momentum. With two low budget films to his name (including tight, realistic neo-Western *The Great Northfield Minnesota Raid*), Eastwood saw him as the ideal candidate to direct. They were not a good fit. Kaufman liked to ponder a shot, improvise, racking up the takes. Which translated to Eastwood as indulgence. What's more, the early dailies were disappointing. Kaufman would last not much more than a week, the growing tension coming to a head when they set out to shoot Josey rescuing Sondra Locke's elfin settler Laura Lee from a rabble of Comancheros, a scene scheduled for magic hour, when the low sun would cast long shadows across the Arizona dunes. Only Kaufman couldn't find his chosen dune. Whatever marker he had left had been consumed by the sand. With magic hour rapidly descending, Eastwood pushed to shoot on a nearby dune he felt served their purpose just as well. Kaufman refused, and set off alone in search of his ideal location. As he departed, his star didn't hesitate.

'Get the camera,'[13] he instructed cinematographer Robert Surtees.

That evening, Eastwood made up his mind, and faced up to doing the firing himself. 'I hated it; it was the worst moment of my life,'[14] he reflected, taking the blame on himself. Kaufman had been his choice. But this episodic film needed a firmer hand. His own. Lawyers were called, the studio

briefed, and a week later he took Kaufman aside and gave him the news. Kaufman would find his voice, eventually. After three years in the wilderness, he would gain acclaim for *The Right Stuff* and *The Unbearable Lightness of Being*, and help write *Raiders of the Lost Ark*. But there was bitterness. 'That's the worst thing anybody's ever done to me,' he said. 'He cut my balls off.'[15]

There was a significant knock-on effect to Kaufman's firing within the industry. Concerned about the wielding of star power over directorial control, the Directors Guild of America decreed a new rule forbidding anyone else on a film taking over if one of their members had been removed. It is often dubbed the Eastwood Rule.

Nonetheless, *The Outlaw Josey Wales* was in the grip of a new certainty – a sign of its director's growing confidence. He was invigorated by this way out Western. 'As I got into it, I began to visualize it differently.'[16] It became a labour of love. Whatever Kaufman might or might not have brought to the film, the project was already inside Eastwood. This was his manifest destiny. Awestruck at the finished film, *Radio Times* wrote

Above: In his performance and his direction of *The Outlaw Josey Wales*, Eastwood brought a highly personal vision to the Western. He saw the film as a saga, a portrait of America's violent birth pangs, out of which hope emerges.

that Eastwood had turned this 'tough, sprawling post-Civil War western epic into something approaching a personal testament.'[17]

They shot through the autumn of 1975, with that low sun providing his favourite ambience: half-lit faces, silhouettes, long shadows, a mood of grim fortitude with a dash of romance. Drawing deep from the landscape, the talented Surtees was equal to the task. Within Eastwood's visual economy there is rich invention. For a nasty stand-off with miscreants at a trading post, daylight spills in through the cracks between ragged planks, painting the actors in ribbons of light and dark. Eastwood was defining himself as an artist.

But it was tougher than any Western he had ever directed, because of that saga element. 'You have to feel the travelling in the land,'[18] he said. They traversed Arizona, Wyoming, and Kanab in Utah for the desert, before finishing in Northern California, which was unseasonally overcast and therefore perfect for the miseries of the first act. He gained a reputation for being lucky with the weather. 'It rained every time I wanted it to – I willed it,'[19] he said.

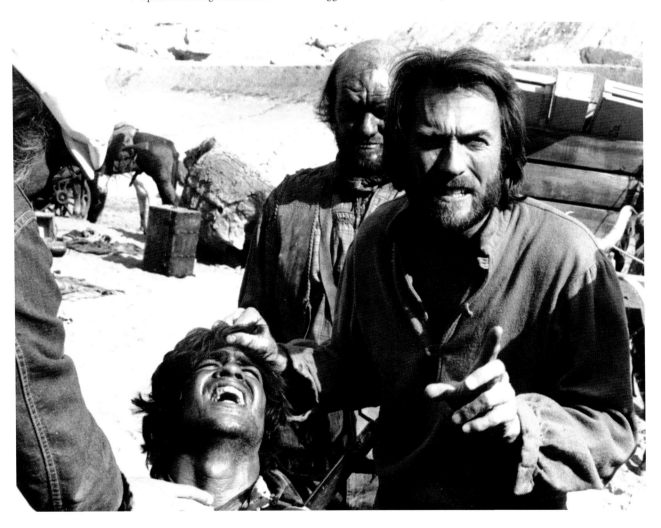

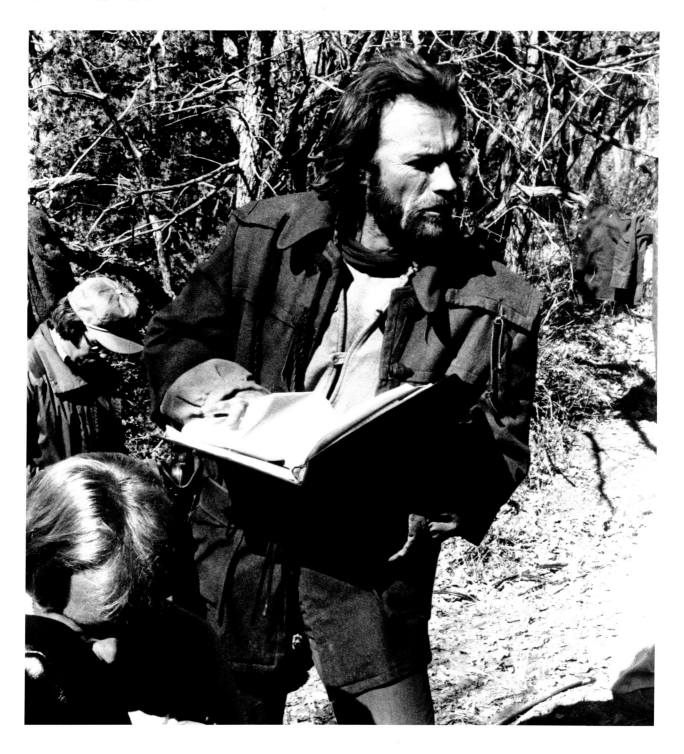

Opposite: While always taxing, Eastwood is happiest while on location. The long shoot for *The Outlaw Josey Wales* would take him from Arizona to Utah to Wyoming to California, but he was inspired by his surroundings, and liberated by being far from the studio's prying eye.

Right: The point about Josey is that he is a nobody, a Missouri farmer, who becomes a legend despite himself – he is a 'hero' by circumstance. Thus the film has been read as an anti-government statement and an anti-Vietnam allegory.

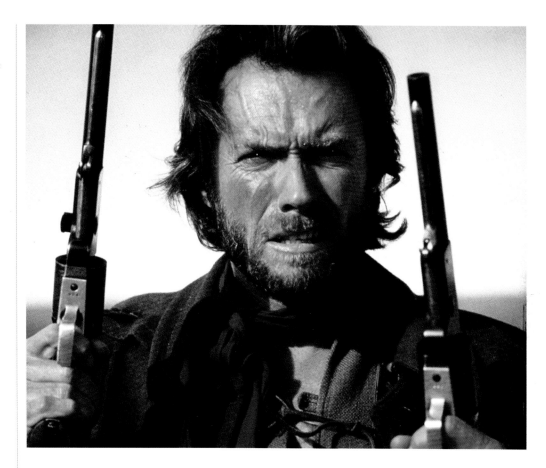

The shoot ran on for eight and a half weeks, only wrapping on a day when they lost the light. Eastwood's energy was astonishing, finishing his part in a scene and spinning behind the camera, still fully costumed, to continue talking his actors through the remainder of the shot, actor to director in a heartbeat. His mantras were firmly in place. Don't over-tamper. Don't have second thoughts. Go with your instincts.

This is the first in an Eastwood sub-genre of what we might call American misfit movies (later examples: *Bronco Billy*, *Honkytonk Man*, and *Gran Torino*). Oddball communities that assemble around the stoic monument of the leading man, paying homage to the variety of his country. The lonely wandering of his youth, drifting among

strangers, resurfaced in his filmmaking. It is the rich tapestry of characters that gifts the film its big heart. The ease at which relationships are established. 'I like the other people in *Josey Wales*,'[20] remarked Eastwood, who let the characters stretch beyond the needs of the plot, taking his time over scenes, allowing long, talky moments to run against the grain of the genre. It felt fresh. Eastwood even undercuts that detached persona that had made him one of the stars of the moment. As Richard Corliss commented in *Time*, 'he surely knows how to direct himself, playing his galvanizing sexiness against his grizzled sense of humour.'[21] Between spitting out gobs of chewed tobacco, Josey affirms his gang's hopes and plans with the deadpan catchphrase: 'I reckon so.'[22]

One of the film's themes is how historical forces shape a man's story. Wales becomes a legend with direct correlation to his desire for the quiet life. He has had all the revenge he can stomach – the film is concerned with the aftermath of the old Eastwood doctrine. Vengeance is depicted as futile. War is brought into question. Violent confrontations are inglorious, ugly events.

In what Schickel cited as the key scene, Wales is tracked down by a young bounty hunter to a shadow-steeped bar at the end of the trail.

'Dyin' ain't much of a living, boy,' growls Eastwood, eyes thinning in the gloom, offering his foe a way out. Thinking better of his chances, the killer leaves, only to return a moment later. Drawn back to the fatal flame of his destiny. His mythical obligation.

'I had to come back,' he tells Wales.

'I know,'[23] replies the hero, before his shot rings out.

In its more strange and searching way, the seeds of *Unforgiven* are planted in *The Outlaw Josey Wales*.

This is the only time an Eastwood Western has explicitly featured Native American characters. More to the point, they are given a rich, humanizing licence seldom granted in the genre. Determined to escape the cliché of humourless warriors scowling through their face-paint, Eastwood cast three real indigenous actors in crucial roles: ageing, wisecracking, Cherokee itinerant Lone Watie (the unforgettable Chief Dan George), left stranded after his horse has surrendered; Little Moonlight (Geraldine Keams), an unflappable Navajo squaw fleeing from servitude; and the forbidding but prudent Comanche chief Ten Bears (Will Sampson from *One Flew Over the Cuckoo's Nest*).

Eastwood had seen George in *Little Big Man* (for which he had been Oscar-nominated as Supporting Actor), an overt take on the Vietnam-as-Western metaphor. 'He's got a face you never get tired of looking at,'[24] recalled Eastwood, as good with the contours of human expressions

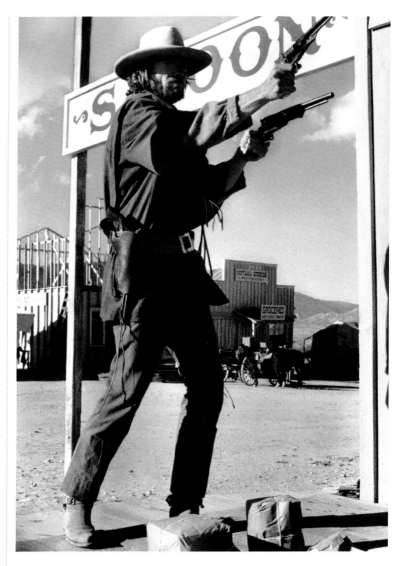

Above: Some commentators have drawn parallels between the character of Josey Wales and real-life outlaw Jesse James. Both were Missouri-born, both enlisted as Confederate guerrillas, and both were accused of war crimes.

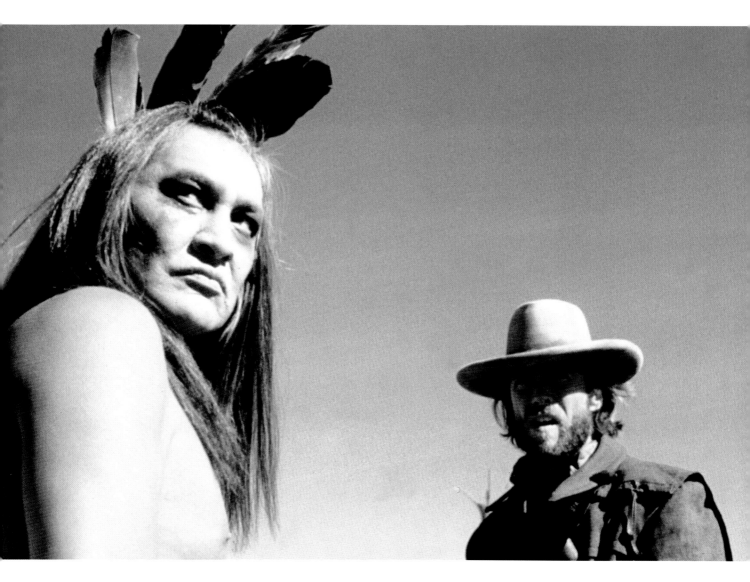

Above: Hands across the divide – strikingly, Josey sues for peace with local chieftain Ten Bears (the great Will Sampson). Unusually, this Western gives a human face to Native Americans.

as the American landscape. 'You put a camera on it and you just can't do wrong.'[25] Remembering his lines was a different matter. So Eastwood asked the erstwhile actor, activist, poet, and chief of Tsleil-Waututh Nation in British Columbia, a man well into his seventies, to deliver Lone Watie's whimsical digressions in his own words at his own meditative tempo. More often than not that gave the director gold. The *Chicago* *Sun-Times* noticed that 'audiences seem to respond to him viscerally.'[26] Everything George utters takes on an air of great importance. We lean forward to know him better. There were moments on set when he brought Eastwood to uncharacteristic tears. Out of this gentle push and pull between director and actor sprang a wonderful, wry, natural performance that drives the film's unconventional spirit.

As Laura, ostensibly Wales' romantic interest, the diminutive (five foot four) Tennessee-born Locke presents the film with yet another peculiar aura. Laura is almost childlike, or strangely touched. She barely speaks at all. She is travelling with a pious grandmother (Paula Trueman), who has plenty to say, but warms to her place in Wales' entourage. Locke had earned an Oscar nomination as a teenage waif in a 1968 adaptation of Carson McCullers' Southern drama *The Heart is a Lonely Hunter*; she had auditioned for *Breezy* and clearly left an impression. After *The Outlaw Josey Wales*, she would have a lasting effect on Eastwood both personally and professionally. The gossip was that that they fell hard for one another during the shoot, and Locke became an inconstant romantic partner to Eastwood offscreen and on for the next fourteen years. Her presence in five more of his films (three he directed) alone make her an indelible presence in the great Eastwood saga.

For now, she would have to get used to her director's aversion to glamour. He would glower at a lurking make-up artist, more than pleased when she managed to singe off her eyebrows, leaving unfetching stumps. That was more honest.

Premiering on 26 June 1976, *The Outlaw Josey Wales* defied the odds and became a considerable hit (making over $31 million), proof of both the durability and range of Eastwood's stardom and gifts as director. As things stood, he was now the only director, and actor, capable of lending the genre credibility. Though, symbolically, in the same year, a dying Wayne made his celebrated Western swan song *The Shootist*, directed by none other than Don Siegel.

Reviews at the time were surprisingly divided. Much of the critical fraternity still doubted whether Eastwood was anything more than an upstart celebrity. They overlooked the film's subtext – its reckoning with contemporary America,

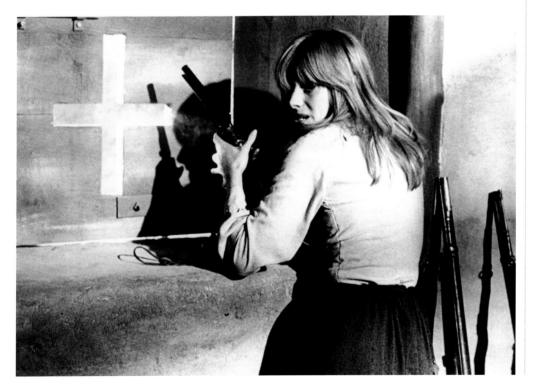

Left: Sondra Locke as Laura Lee, a young woman drawn under Josey's protection. Locke had only one film to her name when Eastwood cast her, but would go on to become his leading lady of choice for the next decade.

Right: Eastwood and Locke share a quiet moment on set – romance would blossom off-screen as well as in front of the camera, something they unsuccessfully tried to keep secret.

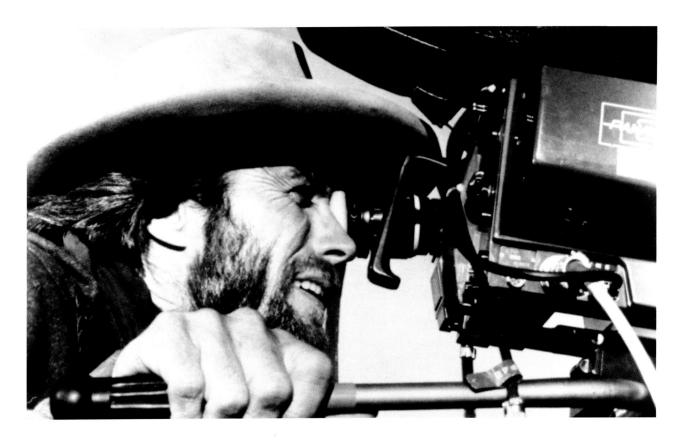

its parsing of Eastwood's past, the ripping up of archetypes – and dismissed it as no more than another round of macho bloodletting. The *New York Times* decried it as 'a soggy attempt at a post-Civil War western epic.'[27] His bête noire, *The New Yorker's* Pauline Kael, couldn't even bring herself to review it, but making a speech on the eve of the film's opening, declared Eastwood 'the reductio ad absurdum of macho today.'[28] The only Oscar nomination it received was for Best Score. To be fair, there was support from certain corners. *The Los Angeles Times* saw 'a timeless parable on human nature.'[29] *Time* placed it among their top ten of the year. Viewed from the high ground of Eastwood's later career, *The Outlaw Josey Wales* marks a turning point and a real statement of intent. The taciturn Josey Wales had given him a voice.

Above: Eastwood came of age as a director with *The Outlaw Josey Wales*, which firmly established his identity as an artist as well as recasting the Western in a powerfully new, ironic light, at once traditional and revisionist.

Maximum Minimalism

Ten great Clint Eastwood performances

Reviewing *The Gauntlet*, what you would think of as a quintessentially Eastwood thriller in the *Dirty Harry* mould, Vincent Canby in the *New York Times* described his style as 'unhurried, self-assured, that of a man who goes through life looking down on other men's bald spots.'[1] There is some truth to that, the superiority. But Eastwood can do so much by doing so little. Away from the clichés and one-liners, he has revealed extraordinary range and ambition in his acting. Indeed, Eastwood the actor tells us so much about Eastwood the director.

BLONDIE IN *THE GOOD, THE BAD AND THE UGLY* (1966)
In the last of his Spaghetti Westerns, Eastwood's Blondie is still the scheming bounty hunter (supposedly 'The Good'), but now partnered in a fizzing double act with Eli Wallach's scoundrel Tuco (very much 'The Bad'). Is that a glint of humanity in his blue eyes?

JOHN McBURNEY IN *THE BEGUILED* (1971)
Eastwood has no interest in riding the straight heroic path. His wounded, manipulative Union soldier holed up at a Confederate girls' school is as near as he came to outright villainy. But easy moral categories don't interest him. To wit…

HARRY CALLAHAN IN *DIRTY HARRY* (1971)
There is so much more to Detective Harry Callahan than the sneering one-liners and oversized Magnum. He is a polarizing character, for sure, with his shoot-first policy decried as fascist in some quarters. But that is to miss a man fraying against an ineffectual system. As well as a dab of self-parody.

BRONCO BILLY McCOY IN *BRONCO BILLY* (1980)
Eastwood in goofball mode, but this down-on-his-heels travelling showman has a melancholy streak, and a hint of self-delusion bordering on madness. He's almost a satire on the acting process.

WES BLOCK IN *TIGHTROPE* (1984)
This New Orleans detective is the antithesis of Dirty Harry Callahan – a decent man whose sexual kinks reveal an unusual vulnerability. For all his cool front, Eastwood often explores frailty.

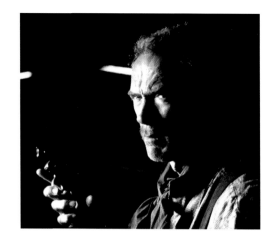

Above: Eastwood as William Munny in *Unforgiven* (1992) – this startling, self-exploratory performance should have won him a Best Actor Oscar.

WILLIAM MUNNY IN *UNFORGIVEN* (1992)
This ageing, bone-weary former gunfighter *(above)* offers a commentary on the entire mythology of Eastwood's career; an immortal study of a past that won't stay buried.

FRANK HORRIGAN IN *IN THE LINE OF FIRE* (1993)
A straight-up heroic part made complex and knowing by the fact this Secret Service agent realizes he's too old for the job.

ROBERT KINCAID IN *THE BRIDGES OF MADISON COUNTY* (1995)
What's this? Eastwood in romantic mode? Has he ever been more feeling? There is genuine agony as his lonely photographer must pull himself away from the love of his life – Meryl Streep's Iowa housewife.

FRANKIE DUNN IN *MILLION DOLLAR BABY* (2004)
Arguably, his finest hour in front of the camera. Dunn is a cranky old-timer with a vivid, turbulent inner life – a man in search of penance, love, a point to it all.

WALT KOWALSKI IN *GRAN TORINO* (2008)
Bitter, bigoted, burned-out Walt Kowalski closes the circle on Harry Callahan, and Eastwood is all too aware of the meta ingredients. But Walt is also a reminder of the sheer presence of Eastwood in front of the camera.

AMERICAN STORYTELLER

The Gauntlet (1977), Bronco Billy (1980), Firefox (1982),
Honkytonk Man (1982), Sudden Impact (1983)

One thing was clear. With five films to his name, Clint Eastwood had taken to directing with ease. There were no lingering doubts. This wasn't a passing phase. He was his own man, an artist even, and Malpaso had grown into a major production company, a heavyweight in the Hollywood ring. Tellingly, Eastwood's take was much simpler: 'My father's dream in life was to own a hardware store,' he said. 'I'm his son.'[1]

His relationship with Warner Brothers was only strengthened by the leanness of his operation. As long as they left him alone, he would turn a healthy profit. Rumour had it that whenever he reached the last day of filming he would call his paymasters and ask them to guess how much he had come in under budget. By the late nineties, it was estimated that ninety-five per cent of Eastwood's pictures had turned a profit.

Another story did the rounds claiming he had banned chairs from his set in order to keep everyone, especially his cast, on their toes. In truth, he had simply told a reporter that he preferred getting out on location. In a studio, he said, everyone's looking around for a chair. On location, everyone's working. Eastwood had grown up in the Depression, seen its effects first hand, witnessed his father going town to town, pumping gas. That leaves a mark. 'It may be a background of not wanting to see waste,'[2] he accepted, unwilling to draw any deeper connection. What was true was that under the terracotta roof of his adobe-styled bungalow on the Warner lot – dubbed Taco Bell by executives – he had gained an unprecedented autonomy.

And yet, Eastwood stood apart from the seventies hotshots, the so-called movie brats busy taking down the old order: the Coppolas, the Scorseses, the young Spielberg. The grand flourish of New Hollywood, throwing off the shackles of convention and cracking open genre, has never been applied to Eastwood. Francis Ford Coppola's prodigal approach to *Apocalypse Now* was alien to his very being. Eastwood could never allow a project to run away from him. But was such thrilling obsession beyond him too? This isn't an arbitrary example: Eastwood had been offered the lead, the covert operative Willard heading upriver – eventually played, with Eastwoodian concentration, by Martin Sheen. He had liked the character and the parallels with Conrad, but couldn't justify spending two years shooting in the jungle. 'No film would justify that,'[3] he declared.

"Making a good movie takes a good cast, a good story, and everything else. But what it comes down to, whether it's going to be any good or not, is how disciplined you are in keeping the overall concept through the assembling." *Clint Eastwood*

Above: Eastwood and Sondra Locke pose astride a chopper in a publicity shot for *The Gauntlet* (1977) – while ostensibly an action movie, it moved across genres, working as a cop drama and even romantic comedy.

1976 **The Enforcer**
Actor

Above: Anti-hero of *The Gauntlet*, Eastwood's Detective Ben Shockley is almost a parody of his *Dirty Harry* character, a washed-up cop who has never questioned authority, but finally discovers a sense of justice.

And yet, something comparable was going on within his work. He had no truck with all the blowhard rhetoric about art and auteurs, but he was shaping films to his own personality with the studio, more or less, bent to his will. The simplicity – maybe the better word is *purity* – of his stripped down, no-waste approach to his craft was deceptive. There were great graces to his filmmaking. A consistent texture had evolved into a style. 'Making a good movie takes a good cast, a good story, and everything else,' claimed Eastwood. 'But what it comes down to, whether it's going to be any good or not, is how disciplined you are in keeping the overall concept through the assembling.'[4] Moving fast, staying fresh, and keeping his thoughts uncluttered allowed him to stay true to his instinct for story.

With less of a song and dance, he was rewriting the rules of genre, ironizing Old Hollywood, and exploring the great puzzle that was America. Even as a star, he cut an anti-authoritarian figure, a blue-eyed totem of individualism. Eastwood had emerged as a quintessentially American storyteller; the land where movie directors were the new poets. It was there in his can-do ethic, his love of purpose, his calloused hands. His hunch for stories of survivors, loners, and killers; all weathered by experience. Landscape was a vital force. He belonged to a wider tradition, driven by self-determination. The comparison to be made is with the hardscrabble worlds of Hemingway, Faulkner – and Steinbeck, another whose heart lay in the Monterey peninsula. Profiling Eastwood in *Parade* magazine, self-styled tough guy Norman Mailer maintained that you can see Eastwood in his work, 'just as clearly as you see Hemingway in *A Farewell to Arms*.'[5]

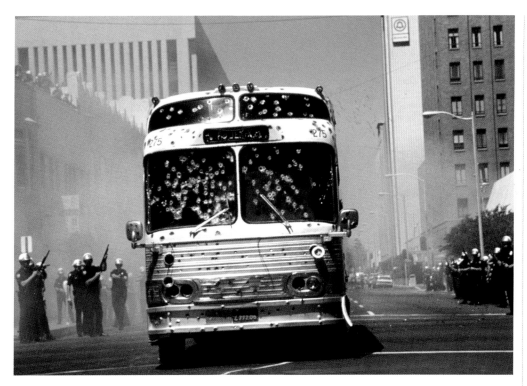

Left: At $5 million, *The Gauntlet* was, to date, the most expensive film of Eastwood's career, and featured what is still one of his most remarkable action sequences – as he pilots a public bus through a gauntlet of armed police and a hailstorm of over 250,000 squibs.

Of course, Eastwood is too savvy to disregard the economics of the business. As the experimental seventies gave way to the brash, glossy eighties, it often appeared as if there were two Clint Eastwoods. One who went looking for hits, films built upon the rock of his stardom, what the audience expected of him. The other who was open to smaller, chancier films, stories that appealed to his sense of adventure and his sense of America. You could say, one allowed space for the other, but he didn't dissect his choices that way. When he knew he knew.

The Gauntlet arrived on his cluttered desk with the usual chequered history. It had been set up as an unlikely-sounding vehicle for seventies icons Barbra Streisand and Steve McQueen, before an inevitable clash of egos led to McQueen bailing out. There were hopes to partner Streisand with Eastwood (who had a similar temperature to McQueen) – the story called for a combustible partnership between a gruff cop and the feisty hooker he is escorting from Vegas to Phoenix, the key witness in a murder trial. A simple enough job waylaid by the corrupt police department she is about to bring down.

Eastwood liked the script. He enjoyed its sleight of hand. As he saw it, between heavy duty action scenes, a screwball romance is underway. It is only disguised as an action movie, as this odd couple, with only each other to depend on, slowly fall in love. 'It's in *The African Queen* tradition,' he announced, as unlikely as that sounded: 'a love-hate thing that turns out to be a love story. It's a bawdy adventure, too.'[6] Highway chases, helicopters entangled with power lines, Hell's Angels being thrown from trains are all present and over the top. There is a vehicular tally of planes, choppers, cars, buses, and motorcycles, but the engine of the story is the jittery back-and-forth between cop and witness.

1977 **The Gauntlet**
Actor/Director

Streisand dithered, concerned she would be a guest act in the Eastwood show. Though what a yin and yang of Hollywood sparring they might have made. Keen to direct his first cop movie, Eastwood moved on, replacing Streisand with Sondra Locke, and a chance to show what chemistry they might have after their minimal scenes in *The Outlaw Josey Wales*.

As he attested, the part of Augustina 'Gus' Mally was much more than 'token window dressing'[7]. She is an equal to Eastwood's Ben Shockley. If not quite Katharine Hepburn, Locke provides a knowing counterpoint to the dumb stubbornness of her caretaker. *Newsweek*

claimed she gave the most 'naturally unaffected'[8] performance of the year.

Shot in the spring of 1977 amid the desert glare of Las Vegas and Phoenix – what Eastwood called 'middling'[9] cities – *The Gauntlet* doubles as both a reminder and parody of the culture that surrounded *Dirty Harry*. Shockley is a lousy cop, relegated to the margins of the Phoenix police department, sinking his failings into a bottle. Realizing he has been set up, a latent sense of justice is awakened. Redemption calls.

Likewise, there is an element of self-parody to the motif of hailstorms of bullets reducing cars to junk and entire houses to rubble, but Eastwood

Below: *The Gauntlet* was another demonstration of Eastwood's feel for location – utilizing the desert country between Las Vegas and Phoenix gave the film a wildness more akin to a Western.

had been inspired by real life. He recalled news footage of Patty Hearst being abducted by the Symbionese Liberation Army, the gunfire crackling like popcorn. 'The real is sometimes surreal,'[10] he noted. Excess, in front of the camera, can make for good dramatic material. For the finale, Shockley and Mally ride into Phoenix to meet their destiny in a public bus, armoured in sheet metal, and are met by another blizzard of lead. The effect is Pop Art violence, Western myths and cop myths and Eastwood myths spilling into spoof. As the *Chicago Sun-Times* surmised, it was all 'cheerfully preposterous.'[11] Whether they were tuned into Eastwood's irony or not, audiences agreed – the film was a hit, making $26 million worldwide.

It was hardly unusual for Eastwood to be approached by a blonde in a restaurant. To be fair, she knew the producer-friend sharing his table. And she wanted to talk shop. There was this script she was certain Eastwood would like. That wasn't unusual either: scripts landing in his lap, everyone certain they had the Clint thing figured out. It turned out she represented two young screenwriters, Dennis Hackin and Neal Dobrofsky, who were struggling to get a foothold in the industry – yet another familiar tune. But Eastwood wasn't unsympathetic to their cause, he had once been on the outside looking for a break. So the next day she dropped off a script entitled *Bronco Billy*.

Convinced this was the story of Broncho Billy Anderson, the silent era's first Western star, Eastwood started glancing through the pages, and never stopped.

Bronco Billy may not have been a biopic of a silent gunslinger, or indeed a Western, but it was overflowing with nostalgia for bygone days. In effect, nostalgia was its theme. The setting is the 1960s, and Eastwood's Billy runs a shabby Wild West show roaming the Midwest, an itinerant dreamer with a collection of oddballs for company. What the director called 'a collage of crazies.'[12] While Billy handles the sharpshooting and saddle tricks, acting the cowboy (the irony is as plain as day), snake handler Chief Big Eagle

Above: The exaggerated release poster for *The Gauntlet* by famous fantasy artist Frank Frazetta, who specialized in images of Conan the Barbarian, was a choice Eastwood had made to push the comic exuberance and thrills of the movie.

(Dan Vadis) keeps getting bitten by his rattler, Lasso Leonard (Sam Bottoms) has dodged the draft, help Lefty LeBow (Bill McKinney) lost his left hand to a shotgun accident, and ringmaster Doc Lynch (Scatman Crothers) has seen better days. But they get by, just. Even if Billy can't hold down an assistant for his blindfolded knife-throwing finale. It was a playful piece, offbeat to the point of whimsy, but he was drawn to something classically Hollywood in it. How it ran consciously counter to the times.

'My first thought was that Frank Capra or Preston Sturges might have done it in their heyday,' recalled Eastwood. 'It had some values that were interesting to explore in contrast to the sixties, Vietnam and Watergate and so on.'[13]

The unexpected success of *Every Which Way but Loose*, in which his bareknuckle boxer is partnered with an insouciant orang-utan named Clyde, had shown that at the right frequency, whimsy can have wide appeal. Everyone had tried to talk him out of that one. But there was something in its meandering story (directed by former assistant James Fargo) that made sense to him; Clyde is not the point, he's just the film's furry quirk. In fact, the joke is less the incongruity of an ape in a trailer park than an ape suffering under the belief that he's the cool Eastwood type in this particular neighbourhood. Unlike Streisand, Eastwood was delighted to be upstaged. Despite predictions of box office humiliation, the film made $85 million, still one of the most profitable of his career.

American eccentricity is one of Eastwood's abiding fascinations. The idiosyncrasies of a patchwork quilt nation. It was there in *Breezy*, and one of the great flavours of *The Outlaw Josey Wales*. Indeed, *Bronco Billy* serves as a sweeter sister film to his oddball Western: another family of misfits dressed up as Western archetypes.

Right: All Eastwood's close advisers implored him not to take on *Every Which Way but Loose* (1978), in which he was knowingly upstaged by an orang-utan named Clyde - but instinct told the star the blue-collar comedy would work. It remains one of his biggest hits.

1978 **Every Which Way but Loose**
Actor

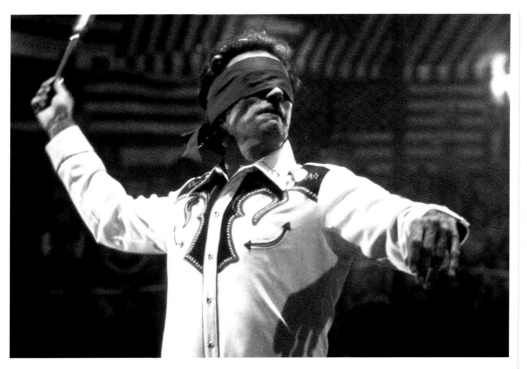

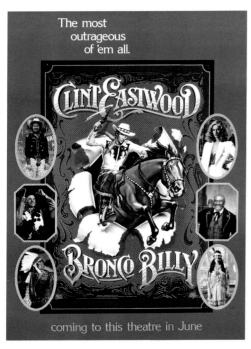

The most
outrageous
of 'em all.

CLINT EASTWOOD

BRONCO BILLY

coming to this theatre in June

Over five and a half weeks, through the autumn of 1979, pleasurably working the same backroads taken by Bronco Billy, the shoot trailed between Idaho towns. 'You do it pure,' he said. 'You don't try to adapt it, make it commercial. It's not *Dirty Bronco Billy*.'[14]

Never one to portray genres straight, it is not entirely clear if *Bronco Billy* is aiming to be funny, though on the page it was a comedy. Eastwood keeps a straight face. This is a fairy tale in broad daylight. The troupe are saddled with Locke's abandoned heiress, Antoinette, a flinty, ungrateful madam whose resistance will be eroded by Billy's craggy charms. She's the most movie-like element. The chatterbox grit that worked so well in *The Gauntlet* is often at odds with the guileless atmosphere.

It is hard not to read *Bronco Billy* as Eastwood's most self-referential film yet. 'I am who I want to be,'[15] Billy informs a sceptical Antoinette. He is totally self-invented, appreciated Eastwood,

1979 Escape from Alcatraz
Actor

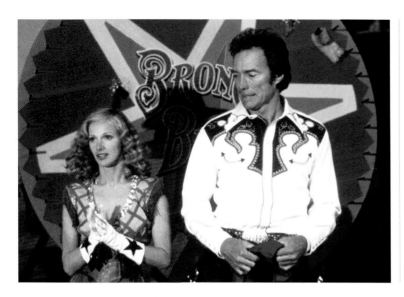

'there was something beautifully naïve about it, a guy who's a shoe salesman in New Jersey, who has this dream.'[16] Moreover, Billy's show serves as a mirror of a Clint production, fuelled by togetherness and centred on his singular presence. 'The relationship of the characters with Bronco Billy was not very different from those the actors had with me,'[17] he accepted.

As biographer Richard Schickel said, Bronco Billy *is* Clint, whether consciously or not – 'or the Clint who might have been had Malpaso turned out to be a rundown Wild West show.'[18]

Without an orang-utan for company, it proved a harder sell, but contrary to popular opinion *Bronco Billy* eventually grew into a sizeable hit ($23 million). He would revive its genial mood in films sooner, *Honkytonk Man*, and later, *A Perfect World* and

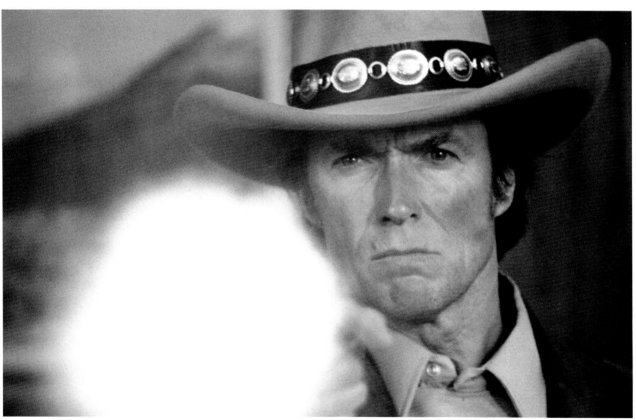

1980 Bronco Billy
Actor/Director

Left: Perhaps the frankest example of how Eastwood's hero in *Bronco Billy* is not entirely situated in reality has to be the would-be cowboy's attempt to hold up a train, only for it to hurtle by obliviously.

Cry Macho. Character pieces. But never sentimental. For one thing, Billy is not altogether sane.

'His brain has snapped,'[19] explained Eastwood. Longing to be in another era, possessed of courtly manner, quixotic, naïve, and a little goofy, Billy is an absurd extrapolation of the Eastwood persona. A joke Clint. With the show down on its luck, his brain fogged with tales of outlaws, Billy concocts a vain plan to hold up a train. Guns ready, he sits on his horse, only for the modern express to race by oblivious. The film ends on another striking image: the show back underway beneath a big top sewn together from American flags by the inmates of an asylum. 'America is the maddest idea,' laughed Eastwood, 'put together by a madman.'[20]

Firefox looks like an aberration. It demanded special effects and a hefty budget of $21 million; Eastwood was casting an eye sideways at a business that had been rewired by the high-concept gusto of eighties filmmaking. However, he thought of it only as a Cold War thriller in a

similar vein to *The Eiger Sanction*. Craig Thomas's novel had actually been recommended by the helicopter pilot on his mountain-climbing escapade. The story follows haunted Vietnam vet ('fragile goods,'[21] we are told) but skilled pilot Mitchell Gant (Eastwood), sent into Soviet Russia to steal the enemy's new super-jet – the Firefox, steered by telepathy – with the help of underground dissidents played by British character actors (Warren Clarke, Ronald Lacey, Nigel Hawthorne). Eastwood talked up some 'pertinent reflections on the arms race.'[22] These were real-world thrills, he insisted.

Like *The Eiger Sanction*, it was a rare European shoot, with Vienna a persuasive Moscow, and the film falls into two distinct parts: a lean, character-driven spy thriller in the austere mode of John le Carré, and a cutting-edge action thriller jetting over the Arctic Circle.

Concerned about the special effects, Eastwood brought in John Dykstra, an Academy Award-

1980 **Any Which Way You Can**
Actor

winning *Star Wars* vet. But the painstaking process (models, process shots, green screens) maddened a director so disposed to travel light. All told, the shoot ran for a year. For their time, the duelling jets (it turns out there are twin super-jets) are effectively done. The sensation of speed alone liberates the film from the dour, exposition-heavy build-up. The loner hero is finally back in the saddle. But there is something self-defeating about confining the statuesque Eastwood to a cockpit. He is literally cramped by a movie that Vincent Canby in the *New York Times* bemoaned as 'a James Bond without the girls, a *Superman* movie without the sense of humour.'[23]

The returns were very decent ($47 million), but nothing compared to Spielberg's *E.T. The Extra-Terrestrial* or a second *Star Trek* movie, released in the same summer. It was a lesson learned. Leave the effects and the hardware to the technocrats, he concluded. 'I prefer a thousand times over to have to deal with human beings and their problems.'[24] Speaking of which...

Above: Cold War thriller *Firefox* (1982) was a flawed but commercially successful venture into the *de rigueur* realm of special effects. But Eastwood became frustrated with the achingly slow process of creating the film's super-jet in flight.

Right: One of the memorable quirks of the story is that Eastwood's ace pilot Mitchell Gant must fly the stolen Russian jet psychically, requiring him to think in Russian.

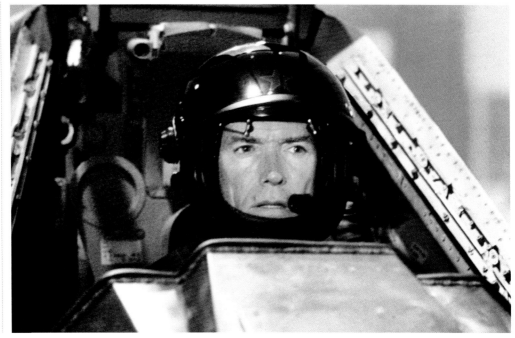

1982 Firefox
Actor/Director/Producer

Left: Depression-era character study *Honkytonk Man* (1982) is still one of Eastwood's most personal films. A hymn to the backroads life of his youth, it offered the chance for the leading man to perform his own songs, and co-starred his own son Kyle (left).

Opposite: Eastwood on the set of *Honkytonk Man* with regular cinematographer Bruce Surtees, and son Kyle. It was another peripatetic shoot, with various locations in California and Nevada standing in for the Oklahoma and Tennessee of the story.

Honkytonk Man was another one from the heart, mixing music, period, and a roughhewn charm, and set, as Norman Mailer put it, in 'the hard, yearning belly of rural America.'[25] Based on the novel by Clancy Carlile (who also did the adapting), the Steinbeck parallels are explicit. For this is the tale of laconic Okie-born Red Stovall (Eastwood), a Depression-era country singer slowly succumbing to tuberculosis, out on the road for one last tilt at the big time. As seen through the eyes of his fourteen-year-old nephew and driver Whit, whose uncanny family resemblance is down to the fact he is played by Eastwood's son Kyle with the natural but fitting tension of a boy trying to please his dad.

The attractions of the material were entirely personal: it stirred memories of the backroads of Eastwood's childhood, and, as a young man, playing second on the bill to country-and-western

groups barely getting by. Red himself was the chief draw. He was a mix of Hank Williams and Red Foley, men who died on the highway, possessed of a kind of willed self-destruction. But Red, he said, was a coward. 'He won't face up to his ambitions.'[26] More than Bronco Billy even, Red was his shadow self who had never made it. This was an exorcism of his own potential for self-destruction.

Honkytonk Man is a picaresque, going town to town, encounter to encounter, by Lincoln convertible. They filmed in California; Eastwood simply preferred it to the flatness of Oklahoma. The hazy, nostalgic, windblown look inspired by browsing through histories of the Great Depression and photo albums of his own family. The first half is brimming with great comedy: prison breaks (for chicken rustling), madcap heists, gambling dens, brothels, and all the ragtag folk along the way, the tone smoothing into a lilt

Opposite: Country singer Red Stovall in *Honkytonk Man* is an unusually tragic figure in the landscape of Eastwood's characters – as if the director-star was contemplating a version of his life in which he hadn't succeeded. He resolutely defied studio pressure for a happy ending.

1982 **Honkytonk Man**
Actor/Director/Producer

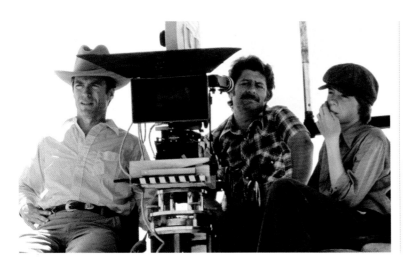

when Eastwood performs Red's songs (in person with a bone-weary baritone) in various saloons and recording studios. Slowly, gently, the film darkens into preordained tragedy.

As Eric Henderson in *Slant* commented, it was one of those Eastwood films that reveals 'the unmistakable disparity between the silent assassin persona audiences had come to embrace in him and the much gentler humanist behind the camera.'[27] French critics compared it to *The Grapes of Wrath*. And if it barely made a ripple at the box office ($4 million and change), here was the soul of the filmmaker. Despite studio protestations, it remains one of the few films in Eastwood's career where he dies on screen.

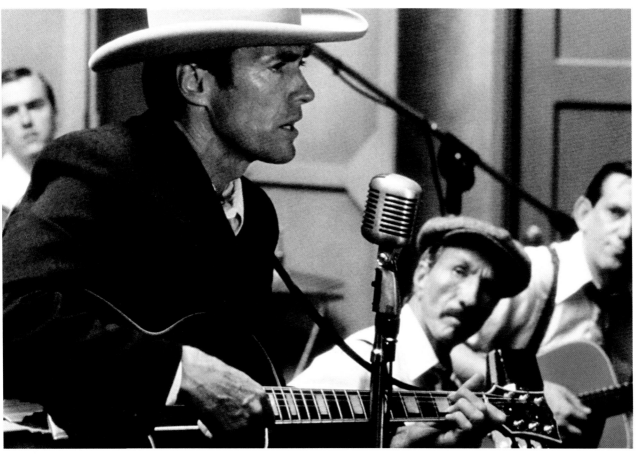

The cheeks a little more lined, the hair flecked with grey, but the tiger's snarl still hungry, Harry Callahan sneaks through the backdoor of his favourite diner with his Magnum drawn. This gang chose the wrong joint to hold up. Taking an innocent bystander hostage, things have turned ugly. For all Harry's inflamed efforts to clean up the streets, San Francisco can't shake its crime wave. So he must take charge in inimitable fashion, facing down the loosest cannon of the bunch, his lips curling back from his teeth: 'Go ahead, make my day.'[28] Eastwood knew it was a good line – delivered in that sandpaper drawl – but he would never escape it. Even Reagan co-opted it. And it comes from *Sudden Impact*, the fourth of Harry's cases, and the first to be directed by Eastwood. 'I didn't realize it would ricochet around the world quite like it did,'[29] he recalled, but in 1983 he knew the value of dusting down the badge, gun, and sneer. Making $70 million, Harry was more popular than ever.

We should recap. While never recapturing the caustic highs of the original *Dirty Harry* – directed by Don Siegel with an edgy, New Hollywood directness – two sequels had been and gone, each a smash hit, each reinforcing what might be called the Clintness of Eastwood. There was never a doubt he was the custodian of the iconic character. After Siegel, the directors were invisible figures.

In 1973, *Magnum Force* flipped the coin on Harry with a team of vigilante cops taking out the city's undesirables. In 1976, *The Enforcer* teamed Harry with a female partner (the excellent Tyne Daly) faced with a gang of disillusioned Vietnam vets.

Warner could barely contain their glee when Eastwood recanted the claim that he had done all he could with Harry, and having found a story he liked was eager to embark on a sure thing. Furthermore, by directing, he could take the character in a (relatively) new direction. 'Even Dirty Harry has changed in fourteen years,' he said. 'He's changed as I have changed.'[30]

Events begin with the aforementioned interruption of Harry's coffee break and the discovery of a body – a man shot first in the testicles ('a .38-caliber vasectomy'[31]) then the head. Like the original, it eschews mystery: we learn the identity of the killer early on. The volte-face comes with a perpetrator who is both female and motivated by a righteous cause.

Artist Jennifer Spencer (Sondra Locke, of course) is taking out the vicious thugs – another gang – who raped her and her sister, who has been left catatonic by the trauma. The script by Charles B. Pierce and Earl E. Smith had been developed not as a potential *Dirty Harry* sequel, but as a female *Death Wish* for Locke, before Eastwood saw a compelling parallel.

Above left and right:
Sudden Impact (1983 is the only one of the five *Dirty Harry* films that Eastwood directed. Tellingly, it features the most morally complex plot, with Sondra Locke's vigilante meting out extra-judicial justice, confronting Harry with a version of himself.

1983 **Sudden Impact**
Actor/Director/Producer

Right: Eastwood directing *Sudden Impact*, a huge hit which connects less with the earlier *Dirty Harry* films than with the sexual tensions of *The Beguiled* (1971), *Play Misty for Me* (1971), and *Tightrope* (1984).

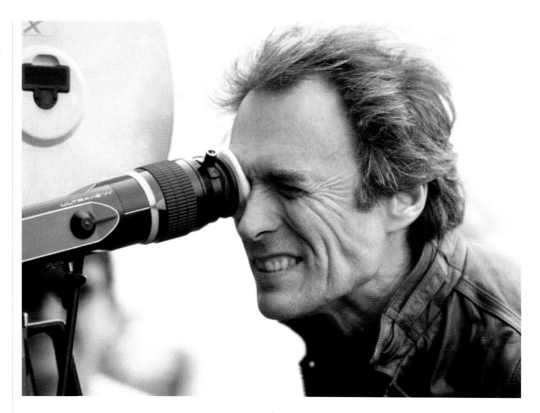

Rewritten by Joseph Stinson, the San Francisco police are convinced they have another serial killer on their hands, putting Harry on the case. Spencer's killing spree is in effect a refraction of Harry's vigilante methods – stepping outside of the law to serve justice.

Eastwood moves Harry into the mythical terrain of film noir: rather than the harsh San Francisco daylight of the earlier films, much of the action takes place after dark, lit in metallic blues. He also makes the bold move of leaving the city and heading down the coast to the fictional town of San Paulo. They shot in the middle-class resort of Santa Cruz (with hints of Carmel and *Play Misty for Me*), with its glittering Ferris wheel, carousel, and pier ready for the final showdown and references to Hitchcock's *Strangers on a Train*.

This was another disquisition on the American justice system and another film to reiterate Eastwood as a feminist filmmaker. He cedes a lot of dramatic space to Locke, but still has to cram in Harry. It's almost two movies. There is a mellow romance with Spencer, before the formula takes hold: the chase sequences, the big gun, and the glower are served up with a weary finality. '[The] action is put over with great force, if also with some obviousness,'[32] noted *Variety*. It was the last film he made with Locke (which ended an era), and claims were made that Harry would retire. But five years later the siren call of the franchise brought us the near-parody of *The Dead Pool*, in which even a film critic gets targeted by the killer.

THE MAYOR

Tightrope (uncredited) (1984), Pale Rider (1985), Heartbreak Ridge (1986), Bird (1988), White Hunter Black Heart (1990), The Rookie (1990)

Thirty years into his career and Clint Eastwood still drove himself to the airport. There were no entourages, no yes men (the frank exchange was always far more productive), no demands. He enjoyed the fruits of his success, with a place in Bel Air, Bing Crosby's old mansion in Shasta County, a retreat in Sun Valley, Idaho, and the estate in Carmel. For those necessary Hollywood meetings, he would fly his helicopter down the coast, floating over the traffic. 'And when you're flying you're out on your own,' he said, 'there are no phones, you just kind of relax and think.'[1]

As the eighties waxed and waned, Eastwood showed no signs of becoming predictable, but there was a distinctive style in his life and art. Crossing genres, eras, and storylines, he had established a form of poetic realism. That Hemingway-with-a-camera ambience. He mixed a documentary clarity with a subtle stylization – the world but with a glint of myth. It was a kind of penmanship: not just what you said, but how you said it. Long before he contemplated being a director, he knew that he loved the contrast between light and dark in the films of Japanese master Kurosawa and the dramatic chiaroscuro of film noirs like *The Third Man*. Key lights breaking through the shadows.

Be it the quaint streets of Carmel, or Las Vegas, or the expanses of Idaho or Wyoming, or the North Face of the Eiger, location was all-important to the Eastwood aesthetic. Reality informed the storytelling; a challenge to be overcome.

Tightrope took him to New Orleans. Reflecting a growing disquiet with the veneration of *Dirty Harry*, Eastwood gravitated to a script where the detective was a tormented man. Wes Block is on the trail of a psychopath targeting prostitutes in the city's fleshpots, but the case crosses paths with his own kinks. Away from his single-parent family unit, with two sweet daughters; outside of the moral code he upholds as a cop, he gets his kicks from bondage. The script toys briefly with the possibility cop and killer might be the same man. Ultimately, the killer acts as a mirror to what *Newsweek* called Block's 'forlorn lust.'[2] These were the flaws of *Play Misty for Me* taken to vivid extremes, the expression of a mid-life crisis, and a further willingness on behalf of an established star to interrogate a blemished life. He was playing a *very* Dirty Harry. In the *Chicago Sun-Times*, Roger Ebert admired how readily he took chances: 'Clint Eastwood can get rich making *Dirty Harry* movies, but he continues to change and experiment.'[3]

Opposite: The director-star Eastwood playing director John Wilson in *White Hunter Black Heart* (1990), a thinly veiled version of real-life Hollywood legend John Huston.

Left: One of the ironic twists of thriller *Tightrope* (1984) is that Eastwood's secretly kinky detective Wes Block is also a decent single father, with Jenny Beck (left) and his own daughter Alison (right) playing his devoted children.

Titillation is not the point. *Tightrope* is a provocative exploration of Eastwood's iconography. There is excellent support from Geneviève Bujoid as a feminist rape counsellor drawn to Block's darker impulses. It's as much an unconventional romance as a sweaty police procedural. It was Eastwood's idea to exchange the San Francisco setting (the original script was based on the unsolved case of a serial rapist in the Bay Area) for New Orleans: this would steer them clear of Harry Callahan's patch while offering a potpourri of genuine brothels, sex shops, and massage parlours that bathed the backstreets of the Big Easy in angry neon. There was an icky realism to be had as they shot through the fall of 1983. Hitchcock would have loved it.

It was also the scene of another behind-the-camera contretemps. The screenplay was by Richard Tuggle (who had co-written *Escape to Alcatraz*), and was sold to Malpaso on the proviso that he direct. Gauging Tuggle's passion, Eastwood agreed. Scan his long filmography on any official database, and you will read that the director of *Tightrope* is indeed Tuggle. But days into shooting he began to dither. His inexperience shone through, and a tight crew of Eastwood regulars began to instinctually glance in his direction.

If history was repeating itself, the past was also presenting a barrier to the obvious solution. Eastwood was forbidden from taking over by the Directors Guild 'Eastwood rule', instituted after Philip Kaufman's enforced exit from *The Outlaw Josey Wales*. So Tuggle remained, but largely in name only. He had seen the film through pre-production, he had brought the shooting script to fruition, chosen locations, helped cast the film. But on a day-to-day level, it was unmistakably Eastwood in charge.

1984 Tightrope
Actor/Director (uncredited)/Producer

Tuggle remained politic in his assessment of the situation. 'Some scenes were done by me. Some scenes were done kind of by him, and most of them were done together.'[4] It presents one of the star's most complex performances on- and off-screen. Opening in the summer of 1984, helped maybe by the more prurient impulses in the audience, *Tightrope* still made $60 million.

Westerns and jazz, held Eastwood, were the only true American art forms. We'll come to jazz shortly. First came an old obligation. 'I just feel the Western is part of the American heritage,'[5] he noted. The genre suited him: the chance to be on location, to be on horseback, to escape to another era, he said, 'when things were more simplified.'[6] When questioned about why anyone would make a Western in 1985, he replied, 'Why not? My last Western went over well.'[7] There was the sense of occasion about *Pale Rider*. This wasn't a Western. This was a *Clint Eastwood Western*.

Above: *Tightrope* is officially directed by screenwriter Richard Tuggle, but Eastwood tended to step in when he found Tuggle struggling to make decisions. What was manifestly true was that the best director of Eastwood is Eastwood.

Right: *Tightrope* ventures off into what we think of as Dirty Harry's patch; it's situated in New Orleans, and portrays Eastwood's archetypal strong-armed cop in far more human terms.

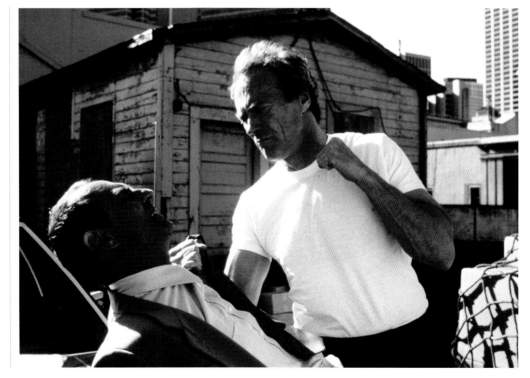

1984 **City Heat**
Actor

It began with an offer. During *The Gauntlet*, screenwriters Michael Butler and Dennis Shryack proposed that they write him a new Western. Based only on an outline, Eastwood committed. It was of a piece with his ironic brand. If *High Plains Drifter* reclothed *High Noon* in nihilistic violence, *Pale Rider* was *Shane* stripped bare of sentiment and set in a remote Californian gold mining community in 1850. For Michael Wilmington of the *Los Angeles Times*, the film had the quality of a world both 'contemporary and remembered, vivid and fervently elegiac.'[8] They shot against the craggy, snow-clad vistas of the Boulder Mountains and Sawtooth National Recreation Area in Idaho. The film has an autumnal beauty as elemental as his hero Kurosawa's.

Akin to his avenging angel in *High Plains Drifter*, Eastwood's Preacher carries a waft of the metaphysical. Is he a ghost? We glimpse the scars of six bullets in his back. There is a simmering history with John Russell's crooked marshal, who can't believe his eyes. Eastwood spoke of the four riders of the Apocalypse; Death beneath a wide-brimmed hat. The title is lifted from the *Book of Revelation*. Sydney Penny's teenage Megan Wheeler is one of a community of prospectors being run off their claim by mining baron Coy LaHood (Richard Dysart), and The Preacher is the answer to her prayers for deliverance. There was a risk of things getting a little self-conscious.

Events conclude in time-honoured tradition with a virtuoso confrontation between The

Opposite: Eastwood back in the saddle as Preacher in *Pale Rider* (1985), a seemingly supernatural presence who rides in to answer the prayers of a community of prospectors being menaced by a mining company.

Below: Eastwood with *Pale Rider* co-stars Sydney Penny and Michael Moriarty. Defying the prevailing commercial appetites, the picture took an impressive $50 million in the US alone.

1985 Pale Rider
Actor/Director/Producer

1985 Amazing Stories (TV Series)
Director (1 episode)

Preacher, alone, and the marshal and his men in the squalid streets of their purpose-built mountain town. Eastwood's death-dealing antihero seems almost able to appear and disappear at will. Nonetheless, iterated Eastwood, 'it's a classic story of the big guys against the little guys.'[9] We can also sense something anti-corporate in LaHood's drilling outfit, with its new hydraulic methods, carving apart the mountains. Eastwood wanted his Western to express 'contemporary concerns.'[10] The film's strident, ecological message was close to his heart. *Pale Rider* is a solemn, assured epic, and, if lacking the charms of *Josey Wales*, still made $41 million. As The Preacher rides off unlamented, we are reminded that no one cultivates the legend of Eastwood better than Eastwood.

Heartbreak Ridge showed that he still had a sense of humour about his status as a macho ideal, even at a lean fifty-six. Tom Highway couldn't be less metaphysical, or more archetypal. He's a spit-balling Marine gunnery sergeant, prone to great arias of profanity and a scowl like Mount Rushmore, as indomitable a projection of American imperialistic bluster as Robert Duvall's Colonel Kilgore from *Apocalypse Now*. In short, he's a kind of an exuberant, caffeinated Clint. 'He's super-macho,' he confirmed, very much in on the joke, 'and he's full of shit. He's ignorant.'[11] A lifetime in the military, including action in both Korea and Vietnam, has cost Highway his marriage (to Marsha Mason), and with a hint of *Dirty Harry* he bucks both up and

Above: Eastwood made light of shooting in Idaho's rugged, often snow-dusted Sawtooth Range, bringing his film in on the standard five-week schedule, and granting *Pale Rider* a very Eastwoodian autumnal grit.

1986 **Ratboy**
Executive Producer (uncredited)

down the chain of command. As the film begins, he's looking distinctly outmoded, relegated to knocking a cocky unit of no-hopers into shape.

The script, written by Vietnam vet James Carabatsos, had been stagnating at Warner since 1984. That was until he got a call and heard those unmistakable gravelled tones on the other end of the line: 'Why don't you mosey on over?'[12] The war film is another genre often associated with Eastwood. He starred in the perennials *Where Eagles Dare* and *Kelly's Heroes,* and will tack a course into more complex waters with *Flags of Our Fathers,*

Letters from Iwo Jima, and *American Sniper. Heartbreak Ridge* falls into the sub-genre of training films, in part a comedy (the unit are like the gurning punks from a high school movie), and filmed (with the eventual approval and hardware of the Department of Defence) at Camp Pendleton in California. At Eastwood's insistence, we get the addition of a minor-league mission to Grenada to give Highway's unit some hokey action in the third act. 'At the end, you can't decide whether Eastwood and his platoon should get medals or merit badges,'[13] groaned Paul Attanasio in the *Washington Post*.

Below: Eastwood's crotchety Gunnery Sergeant Tom Highway knocks his lethargic platoon into shape in *Heartbreak Ridge* (1986) – another knowing spin on his own mythology, and a role Eastwood considered one of his best.

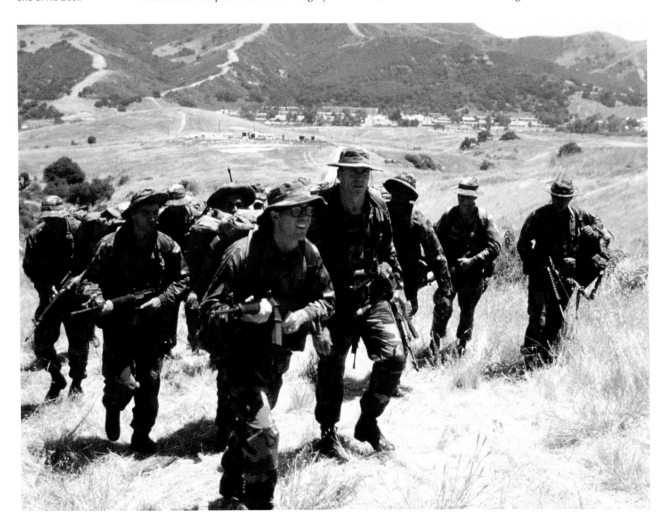

1986 **Heartbreak Ridge**
Actor/Director/Producer

There was something in the eighties air about celebrating, and sending up, American prowess. *Top Gun* was released the same year. And likewise, *Heartbreak Ridge* was a smash hit (the third in a row with $42 million). But we would be wrong to dismiss it as a generic breather after two demanding films. While stirring memories of his brief stint at Fort Ord, Eastwood was drawn primarily to a great part. As he saw it, there were 'shades'[14] in Highway. During the shooting of *Unforgiven*, Gene Hackman informed Eastwood that he thought Highway his finest performance. Many critics agree. Even as he torments his ragged outfit, he expresses doubts about his place in the world: 'What does a warrior do when there is no war?'[15] He's not so distant from Bronco Billy, a relic of an old order, and this tale of ageing and regret reveals Eastwood reflecting upon his place in Hollywood. The hair thinning, the lines deepening, but the eyes and desires still bright, how do you stay relevant?

Above: Eastwood's sourpuss army lifer in *Heartbreak Ridge* exemplifies a popular view of the classic Eastwood character, but is actually a fascinating study in ageing machismo, something that would become a regular theme for the director.

Left: The film was officially sanctioned by the army, and became a big hit – though real-life marines took umbrage at its coarse language and inaccurate portrayal of their training techniques.

Opposite: The release poster for *Bird* (1988), Eastwood's biopic of self-destructive jazz great Charlie Parker.

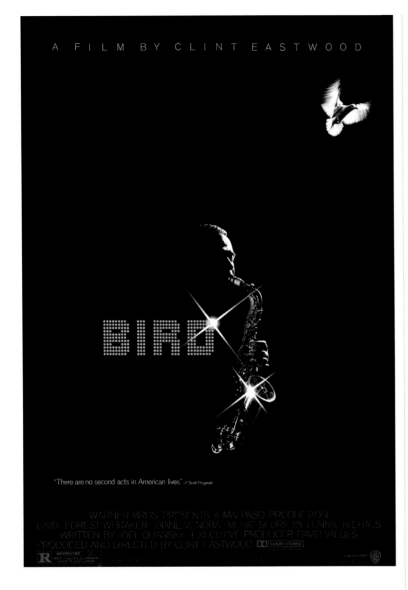

A FILM BY CLINT EASTWOOD

BIRD

"There are no second acts in American lives." –F Scott Fitzgerald

WARNER BROS PRESENTS A MALPASO PRODUCTION
BIRD FOREST WHITAKER DIANE VENORA MUSIC SCORE BY LENNIE NIEHAUS
WRITTEN BY JOEL OLIANSKY EXECUTIVE PRODUCER DAVID VALDES
PRODUCED AND DIRECTED BY CLINT EASTWOOD ▣ DOLBY STEREO

"I saw Charlie Parker when I was a kid in Northern California, and I was always amazed by his music ... His presence was overwhelming."

Clint Eastwood

Bird represents an artistic high, if a commercial low. With *Bird*, Eastwood was becoming conscious of the implications of his work. That he was portraying something, *saying* something. Here was a radical side to him we hadn't seen before, a chance to give voice to his greatest passion outside of movies – jazz. This was a biopic of Charlie Parker, known as 'Bird' (short for Yardbird, a name purportedly acquired after accidentally killing a chicken while on tour), the paradigm-shifting saxophonist who burned brightly but briefly, enthralling the Harlem clubs of the forties, and later the world, before heroin addiction and psychosis led him to an early death.

Eastwood was unusually equipped to take on the subject. A jazz fan since first listening to his mother's Fats Waller records, he began frequenting the Oakland clubs in his twenties, and working his way from King Oliver and Bix Beiderbecke up the chain of complexity to Charlie Ventura, Brubeck, Mulligan, to the heights of Charlie Parker and Dizzy Gillespie. This musical genre shaped his views on art, on life, and on America. Both Eastwood and jazz, said David Kehr of the *Chicago Tribune*, 'operate in the gray areas between the popular and the personal, the bluntly commercial and the purely idealistic.'[16] Eastwood loved how jazz was 'an innovation from the guts of American cities'[17] which became revered around the world. He has produced jazz documentaries, and pursued jazzy scores (listen to *Play Misty for Me* or *Tightrope*). He has even dabbled a little – cornet, trumpet, flugelhorn, jazz piano – but was never good enough to go pro, only good enough to appreciate the greats.

'I saw Charlie Parker when I was a kid in Northern California,' he recalled, 'and I was always amazed by his music.'[18] Parker was a virtuoso who never needed to show off – to 'hot-dog' in jazz speak. He was so confident, so magnetic. 'His presence was overwhelming,'[19] said Eastwood.

He had heard that a Parker script had been doing the rounds for years. Written by Joel Oliansky, it had landed at Columbia with

1988 Bird
Director/Producer

Richard Pryor in mind for the title role. Based on wife Chan Parker's then-unpublished biography *My Life in E-flat*, Eastwood was surprised how good it was, moving in and out of eras, sticking close to recorded fact, with a clear through-line – a genius on a path of self-destruction. He spoke to Warner, told them this was good material. Until now, jazz movies tended toward milquetoast crowd-pleasers with big band scores like *St. Louis Blues* or *The Glenn Miller Story*. This was a chance to capture the essence. To seal the deal, he promised to shoot another *Dirty Harry* movie (*The Dead Pool*) during postproduction.

Warner made a trade (exchanging a noir thriller called *Revenge*, eventually made with Kevin Costner in 1990) and Eastwood had his next movie, planning to capture Parker in all his complexity, his greatness, and his squalor.

From a distinctive angle, *Bird* has the hallmarks of Bronco Billy and Red Stovall from *Honkytonk Man*, artists drawn too close to the flame. But Parker was very real. Born in Kansas in 1920, he learned to play the sax at eleven, by twenty he was improvising a whole new form of jazz (bebop), by thirty-four he was dead. Such was the state of his body, the coroner estimated his age as between fifty and sixty. Between those holy moments on stage, soaring into abstraction, he was a liability, the addictions getting the better of him, at times plummeting into full-scale breakdown with spells in mental institutions.

Unusually, production would be delayed by two years. There was the distraction of running for mayor in Carmel, and then the responsibilities of winning office (see page 89). He was also determined to do his subject justice. And that required care. *Bird* was the first film since *Breezy* on which Eastwood served only as director. He enjoyed being in his own films. At first it had been the only way to get them made. 'It's a lot of work,'[20] he sighed, but there was an unmistakable symbiosis between acting and directing. In this case, even in a minor role he would have been a distraction. He wanted to disappear inside the film.

Eastwood already had an inkling that Forest Whitaker was his man. He had seen the Texas-born actor stand out in supporting roles in *The Color of Money*, *Platoon*, and *Good Morning, Vietnam*. He had a real presence, but wasn't starry. He was a risk, but the audience needed to see only Parker. And there was a physical resemblance to his subject. Chan Parker, Bird's embattled but devoted partner, is brought to vivid, complex life by Diane Venora. The real Chan had advised both actress and production. She is another strong female part, vital to the film's configuration of memory and trauma. We often see Parker through her rational, wounded eyes.

Bird is a rare sighting of Eastwood breaking the chains of linear narrative. The story ostensibly covers the months of Parker's life leading up to his death, but a series of almost freeform flashbacks return us to the significant moments of his past, but not in chronological order. It's jazz, of course, where any structure lies beneath the surface. Eastwood was also circumventing pat moral conclusions. This was the man's life, he seems to say, make of it what you will.

Below: Stars Diane Venora and Forest Whitaker as wife Chan and legendary saxophonist Charlie Parker in *Bird*. The script had been languishing since the early eighties until Eastwood began pursuing this biopic of his musical idol.

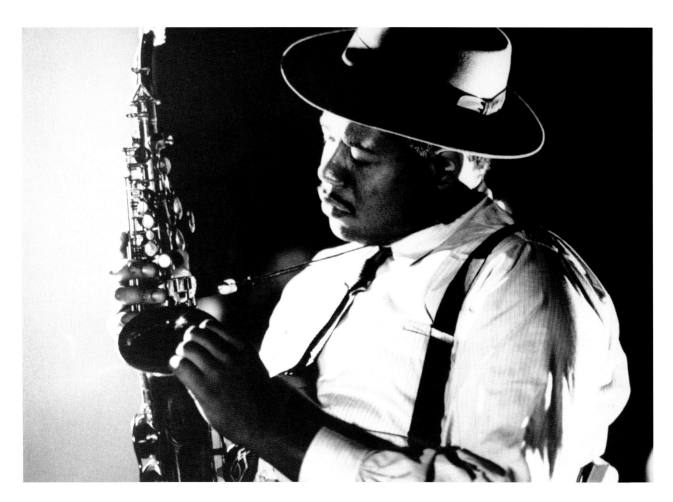

Above: Whitaker went to extreme lengths to bring authenticity to his portrayal of Parker, playing the records day and night, meeting the real Chan Parker, and learning to mimic the exact fingerings of the great musician.

Because Bird was such a stylist, because the world of jazz was a network of basement clubs cloaked in warm, smoky darkness, because Parker was being consumed by his own psychological void, Eastwood took the unusual move of considering the look of his film beforehand. It was the only discussion of style cinematographer Jack Green can recall them having. As a rule, Eastwood would let the style emerge from the story, but here he was determined to capture the nightclub atmosphere of his youth: the shifting darkness pierced by a spotlight.

Green offered to shoot a test, throwing an edge light onto Whitaker's face and bouncing a little off his sax, no more than that. A sense of something incorporeal shimmering against Stygian depths. Sat beside Green in the screening room, Eastwood elbowed his cinematographer in the ribs: 'You got it, bingo.'[21] That image was the foundation for the entire film.

With a budget of $10 million, they began shooting in October 1987, determined to capture the essence of the forties and fifties by recreating West 52nd Street, Harlem's jazz mecca in all its neon plumage, on the backlot of Warner. The shoot span on for an unprecedented nine weeks, with Eastwood caught improvising on set, trying scenes in different ways.

1988 **Thelonious Monk: Straight, No Chaser**
Executive producer

Authenticity was everything. When it came to the soundtrack – the diegetic music *within* the drama – there could be no compromise. Which brings us to Lennie Niehaus. Eastwood and the St. Louis-born jazz saxophonist had met during army training at Fort Ord in the early fifties, bonding over a mutual love of jazz. They lost touch, until Eastwood called him out of the blue to help with the jazz-inflected orchestration on *Tightrope*. Their friendship renewed, Niehaus became part of the creative family, scoring Eastwood's next twelve films from *Pale Rider* to *Space Cowboys*. And he was vital to *Bird*.

As Eastwood insisted, they used Parker's actual playing, 'no sound-alikes.'[22] He and Niehaus tracked down the original mono recordings (which took time) and reprocessed them, an exacting procedure of electronically isolating Parker from the other musicians (San Diego sax man Charles McPherson stood in when all else failed).

Whitaker trained with Niehaus, getting his fingering just so, exuding an unconscious talent that rides free of thought. Luckily, Whitaker was a classical trumpet player, and studied singing at university, and he went deep on Parker: reading the biographies, watching the scraps of footage, meeting with Chan in Paris, and playing the records night and day. In the lead up to production, he practiced for six or seven hours a day. 'When there are close-up of my fingers,' he insisted, 'it fits the notes.'[23] It is an utterly committed performance. Parker is never romanticized. As well as the flights of musical rapture, Whittaker gives us the agony, the rage, the despair, and the vomit. 'Forest Whitaker's brilliance is the force that holds the scattered pieces of *Bird* together,'[24] wrote Hal Hinson in the *Washington Post*.

Bird made its debut at the Cannes Film Festival, where the French critics held Clint Eastwood in high esteem. At three hours, it's an exhausting journey, but the reviews were glowing (undeterred, Pauline Kael described it as a 'rat's nest'[25] of a film). With Whitaker winning Best Actor, Eastwood was widely tipped to be

the festival's Best Director, but screenwriter William Goldman, serving on the jury, thought the stigma of fame got in the way: 'How dare he make a serious movie? And bring it off?'[26] When it came to the Oscars, scandalously *Bird* gained only a single nomination. For Best Sound. With that, its chances at the box office were hamstrung, and it made little over $2 million. Nonetheless, *Bird* is a vital part of the puzzle: this exploration of what it is to be an artist is Eastwood's most challenging and provocative film.

The allure of the self-destructive impulse quickly resurfaced, but from an entirely different angle. Eastwood was on his way back from Cannes when he first read *White Hunter Black Heart*, and was immediately gripped. 'It fascinated me, as obsessive behaviour always does,'[27] he recalled. Here was another choice role: a mix of charm and cruelty, and a rarity for Eastwood – an impersonation of a real person, near enough. The central character of John Wilson is a Hollywood director who bears more than a passing resemblance to the legendary John Huston. While on location in the early fifties, shooting a wartime romance called *The African Trader*, with a *Moby Dick*-like fervour Wilson becomes fixated on hunting down a bull elephant. Written by James Bridges

Above: Eastwood consults with star Forest Whitaker during the shoot of *Bird*. The film never romanticizes Charlie Parker, but focuses on the self-destructive urges that seem to come with genius – his drug addiction and mental collapse.

1989 **Pink Cadillac**
Actor

Below: The elephant man – in *White Hunter Black Heart* (1990), Eastwood tackles the legend of Hollywood heavyweight John Huston and his obsession with shooting a bull elephant during the making of *The African Queen* in 1950.

and Burt Kennedy, it was based on a memoir by screenwriter Peter Verrill (Jeff Fahey in the film) of Huston halting production of *The African Queen*, with Katharine Hepburn and Humphrey Bogart, to go elephant hunting.

Eastwood described his performance as 'patterned after John Huston.'[28] Though he is clearly attempting Huston's rasping drawl. 'What I tried to do was think like him,'[29] he said. He had screened all of Huston's documentaries. These included classic Second World War documentary

The Battle of San Pietro, a film Eastwood used to project for the new recruits at Fort Ord. He also watched the performances, and spoke at length to Anjelica Huston, John's daughter.

Each film dictates its rhythm. If *Bird* has the improvisational guile of Charlie Parker, *White Hunter Black Heart*, shot on location in Zimbabwe and Uganda, is as crisp and linear as the films of Huston. While not as ambitious or moving, it was a film about filmmaking as much as *Bird* was about jazz.

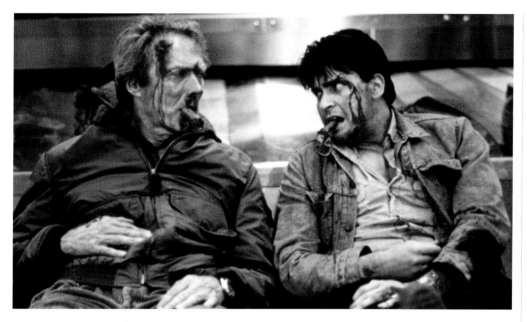

Left: Close but no cigar – Eastwood teams up with Charlie Sheen in the ramshackle buddy-cop thriller *The Rookie* (1990), an attempt to milk the commercial formula of the *Lethal Weapon* films.

Huston had a Hemingway-like zest. He liked living as much as creating. One fed the other. Eastwood identified with that – though Wilson is symbolically unable to fell the magnificent beast. They are different men, different artists: Huston was, quite frankly, an egomaniac. He could stay up all hours downing whiskey then direct the next day, marvelled Eastwood. As Richard Brody noted approvingly in *The New Yorker*, the film cut both ways: 'Eastwood conjures both the legendary grandeur and the destructive self-indulgence of Hollywood's golden age.'[30] Like *Heartbreak Ridge*, it is a satire of machismo. While unsuccessful at the time (making only $2.3 million) here is a deepening of Eastwood's self-reflexive exploration of his own iconography that will lead to *Unforgiven* and *Million Dollar Baby*.

In 1990, as a favour to Warner, Eastwood eased down the gears into commercial formula. And got lambasted. *The Rookie* flirts with self-parody, a jocular buddy cop movie hoping to compete with the *Lethal Weapon* series that teams a cranky old Eastwood variation on the Harry-myth with Charlie Sheen's greenhorn square.

With a good deal of huff and puff, they are on the trail of a grand theft auto ring led by Raul Julia. Not since *The Gauntlet* had Eastwood pushed so hard into stunt-work, including flipping a fifty-foot automobile carrier and driving a Mercedes convertible out of a fourth-floor warehouse window. To little avail. Reviews were scathing. 'Tired,'[31] said the *New York Times*. 'Depressingly familiar,'[32] growled the *Chicago Tribune*. 'The same limited repertoire of squints,'[33] grumbles the *Washington Post*. Eastwood was nearing sixty, and notably cedes the spotlight to Sheen. Looking back, it has a boisterous charm. Think of it as a retirement party for Eastwood as action hero, only things got a little messy.

1990 The Rookie
Actor/Director

Mayor of Carmel

The tale of Clint Eastwood's brief foray into politics

Eastwood loves Carmel-by-the-Sea. The small town gazing out onto the Pacific, nestled among the rocks of Monterey County, has been his home since the late sixties. Sleepy is the adjective people tend to use. When he ran for mayor it had a population of 4,500. Not that he ever really wanted to be mayor.

It came down to a petty grievance. He had bought the tumbledown building behind his *Hog's Breath Inn* restaurant with a profitable renovation in mind. Plans went into the Carmel planning commission, which much to his outrage were immediately overturned. To cut a long and officious story short, it turned out there were less planning rules in Carmel than customs – an almost maniacal need to preserve its 'residential character.'[1] Anything that promoted tourism was viewed as a threat. Of course, this incensed local businesspeople. Even shrubbery had to be registered with the town council.

There was effectively a stand-off between council and local traders. And Eastwood was well versed in stand-offs. 'You run, Clint,' a local innkeeper pressed him during a gathering. 'We'll bust this town right open.'[2]

Eastwood took persuading. Like everything he did, he took it seriously. And he wanted to win. He assembled political consultants, campaign managers, the full armoury of the American campaign trail. Naturally, he also played it cool, not wanting to exploit his celebrity (though that was unavoidable). He didn't write a single speech, extemporizing off the cuff at the various electoral forums. He seemed shy in front of all the gawkers. It was very tasteful, despite the national news crews and reporters flooding into town.

Eastwood's politics have been hotly debated over the years. Do the films reflect his beliefs? And what in truth are those beliefs? He has been a signed-up member of the Republican Party, and at times supported the Democrats. 'I've always considered myself too individualistic to be either right-wing or left-wing,'[3] he has said. Libertarian is a word he has used – upholding non-intervention into the rights of the individual. Which is reflected in the quixotic nature of his characters.

He won comfortably, beating incumbent mayor Charlotte Townsend (who had never heard of *Dirty Harry*), with seventy-two

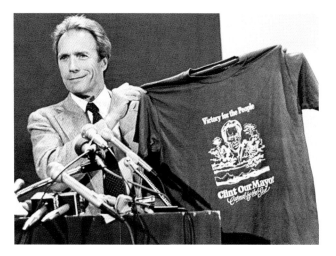

Above: Eastwood displays a T-shirt proclaiming him the Mayor of Carmel during his acceptance speech on 9 April 1986. His venture into local politics would last for two years.

per cent of the vote. 'I would like to think that we can now take the community out of the hands of the few and put it in the hands of the many, the people of Carmel,'[4] he declared in his acceptance speech, refusing to be called 'Mr Mayor.' 'Nah, it's just Clint,'[5] he retorted.

While it is a colourful episode in Eastwood's story, and Carmel remains a draw with tourists suffering under the illusion that he is still mayor, there were no aspirations to take politics any further. The idea of a run at the White House was laughable, even if writer Norman Mailer decided he had a 'presidential face.'[6] He shot *Heartbreak Ridge* and *Bird* during his tenure in office from 1986-1988. Among his local achievements in office was legalizing the consumption of ice cream on city streets. Essentially, the town had outlawed fast food. And certainly raising the profile of local politics. Town council meetings would draw hundreds. But after two years, he declined to run again. It was just another role.

THE LAST RIDE

The greatness of *Unforgiven (1992)*

True to Clint Eastwood's taste for irony, framed on the wall of his office, within the adobe bungalow that houses Malpaso Productions in an undisturbed corner of the Warner Brothers lot, is a story editor's report. Dated 25 January 1984, it concerns a Western script that Eastwood was thinking of picking up. The story editor was the same Sonia Chernus who had worked on *The Outlaw Josey Wales*, and history does her reputation few favours. As the report attests, she made no bones about what she decided were significant shortcomings in the script. 'I can't think of one good thing to say about it,'[1] she declared: the language was rough, the dialogue rambled, diverting the plot into long-winded digressions, and it was all but empty of heroics. Be rid of it, she implored.

History will record that Eastwood completely ignored his story editor. He knew something about this script; that its rough-hewn, verbose style, which he saw as lifelike, was what made it so compelling. He could sense its potential. It had something to say. This is the Western that now lies at the heart of his career; the film that cast his reputation in Oscar gold. More than that even, it is the film that made his elevation to the Hollywood pantheon certain. The advent of *Unforgiven* is a defining moment. For one thing, Eastwood sorely needed a hit. The indulgences of *White Hunter Black Heart* combined with the sizeable commercial missteps of *Pink Cadillac* and *The Rookie* had left his famed consistency open to question. In truth, he hadn't had a substantial hit for ten years. Knives were being sharpened in the press, where he was being dubbed Warner's 'fading house star.'[2] Even within the studio, doubts were being aired. Could it be that Eastwood's day was done? Defying Fitzgerald's dictum, and the *schadenfreude* of Hollywood reporters, *Unforgiven* was the dawn of Eastwood's triumphant second act.

After his seventeenth film, Eastwood was exalted. Rowdy Yates was now a monument. He certainly resembled one, those chiselled features as weathered as a cliff face, the grimace fixed in place, the gimlet stare locked on the far horizon. He had never looked so severe. *Dirty Harry*, as film historian David Thomson put it, came into 'gray eminence'[3] with this confrontation with mortality that left the roots of an entire genre exposed. More irony: a film about the frailty of myths would make Eastwood a legend.

The script had come to him by circuitous routes. TV news editor turned screenwriter David Webb Peoples, who had a hand in *Blade Runner*, had written *The Cut-Whore Killings* in 1976 under the spell of Martin Scorsese's blood-and-neon-soaked New York noir *Taxi Driver*. Catching the tenor of the filmmaking times, Peoples took a revisionist slant to the Western, searching for the reality behind the morally assured folklore fashioned by Hollywood. His story told of a former gunslinger, real sonofabitch, name of William Munny, who, in need of money, is drawn back irrevocably into the violence he thought he had left behind.

Opposite: Eastwood as William Munny in *Unforgiven* (1992) - an ageing gunfighter drawn out of retirement, and the role that redefined our perception of him as star and artist.

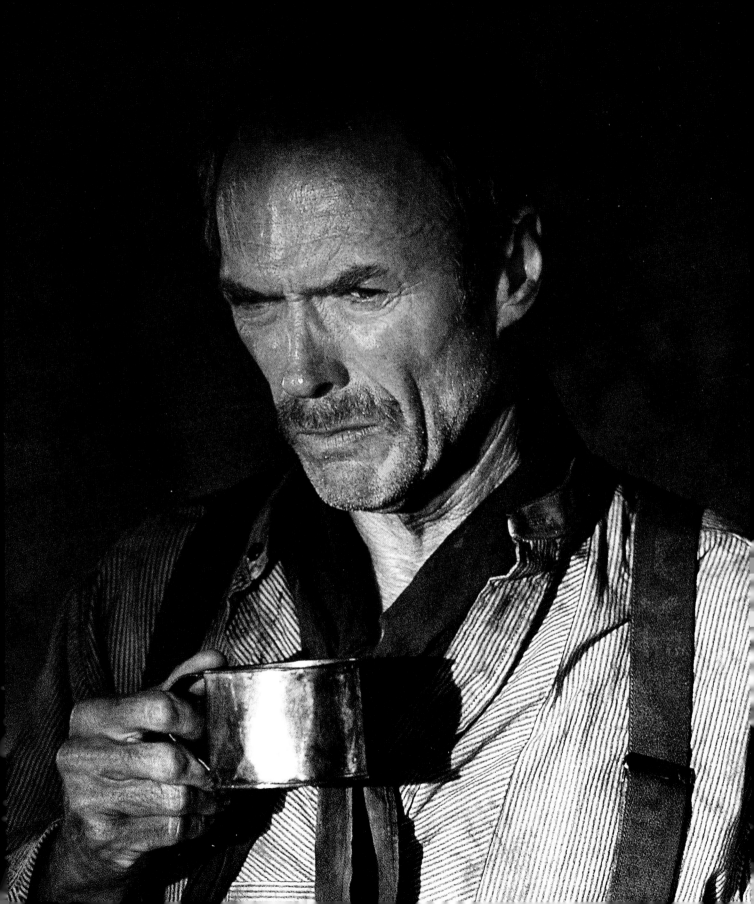

'All of a sudden I see *Taxi Driver* and people are getting killed, and the characters maintained how they would be in real life,' recalled Peoples. 'But at the same time, it's an entertaining movie, and that was always important to me...'[4] More directly, *Taxi Driver* is the tale of a lost soul with a bloody past who triggers latent violence in his efforts to protect a young prostitute. Munny's quest begins in seeking restitution for the mutilation of a prostitute.

The title softened to *The William Munny Killings*, the script had drifted around Hollywood, dismissed as the wrong genre, indeed the wrong *approach* to genre, until Francis Ford Coppola optioned it in 1983. He would have been a good bet, skilled at locating the reality beneath the surface of movie tradition. But he was in financial straits after experimental musical romance *One from the Heart* nosedived at the box office. So a year later Eastwood came into possession of the rights. We might call it destiny, though he never would. Fate perhaps. Peoples for one could see that it fit the star like no other. 'Francis would have done it brilliantly as he does everything else, but it's hard to imagine anyone making it as straightforwardly and uncompromisingly as Eastwood. No studio would have made it that way – dark, moody.'[5] And Eastwood brought the perfect *baggage*: good, bad and ugly. In his gun-calloused hands it *resonated*.

William Munny was the bitter culmination of all his men of the West: the disdainful cool of The Man with No Name, war-soured Josey Wales, the ghostly avengers of *Hang 'em High*, *High Plains Drifter*, and *Pale Rider*. Beyond *Rawhide*, he had never been cast from a heroic mould. After seeing *High Plains Drifter*, John Wayne had sent him a letter. 'This isn't what the West was all about,'[6] he admonished Eastwood. The younger man should be printing the legend, according to the laws laid down by his great mentor John Ford. But Eastwood was always more interested in the darkness beneath Western heroism. 'I was never John Wayne's heir,'[7] he insisted. Irony and reflection were part of his lexicon. That compulsion for self-exploration that can be traced back to *Dirty Harry*. What writer Peter Biskind called 'journeying into the shadows of his persona.'[8]

Left: *Unforgiven* screenwriter David Webb Peoples was inspired by the realism Robert De Niro and director Martin Scorsese brought to screen violence in the seminal *Taxi Driver* (1976).

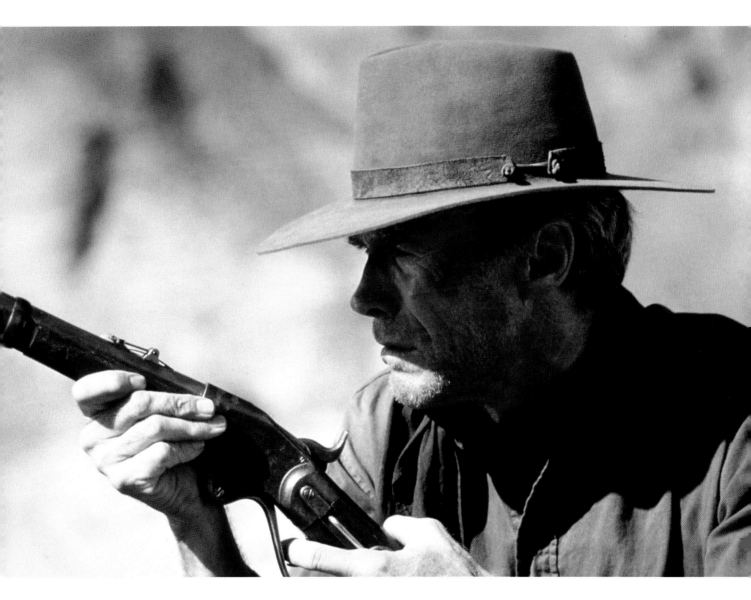

Above: Eastwood's William Munny takes aim at his quarry – having bought the rights to the *Unforgiven* screenplay, the star waited for over a decade to be the right age for the part.

"All of a sudden I see *Taxi Driver* and people are getting killed, and the characters maintained how they would be in real life..." *David Webb Peoples*

Whether or not this was 'psychobabble,'[9] and Eastwood cringed as he allowed a touch of self-analysis to creep into interviews, what he had before him served both as capstone and commentary on his place as the modern father of the Western. The figurehead born not of Ford and Howard Hawks, but Sergio Leone, the ironic maestro who made opera of the past. Indeed, in the closing credits, *Unforgiven* is dedicated to 'Sergio and Don,'[10] – his two great mentors, Leone and Don Siegel, who had passed away in the lead-up to filming.

Leone died in April 1989, only months after Eastwood had dined with him while visiting Rome to promote *Bird*. It had been years since they had last seen one another, an air of resentment lying between them. Years in which Eastwood had thrived, while his former director had struggled to get films made. They got on well that night, recalled Eastwood, better than when they had worked together. Leone knew he was dying, but never let on. 'It was almost like he had called up to say goodbye.'[11] Siegel died two years later, in April 1991, having not made a film since 1982. Another quieted force. The director who had taught him a sinewy realism. The bite of the real world. The truth of man's atavistic urges.

This was to be a film that tallied the wages of violence. The weight of killing on a man's soul. 'Hell of a thing, killin' a man,' pronounces Munny, in one of the script's numerous haunting homilies, Eastwood's growl like the scraping of granite.

Right: Hired-but-tired guns – The Schofield Kid (Jaimz Woolvett), Ned Logan (Morgan Freeman), and a fever-stricken William Munny (Eastwood) make their way to Big Whiskey and a confrontation with past sins.

Above: Morgan Freeman and Eastwood keep things serious for a publicity shot – *Unforgiven* would commence a wonderful, textured partnership between the two actors.

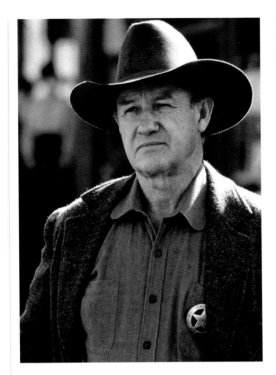

Right: Gene Hackman, who needed persuading to take the role, would win an Oscar for his portrayal of sadistic idealist Sheriff 'Little Bill' Daggett. *Unforgiven* was knowingly starry; the characters have reputations that come before them.

'Take away all he's got and all he's ever gonna have.'[12] It has been eleven years since Munny last fired a gun; he can barely mount his horse. It was seven since Eastwood had turned his profile to the big sky of a Western tableau. 'I'm just a fella now,' Munny tells himself. 'I ain't no different than anyone else no more.'[13] As Eastwood well knew, the past has a way of lurking about a man. Some sins are never truly forgiven.

As biographer Richard Schickel says, this was a film that assays the *consequences* of killing. Put simply, it was about comeuppance. 'None of its bodies are nameless,'[14] he observed. Eastwood repeated a similar line. What he liked about the film 'was that people aren't killed, and acts of violence aren't perpetrated, without there being certain consequences.'[15] Stock Western situations were refashioned by way of psychological realism. Vengeance leads not to satisfaction, but to something close to madness. 'It's a matter of eternal concerns,'[16] preached Eastwood.

Peoples wouldn't meet his director until the day he saw the finished film. They talked on the phone as Eastwood debated rewrites, before realising he would be wrecking what made it so good. Some of the more colourful, expository speeches were toned down, but the main change was the title. He wanted something leaner. So he called it *Unforgiven*.

The actor-director was also willing to wait. Putting the script in a drawer while he went off 'to do some other things.'[17] After all, he was fresh off *Pale Rider*, which had mused more conventionally over his Western legacy, and a little saddle-sore. He wanted to mix things up. And he wasn't quite old enough to do justice to the part he was set on playing. He knew that, in this most un-Hollywood of reckonings, 'age would be a benefit.'[18] We would know Munny as a man hard-used by life. 'I was kind of savouring it,'[19] said Eastwood, as if it were a bottle of whiskey like those Munny has quit.

When we meet him, the year is 1880 and Eastwood's antihero ekes out a frail subsistence as a pig farmer in a ramshackle corral on the Prairie – a widower close to sixty, but he looks ancient, slipping into ruin in the company of two young children. Salvation, or damnation, comes with an offer from a band of whores in a far-off town. A bounty to kill the men who have left one of their number scarred after she giggled at one damn fool's tiny manhood. Notions of manhood will be constantly revealed for what they are. So Munny takes to the saddle alongside his old gunfighting compatriot Ned Logan (Morgan Freeman), another survivor, but softened by age, and a brash upstart calling himself The Schofield Kid (Jaimz Woolvett), as if you can assemble a reputation with words. Ahead of them is the town of Big Whiskey, Wyoming, and Sheriff 'Little Bill' Daggett (a virtuoso Gene Hackman), determined that order will be upheld. Daggett is certain that this thing they are shaping called America must be built by laws not outlaws. The foundation of civilization is another theme. What shapes the soul of a nation. The matter isn't so simple – this is an Eastwood Movie – for Daggett is also a sadist. Critics likened his methods to those of Dirty Harry.

It was certainly a risk to head up to Alberta, Canada on 26 August 1991 and unpick the stitching of his own career. To put a bullet in the genre that had made his name. Would audiences follow him into the dark? At a time when they seemed reluctant to follow him anywhere. But then it was always Eastwood's inclination to go against the grain of pervading logic. 'Hell, you can't be an actor in the first place if you're afraid,' he said. 'You can't be afraid of failure, can't be afraid of falling on your face. It's all a crapshoot, anyway.'[20]

Naturally, he would keep the finances in check. The film cost no more than $14 million. And he would make his masterpiece as he always did, without fuss or pretension. Nonetheless, close collaborators noticed a change. He wasn't making explicit claims for his next film, but

his intentions were more ambitious, more serious. A sense of grandeur was added to his naturalism. The sets were more elaborate, the rehearsals longer, the schedule twice that of *Pale Rider*. They noticed that Eastwood was allowing more takes, pursuing something elusive, even magical. Where once he might have populated the story with the anonymous jawlines of character actors, the cast was as starry as it had ever been, the performances impeccable.

We drink in the warm presence of Freeman (commencing a wry and fertile partnership with the director) as doomed Ned. Sample a raucous Richard Harris enjoying every unctuous drip of 'famed' gunfighter English Bob's braggadocio, his dubious crowing cut short by a bruising encounter with Little Bill's uncompromising

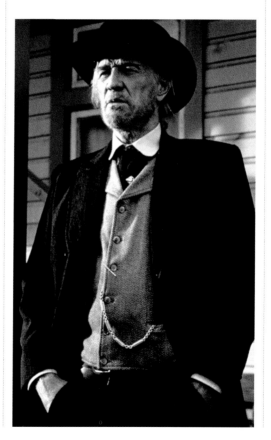

Left: Richard Harris as braggart bounty hunter English Bob – an extended cameo that serves as a brutal overture for the arrival of Eastwood and his companions.

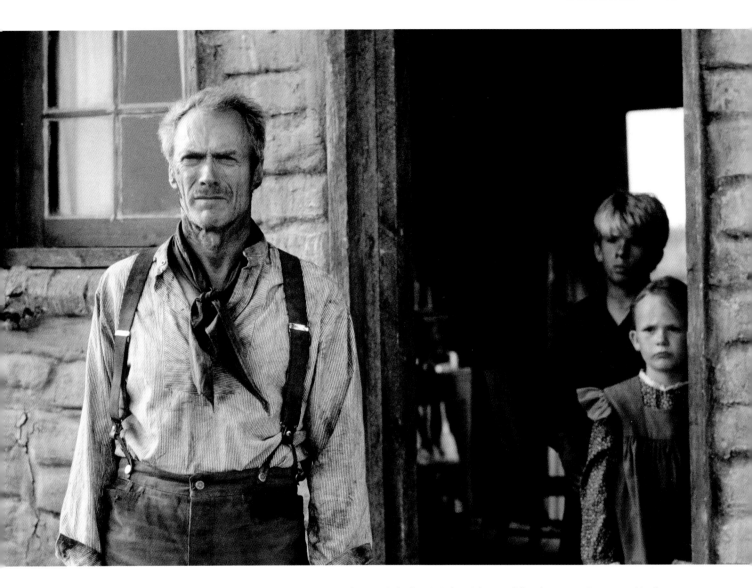

variation of law and order. Amusingly, Harris had
been watching *High Plains Drifter* on television
at the very moment Eastwood called, and had
to be convinced it wasn't a prank. And we are
awed by Hackman's equally prolix presence as
the town's pathological, self-regarding sheriff.
In fact, Hackman turned down the role, for a
second time. He had been approached by Coppola
to play Daggett and felt no change of heart.

'The violence of the characters I portrayed had
begun to wear on me,'[21] he confessed, blind to
what Eastwood could see so clearly – that this
film called into question that very violence.
The director pressed him to think of it as an
exorcism, and Hackman came round to the part
that would deservingly win him a second Oscar,
influenced in part by the beating of Rodney King
by LA police splashed across every news report.

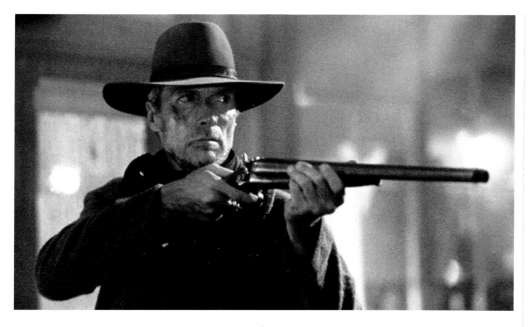

Each and every scene in *Unforgiven* projects authority and authenticity and wit. Every character comes fully to life. Eastwood the director had rarely been so fully in control. The confrontation between Little Bill and English Bob, kicked through the mud in a ritual humiliation, serves as a microcosm of the film's deconstruction of Western mythology. The fabled gunfighter proves a blowhard coward; the upstanding sheriff a plainspoken psychotic. A point underlined by the presence of Saul Rubinek as dime novelist W.W. Beauchamp, who literally peddles the legend in tawdry paperbacks – and, under Little Bill's tutelage, gets a dose of the brute reality of frontier life. Mirroring Beauchamp, there is Canadian actor Woolvett (in his case, quite deliberately an unknown) as The Schofield Kid, a nobody intent on killing his way into being a somebody, despite proving to be hopelessly and symbolically myopic. Violence, we are told, is so often the product of macho posturing. On one level, *Unforgiven* is also a disquisition on celebrity.

As we know, Eastwood likes to work remotely from Hollywood, often in deep country where the challenges of location test the mettle of his storytelling accompanied by a lack of creature comforts. You have to be ready to tough it out. And never more so than on the E.P. Ranch, sixty miles from Calgary, where a 360-degree sweep of the horizon betrayed no hint that this was the twentieth century. Furthermore, with the single exception of the camera-crane truck, Eastwood banned motorized traffic between base camp and set. You made the uphill trek to Big Whiskey on horseback, wagon, or foot. This avoided anachronistic tyre tracks and imbued in cast members an overwhelming sense of entering the past. Westerns are landscape films, it's one of their great appeals to the director – to be out in the air and light of another time. Despite a wind that could cut a man in half, he was as content as he had ever been on set. Calmness pervaded. Not once did he have to ask for quiet.

Shooting from August to September, they were chased by the early winters that claimed the region. In fact, a seasonal change was vital to the mood, charting the passage of Munny, Ned and The Kid from sunlit plains to sullen,

overcast Big Whiskey, where they are met by a biblical tempest. 'In *Unforgiven*, there is a storm that becomes almost a character itself, a determining factor,'[22] explained Eastwood. Whereupon Munny is consumed by a fever in which he is confronted by the Angel of Death and the sight of his long-dead wife, his past sins swimming around him in his delirium. Schickel sees it as a 'soul sickness.'[23] He is reborn (or rises from the dead) as Eastwood's traditional self – the righteous avenger. But unlike any character he had played before, a killer fully conscious of the damnation that will accompany his actions. The effect is chilling rather than thrilling.

In line with his grander preoccupations, the visual style was more elaborate, the camera getting closer to the characters, staring at them more intently. Never romanticized, Eastwood's West had grown increasingly stark, increasingly nihilistic. His penchant for history's mud-caked realism was taken to apotheosis – we first meet Munny covered in pig manure. But the vastness of America is never in doubt. Production designer Henry Bumstead was charged with maintaining a 'drained, wintry look.'[24] This was a time when interiors were barely lit by oil lamps. He asked Jack Green, his cinematographer, to light it 'like a black and white film.'[25]

In the film's most powerful moment, indeed the lynchpin of Eastwood's entire career, we find The Kid nursing a whiskey bottle on a hilltop, distraught at having finally shot the local cowboy who slashed the prostitute – his first kill, likely his last, ignominiously dispatched while squatting in the outhouse. Munny stands, face to the wind, eyes slitted, teeth bared, taking a forbidden swig from the bottle, before snarling the grave ethos of *Unforgiven*.

'We all got it comin', kid.'[26]

Consequences: Munny will learn Ned has been captured and flogged to death, his body displayed in the saloon. His destiny is set. At last the film embraces what might be classified as traditional gunplay as Munny confronts Little Bill and his deputies in the shadow-soaked saloon, a man possessed. Scenes that were tense to film in the close quarters of the set, a fog machine stifling the air with the clammy haze of stove smoke, and Eastwood's prop pistol repeatedly jamming.

'I don't deserve this… to die like this,' cries Little Bill, gut-shot, death-bound. 'I was building a house.'[27]

'Deserves got nothin' to do with it,'[28] replies Munny. Good, bad, or ugly: humans are much more complicated than that.

The snow was almost upon them as they grabbed the last shot in Big Whiskey: Munny mounting his horse as the unholy rain comes sheeting down, yelling desperate threats to the empty street. They had a choice, Eastwood's executive producer David Valdes told him: work right through without a break, cramming two days into one, shooting into the early hours, or risk being delayed. The director-star didn't hesitate, his crew grimly following their leader. The ground froze, the rain machines froze, and Eastwood's teeth chattered as he let forth Munny's maddened invective, but the shot was completed as dawn broke and the first snowflakes began to fall.

The *Unforgiven* effect began when Eastwood showed the film to Peoples. 'I'd never seen or imagined anything so dark and relentless and powerful,'[29] the writer recalled. If anything, Eastwood had made it even more uncompromising than his original script. Within the studio, a sense of something momentous was underway even as Eastwood strove to subdue expectations. Critics were soon to add their own gasps, unsettled by not having seen it coming – a midsummer masterpiece; Eastwood's signature film. 'The finest classical Western to come along since perhaps John Ford's 1956 *The*

Left: Nominally in Wyoming, Big Whiskey was constructed on a ranch in the vastness of Alberta, Canada, sixty miles from Calgary, isolated from any Hollywood distractions, where the entire production plunged back in time.

Above: Eastwood takes a break alongside co-star Jaimz Woolvett – it was a shoot of few creature comforts, with a wind that could cut right through you, but such hardships, the director insisted, were part of the appeal of making a Western.

Searchers,'[30] clamoured the *Los Angeles Times*, ironically comparing *Unforgiven* to Ford's rich mythologizing. 'Magnificent,'[31] said the *Observer*. 'Captivating,'[32] purred *Empire*. 'All in all, it's a hell of a thing,'[33] acknowledged the *Independent on Sunday*, paraphrasing the film's rich, biblical cant. There were those who raised a questioning brow, suggesting the final gunfight reverts to the Leone absurdity of old, but that missed the declaration that Munny simply gets lucky in the saloon. By the end of the year, *Unforgiven* had appeared on over two hundred top ten lists.

Amid all the beaming, death-dealing blockbusters of 1992 (*Basic Instinct, Batman Returns, Lethal Weapon 3* et al), audiences followed Eastwood into the dark, and this sombre film made $158 million worldwide, then the biggest hit of his career.

From the opening shot, a sunset silhouette of Munny at his wife's graveside (that recurrent Eastwood motif), every scene destabilizes our expectations of the genre. This is a revision to the revisionist template (Schickel called it 're-revisionist'[34]), which makes a full accounting of

the nihilism and death of Eastwood's past, and furthermore explores his age, reputation, and place in Hollywood history. It was, said Richard Corliss in *Time*, a meditation 'on Clintessence.'[35] Here was a new, even more reflective version of the old director. 'Starting with maybe *Unforgiven*,' noticed Meryl Streep, who would soon thrive beside the elevated Clint making *The Bridges of Madison County*, 'he started bringing [the audience] along on a left-hand turn, where violence wasn't the thing you got your rocks off with. It was something horrible. And only he could bring them there.'[36] Overnight, and thirty years into his career, he was perceived as an artist.

Was it to be his last ride? The final Western? Not one for grand pronouncements, he tended to shrug at the idea. 'No one knows what became of Will Munny,'[37] declares the film's epigraph – and, as it was to prove, Eastwood's presence as a Western icon would disappear with him. After *Unforgiven*, he was free of the past.

Eastwood hadn't attended the Academy Awards for nineteen years. He was never part of the 'country club'[38] as he put it, and had sworn away from the event after the unfortunate events of 1973. His first Oscars had made for a grim evening, when he had been persuaded to fill for Charlton Heston, one of the four hosts, currently caught in traffic. Just for the opening, he was promised. Hustled on stage with seconds to go, he discovered that the already lame jokes on the teleprompter remained Heston-based. The

Above: As director and leading man, Eastwood was well used to switching from in front of to behind the camera in a heartbeat, commanding his set from beneath the brim of his hat.

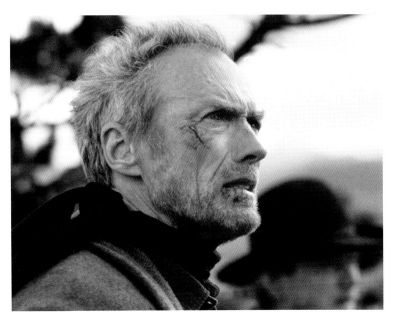

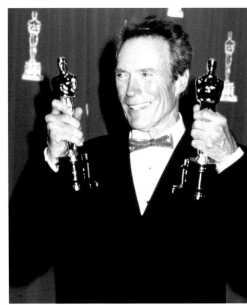

Above left and right:
'Deserve's got everything
to do with it'; *Unforgiven*
would, of course, triumph
at the Oscars in 1993
– the culmination of an
extraordinary career,
which was far from over.

audience titters were deafening, as he spouted
nonsensical lines about *The Ten Commandments*,
when Heston arrived to save his blushes. This was
also the notorious year Best Actor winner Marlon
Brando sent Sacheen Littlefeather to accept in his
stead, highlighting the poor treatment of Native
Americans on film to a chorus of boos. Presenting
Best Picture, as planned (and a big honour),
Eastwood, aiming for irony but arriving at sour
grapes, suggested the award be dedicated to 'all
the cowboys shot in all the John Ford Westerns.'[39]
He flatly refused to return, figuring he didn't make
the kind of films likely to be nominated. But that
had changed.

He claimed to have been asleep as the
nominations were read out. *Unforgiven* received
nine, including Best Picture, Best Director,
Best Actor for Eastwood, Supporting Actor for
Hackman, and Best Original Screenplay for
Peoples. And all of a sudden he was the favourite.

Eastwood was wary of throwing himself into
the attendant glad-handing and magazine profiles.
He didn't want to appear desperate, and the
disappointment of *Bird* still hurt. When it came to

the Oscars, *deserves* often had nothing to do with
it. But critics and even more so the studio sensed
the moment was ripe, and perhaps Eastwood was
more eager for recognition than he made out. IRA
thriller cum unconventional love story *The Crying
Game* was his biggest rival, but it was Eastwood's
night as he picked up Best Director and Best
Picture. All he was denied was Best Actor, which
went to Al Pacino for his overwrought turn in
Scent of a Woman. Eastwood's textured performance
deserved better, but *Unforgiven* also marked a
significant shift in perception. We would think of
him first as a director.

THE INTREPID ICON

A Perfect World (1993), The Bridges of Madison County (1995), Absolute Power (1997), Midnight in the Garden of Good and Evil (1997), True Crime (1999), Space Cowboys (2000), Blood Work (2002), Mystic River (2003)

There was before *Unforgiven* and after *Unforgiven*. This is the accepted history (the legend, so to speak, and not far from the case): with Clint Eastwood canonized as a cinematic great, every film he made was an event in itself, judged not by Hollywood's statutory accounting, the slings and arrows of box office performance, but in rarefied terms. Those applied to auteurs. Retrospectives were mounted at New York's Museum of the Moving Image, invitations arrived to serve as president of the Cannes jury, French critics wrote lengthy appraisals, biographers sharpened their pencils, as Eastwood was reborn as a major American filmmaker who could bear comparison with the greats.

Now this is still a relative distinction: there will be miscalculations and commercial failures to be regarded alongside plentiful late-career excellence, and, as we've seen, he had always been a highly personal director. There is little argument that this was where the trail was headed. But he was keener to experiment, and that sense of adventure was accepted as another facet of his house style. *Unforgiven* had freed him from the need to be quite so Clint Eastwood.

Concomitantly, he was also established as that rarest of Hollywood beasts – a star accepting his ageing, indeed making a boon of his craggy face and grey hair, and the legacy he carried with him.

In the simplest of terms, from the early nineties there was a shift away from the hard-man formula. Even thrillers like *Absolute Power* and *Mystic River* broke with convention, taking their time; dwelling on the lives involved, their weaknesses; the settings, an exploration of America. At some point in your life, he said, 'you look for character studies instead, even if it's less commercial.'[1] Uncommercial was often in the eye of the beholder. He had convinced himself *Unforgiven* was destined to fail because it placed limits on traditional action, but the film proved that audiences were hungry for depth and texture, a point soon reinforced by *A Perfect World* and *The Bridges of Madison County*. Nonetheless, it would always be a delicate balance.

Right: Eastwood lines up a shot on *The Bridges of Madison County* (1995) – as he entered the second phase of his directing career, he was proving more adventurous than ever.

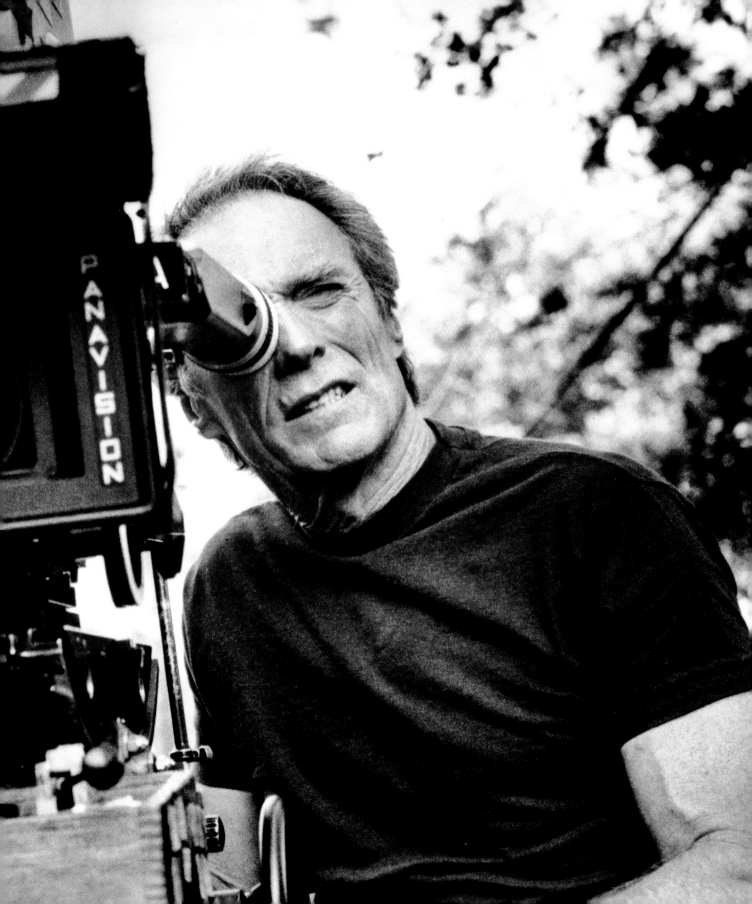

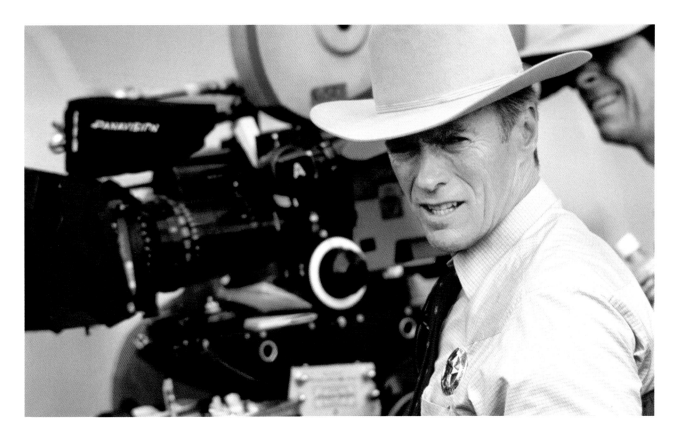

But first, the exception to prove the rule: *In the Line of Fire* (1993). Eastwood was already committed to an old-fashioned starring role, with Wolfgang Petersen directing (the dynamic force behind *Das Boot* and Eastwood's choice), and this smash-hit potboiler bears mention because it was a hard-man movie precisely about age, and one that fortified Eastwood's post-*Unforgiven* grandee-with-irony status. With some pointed huff and puff, he plays cranky secret service fixture Frank Horrigan, haunted by his failure to take a bullet for Kennedy in sixty-three. Horrigan is taunted by ex-CIA maniac Mitch Leary (a deliciously reptilian John Malkovich, who claimed Eastwood reminded him of his elegant but temperamental father), who is intent on killing the current president. Thus Eastwood's hero is forced to use brain over braun to stave off another assassination.

Critics noticed how readily Eastwood played with his persona. Petersen too saw an actor who psychologically, was 'willing to take risks.'[2] The success of *In The Line of Fire* vouchsafed his new status as American icon. In two films Eastwood had gone from outmoded superstar to sure thing. He was a changed man: reinvigorated, influential, self-determining, and box office gold. He sat tall, this intrepid icon.

A Perfect World landed on his desk as a sample of writer John Lee Hancock's talents, and Eastwood's first thought was that he would love to take on the lead character, Butch Haynes. Only he was twenty years too old. The year is that same, momentous 1963, when the country was 'in a state of suspense.'[3] Haynes has absconded from prison and taken a child hostage as he flees through the sun-caressed farm country of

Above: Eastwood directs the thriller *A Perfect World* (1993), as well as taking on the smaller role of Texas Ranger Red Garnett, at the behest of his star Kevin Costner.

1993 **In the Line of Fire**
Actor

southern Texas, the antithesis of the director's usual gloom. The emotional current is provided by the bond that forms between the criminal and this boy, a Jehovah's Witness, denied what Butch takes to be the pleasures of childhood. On their trail comes Red Garnett, an ageing, disenchanted Texas Ranger, and his slightly screwball team. As Eastwood decreed, the pace would be unhurried, the tone wistful, with its theme of lost childhoods and absent fathers (those of Butch; the boy, Philip; and an America soon to lose a president), as they milked the landscapes around Austin, jolting the warm air with flashes of suspense and violence. Here was the fable-like quality he enjoyed: rural America, forgotten lives, shattered dreams.

Furthermore, Kevin Costner had thrown his hat into the ring to play Butch. The actor was on a box office streak so strong it had been labelled the 'Costner factor,'[4] and the studio could hardly contain their excitement. Costner had also established himself as the other modern purveyor of Westerns with *Silverado* and the Oscar-winning *Dances with Wolves*. The symbolism of their partnership was highly marketable, though Eastwood initially had his doubts whether the

virtuous Costner could locate the near-psychotic capacity for violence lurking within Butch. The director strove to preserve a 'certain toughness'[5] in his lead akin to Bogart, Cagney, Mitchum, or Eastwood. Costner came with a demand: that his director play Red, a relatively small role. He couldn't see why not and they set off for Texas in April 1993.

As the director patiently drew out a wonderful, natural performance from seven-year-old T.J. Lowther as Philip, relations with his star briefly threatened to disturb the prescribed equanimity of the Eastwood production. Tensions had steadily grown when the film's start date was delayed to allow Eastwood to campaign for *Unforgiven* at the Oscars, putting pressure on Costner's schedule with his revisionist *Wyatt Earp* looming. Costner also came to set with ideas that he wanted to discuss. At length. Things reached a head when an extra on a distant tractor missed his cue to wave. After a second take resulted in the same mistake, Costner threw down his prop bag and flounced off. With the camera positioned behind Butch, Eastwood didn't hesitate.

'Find his extra,' he commanded, 'and put a shirt on him.'[6]

Below left and right: Costner as prison escapee Butch Haynes and T.J. Lowther as Philip, the sheltered boy he takes hostage. Costner proved a nettlesome star, needing to talk through every detail, trying different things, infuriating his straight-thinking director.

1993 **A Perfect World**
Actor/Director/Producer

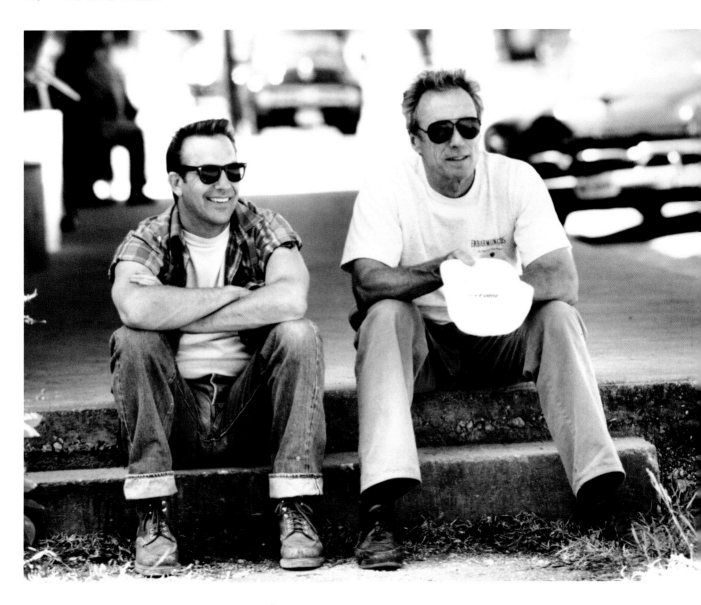

Above: A contented moment on set – *A Perfect World* united the two biggest stars of the early nineties, but proved a far less conventional film than expected. In hindsight, a far better one too.

"Find his extra, and put a shirt on him...
I'm not here to jerk off."

Clint Eastwood

Right: What became clear was that after the glories of *Unforgiven* (1992), Eastwood was interested in more emotional material, exploring a father-son bond in *A Perfect World*, and a late-blooming romance in *The Bridges of Madison County*.

Having cooled off, Costner was confronted by the news they had the shot. Eastwood laid down the law as he had in front of the camera for decades, like the shifting of a tectonic plate: if you walk off, this guy'll play the whole movie. 'I'm not here to jerk off.'[7]

A Perfect World doesn't get the recognition it deserves. If it didn't quite hold to the promise of uniting the doyen and young pretender of the West – the two actors barely share the screen – it was another fine example of the sensitivity and moral uncertainty taking precedence in Eastwood's work. Rather than a genre showpiece, the longed-for Western, Eastwood delivered an intimate parable enclosed within a prisoner-on-the-run drama, indeed featuring one of Costner's best performances. And it made money: the relatively slender budget of $14.4 million was more than recouped with a global tally of $135 million.

Perhaps the close proximity of *Unforgiven* overshadowed this more tender exploration of

American manhood, but critic Walter Chaw, waxing lyrical in *Film Freak Central*, made a retrospective case for it to sit among Eastwood's best pictures. 'It captures the world the way that Terrence Malick captures it in *Badlands*, *Days of Heaven*, and *The Tree of Life*: a place where sublimes of passion and despair are both possible, shot through with golden light and pollen swimming in the air.'[8] We can see what it shares with later films like *Mystic River* and *Million Dollar Baby*. Films steeped in a melancholy nostalgia, where darkness lurks in the wings.

What came next was even more surprising – an Eastwood love story. *The Bridges of Madison County*, written by a former economics professor named Robert James Waller, was a sensation. This novella about a middle-aged romance kindled during a chance encounter in deepest Iowa took root in the bestseller charts, selling in the region of 9.5 million copies before an adaptation was finally commissioned. It was a saccharine piece,

1995 **Casper**
Actor (uncredited)

1995 **The Stars Fell on Henrietta**
Producer

set in 1965: the tale of dishy *National Geographic* photographer Robert Kincaid, who has come to Madison County, Iowa to shoot the famous covered bridges. Here he meets lonely Italian housewife Francesca, a war bride who has accepted her placid lot until this tousle-haired photographer turns up in her front yard. It is the start of a brief, life-changing affair.

Any adaptation would have to keep what was so beloved about the book – this late-blossoming adult love story, the richness of the two characters – and throw out Waller's cod-philosophizing and flowery prose. And the man to do that was Steven Spielberg, at least at first. So attuned to pop culture, he had optioned the book before it captured the public's imagination. Straightaway, he pictured Kincaid with the mix of rugged and wry that came with the sixty-four-year-old Clint Eastwood. Public debate had thrown its lot in with Robert Redford, but Spielberg knew he was too matinée idol. The idea was to find a reality beneath the fairy tale.

'I've been friends with Clint since the *Play Misty for Me* days in the early seventies,' he recalled. 'I've always felt that Clint in his real life was a much drier version of Kincaid in Waller's book. He was always my first choice.'[9]

Keen for a diversion after two taxing films, and his interest piqued by the challenge, Eastwood accepted Spielberg's offer of the most purely romantic figure he would ever play, but a character who was still earthbound, this solitary soul navigating lonely roads in his battered pickup. Just as he once had, scouting locations: 'I'd get in a pickup truck by myself, drive up the Sierras, come upon a location I like…'[10] He didn't run across any Italian housewives, he added, but he could have. So it was only so much of a stretch. His performance, those who know him commented, is as close as we have had to the real Eastwood on screen.

With Francesca yet to be cast, the project ran into trouble. Spielberg, exhausted after *Schindler's List*, retreated to the role of producer. Sydney

Above: True to form, Eastwood was determined to shoot *The Bridges of Madison County* on location in the honest landscape of Iowa, utilizing the famous covered bridges around Winterset.

1995 The Bridges of Madison County
Actor/Director/Producer

Above: Meryl Streep was Eastwood's one and only choice for the role of Francesca – he found himself inspired by her gifts, and allowed room for improvisation, but forbade her time to rehearse, as he wanted the romance to seem as lifelike as possible.

Pollack dallied for a while, hinting he preferred Redford as Kincaid, before Australian director Bruce Beresford (*Driving Miss Daisy*) signed on. But there was still no firm direction over how the material would be treated.

'The three or four versions of the screenplay they had were all over the place,' said Eastwood, growing testy as time ebbed away, 'and one or two of them changed the storyline completely.'[11]

Both Eastwood and Spielberg preferred the version by playwright Richard LaGravenese, who had made the enlightened choice of telling the story from Francesca's point of view, where the book is Kincaid's account. The framework has her grown-up children discovering her journals and the profound secret that lay within.

Beresford was keen on either Lena Olin or Pernilla August – two excellent Swedish actresses, but hardly marquee names – as Francesca. With a contractual say in casting, Eastwood vetoed both. Beresford then suggested Isabella Rossellini, who

at least was half-Italian. Eastwood turned her down as well, and two weeks before they were due to start, Beresford departed, leaving *The Bridges of Madison County* with no Francesca and no director. Just as pressing, if they wanted the splendour of fall in Winterset, Iowa, where they planned to shoot, there was no time to spare.

It was Terry Semel, head of Warner Brothers (who were producing the film with Spielberg's Amblin Entertainment), who simply saw what was obvious and put in a call to his leading man. 'How about you direct it?'[12]

'Give me twenty-four hours,'[13] replied Eastwood, and took the Warner corporate jet straight to Winterset to inspect the covered bridges first hand. He knew right away that he wanted to shoot the real thing – they shouldn't fake it. They needed to lift the story out of a cloying book and place it in an honest landscape. This would be a romance Eastwood style. Then he called Semel back, 'Yeah, I'll do it.'[14]

He had a vision for the movie. 'A set of circumstances,' as he calmly explained it, so averse to sentiment. 'Two outsiders getting together in the centre of America.'[15] He liked the simplicity. You can't stray too far from that. It was a film about time and regret and lost chances. Real things. He also knew exactly who Francesca was.

When Meryl Streep picked up the phone, she was taken aback to hear the unmistakable tones of an American icon. There were no agents involved, no executive to smooth the way. Eastwood called direct, explained that she had to play Francesca, that the story would be told through her eyes, and that he would be her romantic partner. 'It was hard to say no,'[16] she laughed.

Inspired by his partnership with Streep, Eastwood allowed a rare improvisational spirit to flourish on set. He likened her to Gene Hackman or Morgan Freeman: she was always ready and gave everything. He didn't allow too much rehearsal, if things were awkward then so much the better – that was life. Streep finds an uneasy flux of passion, doubt, and anger in this rooted

woman discovering love at the wrong moment. Though Eastwood's economical approach to his craft took getting used to.

'As director, I would sort of have to divine when he was starting to act,'[17] she said. Eastwood's habit was to stroll from behind the camera into the scene and simply say, 'Okay.' It took her a few days to realise 'Okay' meant to start acting. He was seamless. 'He doesn't play a wide range of characters – he looks like Clint Eastwood, he talks like Clint Eastwood – but he was fully committed as an actor.'[18] The one-take thing was another learning curve. 'That felt pretty good,' he would smile, 'let's move on.'[19]

From any angle it was an unexpected triumph, earning $182 million worldwide and another Oscar nomination for Streep (her equally deserving co-star was denied). But what stunned critics into submission was a twofold miracle – that such an authentic romantic story could be excavated from Waller's manipulations, and that it took what *Slant* classified as Eastwood's 'minimalist poetry'[20] to

do it. The flat, autumnal landscape is shot by a hand well-versed in Westerns: this is not a backdrop, it is context. The film never gets carried away. Its power lies in denial. 'One of the sources of the movie's poignancy is that the flowering of the love will be forever deferred,' noted Roger Ebert in the *Chicago Sun-Times*; 'they will know they are right for each other, and not follow up on their knowledge.'[21] What could be more Eastwood than that?

Deft in unexpected ways, formulaic in others, *Absolute Power* embodies the Eastwoodian storytelling of 1997. It follows an ageing cat burglar (preying on the overstuffed mansions of billionaires and boasting Eastwood's laconic charm) who witnesses a murder-mid-(violent)-coitus involving none other than the President of the United States (Gene Hackman, as reliably amoral as ever). In the past, such a far-fetched thriller, based on former Washington, D.C. lawyer David Baldacci's novel, would have concerned itself with the commercial vernacular

Left: Meryl Steep would be Oscar-nominated for *The Bridges of Madison County,* but Eastwood was the revelation – more vulnerable and tender than he had ever been on screen, and closer, friends said, to the real man.

1995 **77 Sunset Strip** (TV Movie)
Executive Producer

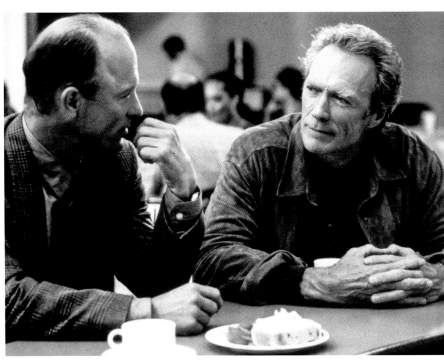

Above left and right:
Absolute Power (1997) was
a commercial-sounding
Washington thriller of
cover-ups and conspiracy,
which Eastwood saw as a
character piece,
populated with reliable
actors like Laura Linney
and Ed Harris.

of the material: the car chases, the shoot-outs, the withering one-liners. But Eastwood was drawn to this bestseller by the characters, and he recalibrated a page-turner as a slow-burning drama in which the thief, Luther Whitney, fingered for the crime, turns to his estranged daughter (Laura Linney), a prosecutor, for help.

The project was set up at Castle Rock, the same production company behind *In the Line of Fire* – which, with a sister study of ageing action-heroics in mind, offered it straight to Eastwood. He signed on to direct as well as star, with a sizeable (certainly for him) budget of $40 million, thanks to a cast that also included Ed Harris, Judy Davis, and Scott Glenn. They shot in Baltimore and Washington during the summer of 1996, coming in seventeen days ahead of schedule, and working from a script by the eminent and outspoken William Goldman (*All the President's Men*). Goldman later grumbled that Eastwood had blunted the edge of both novel and his initial

draft in which Whitney is killed halfway through. Director informed screenwriter that he wanted his character to 'live and bring down the president.'[22] Goldman wearily obliged star power, but his rewrite never fully resolves the need for urgency, with ambling scenes in which father and daughter thrash out their differences.

There were advocates. In the *San Francisco Chronicle*, Mick LaSalle considered it a first-rate thriller about 'a showdown between two kinds of American: the omnipotent bureaucrat and the enterprising mind-his-own-business loner.'[23] Which roots the film in Harry Callaghan's philosophical persuasion – the triumph of the individualist against a corrupt system.

At sixty-seven, Eastwood's productivity put younger directors to shame. Before *Absolute Power* was released into theatres, where it would make a satisfactory if unspectacular $50 million, he was at work on his next: another adaptation, another bestseller, but a different kettle of fish entirely.

1997 Absolute Power
Actor/Director/Producer

John Berendt's *Midnight in the Garden of Good and Evil* had spent a record 220 weeks in the charts, but was considered unadaptable. Written in a rich, novelistic argot, it is the sprawling, real-life account of the citizenry of Savannah, Georgia; at its dark heart, local bon vivant Jim Williams (Kevin Spacey), accused of murdering his unsavoury lover Billy (Jude Law). Eastwood had read John Lee Hancock's screenplay first, while shooting *A Perfect World*, so was free of preconceptions. He liked the title and this corner of the country frozen in time, with the kind of community of eccentrics he is often drawn to. Nouveau riche antique dealers, voodoo witches, transgender socialites, gin-supping widows giggling over their husbands' suicides: they all seemed to tolerate one other, he said, with a rather 'libertarian point of view.'[24] The atmosphere made it so much more than a straight courtroom drama. At the same time, he was impressed by Hancock's solution to the book's digressive nature, placing

the writer (John Cusack's reporter) within the story to play detective. He likened it to *In Cold Blood*, if considerably warmer and wealthier.

In truth, the book's whimsical, gothic tone called for a flamboyance beyond Eastwood's instincts, though he shot dutifully among the famous plazas in the summer of 1997, using locals as extras. Indeed, the drag queen Lady Chablis is sweetly played by the real Lady Chablis. The result is prosaic rather than relaxed, its various flavours combining for a tasteless cocktail, with the mystery that hovers over Williams' shifting interpretation of events never involving. Critics were dismayed that the Savannah on screen wasn't what they had imagined on page. 'Something ineffable is lost just by turning on the camera,'[25] suggested Roger Ebert as it wilted at the box office with $25 million worldwide. Maybe it was unadaptable.

True Crime fit the bill perfectly: a washed-up, emotionally scarred investigative reporter (Eastwood, scuffed up a tad more than usual) who

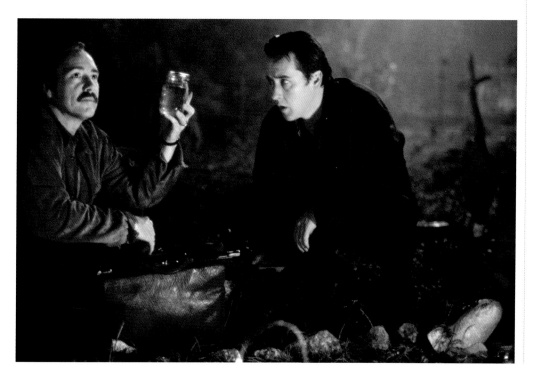

Left: Eastwood's adaptation of exotic real-life murder mystery *Midnight in the Garden of Good and Evil* (1997) starred Kevin Spacey and John Cusack, but never quite gelled with the director's leaning toward realism.

1997 **Midnight in the Garden of Good and Evil**
Producer/Director

Right: Death Row drama *True Crime* (1998) had Eastwood's down-at-heel reporter spar with James Woods as his cranky editor, but was another picture stuck in second gear.

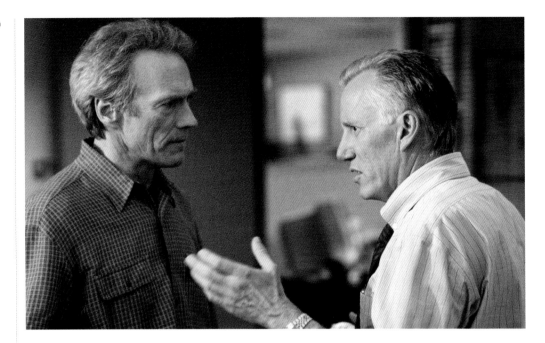

has twelve hours to prove a Death Row inmate (Isaiah Washington) is innocent of murder. He is also having an affair with the wife (Laila Robins) of his city editor (Denis Leary). Redemption, we sense, is overdue. *True Crime* could happily have been released twenty years earlier: the grey-brown palate, the reporter's quotidian rituals (coffee, arguments, deadlines, bourbon smuggled in a flask), America (in this case Oakland) captured at street level. Eastwood, the actor, is only tested when sparring with bellicose editor-in-chief James Woods. 'It's a bit too creaky, with dialogue that's a little too corny and a plot that just ambles along,'[26] complained Keith Phipps in the *A.V. Club*, while admitting it was always watchable.

With a third listless crime story in succession, Eastwood was playing it safe and audiences were left uninspired. The film slumped to $16 million at the box office against a budget of $55 million, his second-biggest flop after *White Hunter Black Heart*. He was at least headed to space next.

In its endearingly daft way, *Space Cowboys* marks Eastwood's second dalliance with special effects after *Firefox*. Comparisons cease there. *Space Cowboys* is sure of its tone – eccentric – and its ambitions are breezily easy-going and generically thrilling, exactly what you might expect if Clint Eastwood had chosen to direct *Armageddon*. Often very funny, it is an earthy space saga shouldered on the iconography of not one but four ageing greats: Eastwood, Tommy Lee Jones, Donald Sutherland, and James Garner.

Written by Ken Kaufman and Howard Klausner, the plot doesn't blink in the face of absurdity. That is almost the point. When an equally aged satellite threatens to topple from orbit onto America, it is only the original designer of its guidance system, Frank Corvin (Eastwood), who can avert disaster. But he insists he is accompanied by his original team (the aforementioned sixty-somethings), a quartet of astronauts who had been passed over forty years before, but prove to still be in possession of the right stuff. In its lighthearted way, there are echoes of *Unforgiven*.

In fact, Eastwood reframed the story as a NASA Western. Hence the rather deliberate title.

1998 **Monterey Jazz Festival: 40 Legendary Years (Video)**
Executive Producer

1999 **True Crime**
Actor/Director/Producer

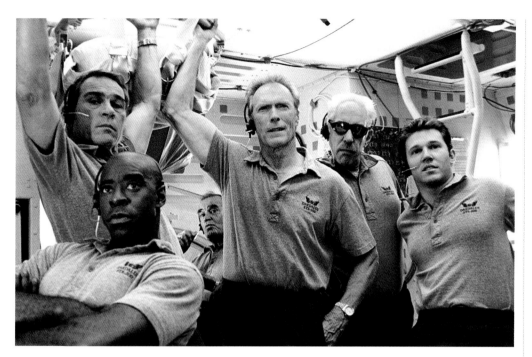

'Cowboys were the pioneers of the American frontier,' he said. 'The new frontier is space, so astronauts are the cowboys of space.'[27] It is another generational story, the past leaning on the present, with flashbacks to the hallowed Americana of the Space Race (where Toby Stephens makes a credible young Eastwood), but in science-fiction terms doggedly rational. NASA were game, and they filmed at the Johnson Space Center at Houston and at Cape Canaveral. Background realism was crucial, something Eastwood impressed upon Industrial Light & Magic, who were cooking up his effects as the budget swelled to $65 million. But what made it a minor hit (if not a major work), with $128 million worldwide, was its good-humoured exploration of age and masculine bravado, and 'the abundance of charm and screen presence from the four veteran actors,'[28] as the *Chicago Sun-Times* reported. Any parallels with Eastwood's career were entirely deliberate.

Passing seventy, Eastwood returned to the crime beat, assuring the studio that *Blood Work*, based on the novel by Michael Connelly, was a brisker, more Harry-esque, high concept detective story. Eastwood simply liked the lead character, Terry McCaleb, a retired FBI profiler recovering from a heart transplant. He called it the 'vulnerability factor.'[29] Imagine Dirty Harry having to pop thirty-four pills a day. McCaleb is drawn back into investigating an unsolved murder when he discovers the victim was his donor, joining the dots to the serial killer he was tracking before his heart gave out. The film co-stars Jeff Daniels and Anjelica Huston (as McCaleb's cardiologist!), the latter adding a flicker of resonance being the daughter of John Huston, the subject of *White Hunter Black Heart*. Shot around Long Beach, this white hunter, bad heart noir required a gothic sensibility over Eastwood's efficiency. '*Blood Work* is a clockwork, lock-step, shake-and-bake thriller that has nothing new to offer the genre,'[30] concluded *Film Freak Central*, with a figurative shake of the head. Audiences agreed, and there were concerns Eastwood's renaissance had run its course.

'The loss of innocence obsesses me,'[31] reflected Eastwood, promoting his twenty-fourth film as director, and only the fourth after *Breezy*, *Bird*, and *Midnight in the Garden of Good and Evil* in which that iconic face was absent. A film that returned him the authority and adulation of *Unforgiven*, and another reckoning with his past. Sleekly adapted from Dennis Lehane's novel by Brian Helgeland (who had written *Blood Work*), *Mystic River* bore witness to the sins of the other genre that shaped Eastwood's career – the crime thriller.

He had bought the rights, as he so often did, on an impulse, having read the synopsis in a newspaper. It was another simple calculation: 'I think I can make an interesting movie out of this.'[32] But that 'interesting' carried weight. He was more inspired than he had been for years. This is another story that explores the legacy of violence, a generational tragedy that follows three childhood friends, Jimmy, Sean and David, from a rough pocket of Boston, down by the titular river, an unremarkable ribbon of black water flanked by wasteland, calm on the surface, treacherous beneath. Their lives are shattered when David

is snatched by faceless cops in a dark sedan and not seen again for four days. He may escape his pederast captors, but his mind is trapped forever in trauma.

The abuse of the innocent had stirred the moral landscape of *Sudden Impact* and *A Perfect World*, and was to be the focus of *Changeling* in 2008, but Eastwood had never been as raw or compassionate. Twenty-five years later, no longer friends, the lives of the central trio are interwoven again when Kevin Bacon's Sean, a detective, is called to the scene of a crime. The body of a teenage girl has been found – the daughter of Sean Penn's Jimmy, an ex-con who keeps ties to the underworld. Suspicion will fall upon Tim Robbins' hangdog David, a shadow of a man barely able to hold down a job, who returns home with blood stains on his clothes. Did trauma beget trauma? Within the framework of a whodunnit (with the emphasis on *did-he-do-it?*), in that Eastwood way, this is also an exploration of community: the complex codes, the secrets, and the often painful relationships between husbands and wives, fathers and their children, and the bonds between friends. Laura Linney and Marcia Gay Harden both give riveting performances as the wives of Jimmy and David.

The film is richly done with a brooding, haunted, almost timeless atmosphere, and that signature inky gloom, noir stripped to its bones. They shot through the autumn of 2002 in Boston, capturing the forlorn bars and rundown shops, place and plot entwined. 'Everyone is the creation of the community in which they were reared,' wrote Philip French in the *Observer*, 'and the moral struggle their background engendered.'[33]

With no role for him, Eastwood was happy to remain behind the camera and draw excellent work from his cast, and without a murmur of ego. 'He's not the director as disapproving father,' said an admiring Penn, 'Clint is the approving, rascal older brother.'[34] There was a lot of laughter. In the only knowing touch, Eli Wallach (from his Spaghetti days) appears as the elderly owner of a local liquor store.

Below: *...but Blood Work* (2002), which played to Eastwood passing seventy by saddling his character with a heart condition, did no more than deliver clockwork thrills.

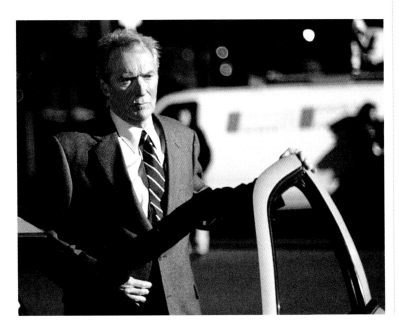

2002 **Blood Work**
Actor/Director/Producer

You could say that the Eastwood persona is split between two characters. Back in his forties, he might have taken the Bacon role, the good cop. It is Bacon who gives the most Eastwood-like performance: restrained, cool-headed, even drily funny, compared to the showy work of his co-stars. He even got permission to wear identical sunglasses to Dirty Harry. But we also see his righteous furies in Penn's Jimmy, the man who is prepared to deal in frontier violence. Whatever the consequence. Whatever the cost. Equal and opposite to the loss of innocence comes the desire for revenge. As inescapable as gravity, Jimmy will take matters into his own hands just as William Munny had returned to Big Whiskey.

'If a Greek tragedy could be transposed to Boston, it would look a lot like this,' extolled Mark Steyn in *The Spectator*. 'I'm not saying Clint Eastwood's Sophocles, but he does a passable impression.'[35]

From *Dirty Harry* to *Mystic River*, the same theme has been bugging Eastwood throughout his career – the limits of institutionalized justice. Those frail doctrines by which America holds itself together. Even as Eastwood shied away from the inevitable debate, commentators sprang upon *Mystic River* not only as a return to vital form, but as a riposte to the legacy of the *Dirty Harry* films and their kin, where the body count mounted without consequence. In *Mystic River* everything is touched by violence, like ripples across the oily water.

This was his strongest, darkest work since his Oscar-winning Western, a reminder that Eastwood had a storytelling gift to honour and plenty to say. After raves upon *Mystic River*'s debut in Cannes, and $157 million in takings, Oscar nominations followed, with only Robbins (for Best Supporting Actor) and Penn (for Best Actor) called to the podium. 'God, I really thank Clint Eastwood, professionally and humanly, for coming into my life,'[36] declared Penn, never one to hold back. Eastwood wouldn't have long to wait until he was back on that stage.

Above left and right: Adapting Dennis Lehane's Boston-set *Mystic River* (2003) reinvigorated Eastwood, suggesting a moral complexity beneath the cop thriller just as *Unforgiven* had probed the Western. Sean Penn would win Best Actor as the local hood who takes the law into his own hands.

2003 Mystic River
Producer/Director

Above: Eastwood took great pleasure in only being required to direct his relatively young cast, including Kevin Bacon and Laurence Fishburne, joking that he could wear his sneakers to work.

2003 **The Blues** (TV Mini Series)
Producer/Director (1 episode)

AMERICAN SOUL

The emotional triumph of *Million Dollar Baby (2004)*

If there is a moment that epitomizes Clint Eastwood's unassuming stature as a filmmaker then look no further than the Oscar ceremony of 2005. During early campaigning, Hollywood's clairvoyants had convinced themselves that this was to be Martin Scorsese's year. As one of the modern era's greats, he was long overdue. What's more, his latest film and frontrunner, *The Aviator*, was an epic about Hollywood itself, albeit veined in dark matters as suited the Academy's taste for the serious, being the tale of Howard Hughes, the billionaire producer-crank sinking into psychosis as *Bird* had once done. Mid-life crisis comedy *Sideways* was the dark horse, likely to pick up some acting honours, maybe screenplay. The matter was resolved. After all, hadn't Eastwood had his day in the sun? All that recognition for *Unforgiven*, his great statement on the Western.

Without fanfare, in the summer of 2004, Eastwood had been hard at work on another movie. Such was his way – to calmly keep on moving. What came next is what mattered. But by late August, as the finished film screened at Warner Brothers, internally word was growing that *Million Dollar Baby* was very special indeed. Yet still it kept a low profile, setting a release date of 5 December, a latecomer in awards terms: from the outside, as far as anyone could tell, Eastwood's latest was one of those quaint, smaller pictures he did every so often. A low-key boxing drama set in rundown fringes of Los Angeles.

What typified the Eastwood picture of the new millennium? His choices were idiosyncratic, like those of an indie filmmaker. Nevertheless, he explored the world in his own meditative way. As Kenneth Turan described him in *The Los Angeles Times*, he was 'Hollywood's last and best classicist.'[1] He made films with soul.

By the night of 27 February 2005, at the Kodak Theatre on the gaudy corner of Hollywood Boulevard and Franklin, it was no longer a shock. Critics had caught on, audiences too (the film made $217 million worldwide), and Eastwood would triumph again and Scorsese be denied once more (for better or worse, he would have his day with *The Departed* in 2007). It was Dustin Hoffman and Barbra Streisand (who once could have been his co-star) who presented Best Picture. 'I am so happy to give this to you again Clint,'[2] blurted Streisand before even naming the film. In fact, she had presented him with his Best Director Oscar for *Unforgiven* in 1993. It still felt a little cosy.

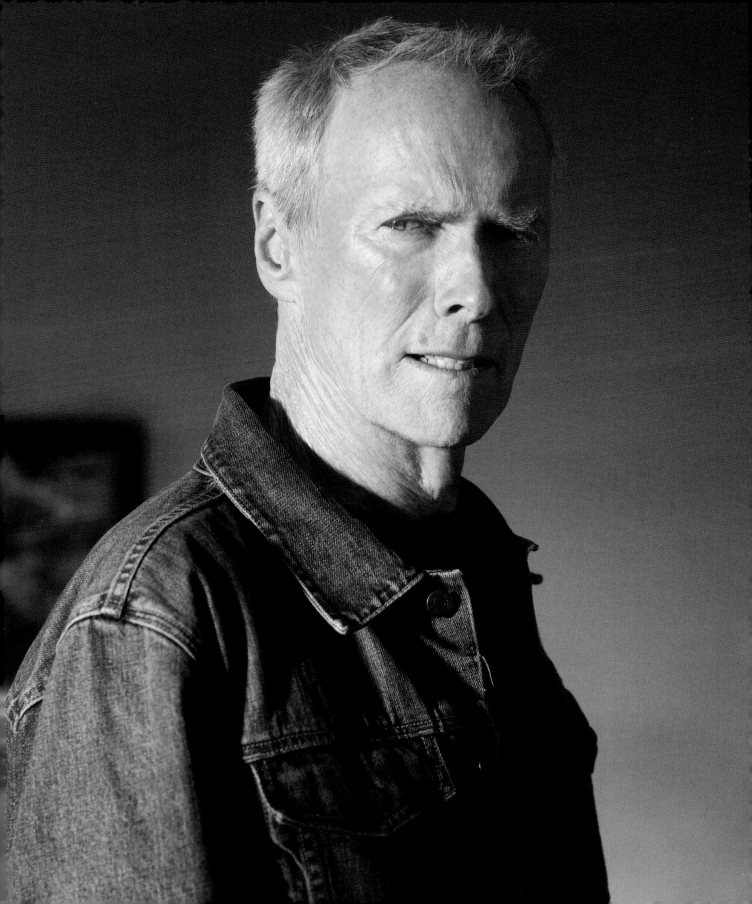

What was clear was that the better film had won. In a rare triumph for the Academy, the best picture of the year had been honoured. And it had done more than win Best Picture: Eastwood also came away with another Best Director award. He had attended with his mother in 1993, with *Unforgiven*, and she was with him again, aged ninety-six. 'I would like to thank her for her genes,'[3] he grinned as he accepted the statue. There were also victories in Best Actress (for Hilary Swank), and Best Supporting Actor (for Morgan Freeman) as well as nominations for Eastwood as Best Actor and Paul Haggis for Best Adapted Screenplay.

The truth is, more than even *Unforgiven*, *Million Dollar Baby* epitomizes Clint Eastwood.

Whether consciously intended or not, *Mystic River* was a return to first principles: grab the good scripts, focus on what drives the story, let the critics divine a message. Keep it lean. But *Million Dollar Baby* would double down on the union of material and artist at the perfect moment in his career.

'*Unforgiven* may be more magisterial, but *Million Dollar Baby* is the tougher work of art,' asserted Amy Taubin, assaying the film in *Film Comment*, 'in the sense that it's easier to fuel a film with anger and the desire for revenge, as *Unforgiven* is, than with a grief that can never be assuaged.'[4]

Producer Al Ruddy, the man who had made *The Godfather*, had come to Eastwood with the book. *Rope Burns: Stories from the Corner* was a collection of short stories set on boxing's lower rungs, written by F.X. Toole, a former fight manager and cut man, staunching the split brows and bleeding lips. The tales had an earthy power and the tight, to-the-point urgency of hardboiled crime fiction – real people shaded in the vernacular of their rundown world. There was one story in particular that had real potential.

'Million $$$ Baby' was a tale of long shots and second chances. Frankie Dunn (Eastwood) runs the Hit-Pit, a boxing club in Downtown L.A., with his old friend and former contender Eddie 'Scrap-Iron' Dupris (Freeman, who gifts the film

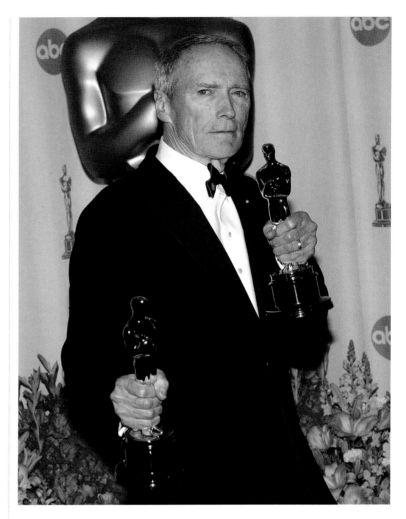

"The movie is simultaneously conventional and subversive, broad and nuanced, shamelessly manipulative and genuinely moving, a cheap sucker punch and a work of real moral weight."

Christopher Orr (The Atlantic)

Opposite: Eastwood triumphant at the Oscars again, winning Best Picture and Best Director – but unlike *Unforgiven* (1992), no one had seen *Million Dollar Baby* coming.

Below: The odd couple – one of the film's great pleasures is the sparring between old friends Eddie Dupris (Morgan Freeman) and Frankie Dunn (Eastwood), and two seasoned actors using their own friendship as a source of humour.

the same register of soulful narration that had elevated *The Shawshank Redemption* to parable). They spar verbally, contentedly, two old men left behind by life. Then one day in walks Maggie Fitzgerald (Swank) in search of a coach, a kid from the Ozarks down on her luck, but the bit between her teeth. Frankie resists, he caves, and she proves to have a punch that could take her all the way. Despite all his misgivings, and an overprotective nature, Maggie gets her shot. What counts is the relationship, not the formula. Frankie, we discover, has lead bars of guilt weighing down his heart. There is a daughter lost to him, though the reason for their rift is left obscure. He may need Maggie more than she needs him.

Ruddy returned with a finished script and Eastwood knew that old certainty again. This was his next film. 'Planning can kill you,' he said: 'mapping out your career.'[5] There is no one better at seizing the moment.

This was another sleight of hand, a profound piece of storytelling hidden beneath the humble front of its director. As Christopher Orr wrote in *The Atlantic*: 'The movie is simultaneously conventional and subversive, broad and nuanced, shamelessly manipulative and genuinely moving, a cheap sucker punch and a work of real moral weight.'[6] When it came to it, *Million Dollar Baby* recalled the unconventional movements within genre synonymous with New Hollywood far more

than Scorsese's complex but flamboyant epic. This was Eastwood's autumnal masterpiece: a tale of ageing, regret, hope, tragedy, class, religion, friendship, fatherhood, boxing, and a whole lot more besides. A character piece with an agonizing twist hidden beneath the cover of a sports movie.

Not that it was an easy sell. Ruddy had spent four years trying to interest Hollywood. The scriptwriting had been backed by Lakeshore Entertainment, an independent, but they couldn't raise the whole budget. For the time, it was priced at a relatively conservative $30 million (*Variety* ran a story that it eventually cost $18 million, with the inflated sum a publicity ruse). Eastwood turned to his patrons at Warner, but for once they winced. 'Warner weren't into it,' he recalled, enjoying the irony in hindsight. 'Boxing? Will that sell?'[7]

He had been plain enough. 'I am going to make this picture – even elsewhere.'[8] The idea of losing their golden son (not to say cash cow) brought them to their senses. Warner entered into a co-production with Lakeshore, and Eastwood shot his movie in thirty-seven days on location in Los Angeles' unkempt corners, having been scheduled to take thirty-nine. He kept the same trusted crew from *Mystic River*: including Joel Cox as editor, Henry Bumstead (himself eighty-nine) as production designer, and Tom Stern as cinematographer. They stuck to the same brand of lyrical stoicism, a rough-hewn noir of deep-set shadows and bowed profiles, pepped up by the brief flurries of boxing as Maggie takes to the ring. Eastwood wanted it to feel as if it could be the thirties or forties, where only the cars give away that it's present day. 'Do you want the light on or off?' Stern would ask before a shot. 'Off,'[9] he would reply, almost without fail. He wanted his characters to retreat into the darkness of their thoughts.

Left: Shadow boxing – the noirish look of *Million Dollar Baby* exemplifies Eastwood's love of visualizing the emotional states of his characters, pooling them in darkness.

With *Million Dollar Baby* the different parts of Eastwood become one: artist and popular star. He was still ranging across genres, but now gave no impression of ever doing one for the studio. Harry Callahan was doing just fine in retirement. Of course, he doesn't look at it that way, because he chooses not to look. That would be the biggest risk of all: 'I've gotten so lucky relying on my animal instincts, I'd rather keep a little bit of the animal alive.'[10]

It could have been Frankie who spoke loudest to those instincts. Eastwood had threatened to quit acting after *Blood Work* in 2002, wondering if audiences had grown tired of his face. In any case, where were the good roles for someone of his age? It was easier to stay behind the camera. He had

enjoyed *Mystic River*; comfortable to relinquish the light to his (relatively speaking) younger cast. But Frankie called to him with his Irish-American rasp – a grinding of millstones harsh even for Eastwood – and the director inside of him had to appease the leading man. 'This was just a good role,'[11] he said, with deafening understatement.

What is so certain with *Million Dollar Baby* is the symbiosis of Eastwood's craft where performance and direction are extensions of one another. In 2005, there was surely no actor-director alive more experienced at the dance between the two roles. And here it reached a zenith. As soon as he stepped in front of the camera, he was no longer a director, he was inside the role. 'You have to get in there with intensity,'[12] he said. Otherwise

Above: Lord of the ring – Eastwood and cinematographer Tom Stern work out their angles for what has become the cinematic staple of shooting boxing.

there is this glazed-over effect. You can't reach deep within if your mind is with the camera. This was the category the Academy got wrong. As good as Jamie Foxx was in *Ray*, Frankie is Eastwood's quintessential moment in front of the camera. In *The Los Angeles Times*, Kenneth Turan saw Frankie as 'the most nakedly emotional'[13] performance of his career.

Eastwood was seventy-four, it had been fifty-one years since he got his Screen Actors Guild card, and this has-been boxing coach was his *King Lear*.

The director allows the camera to linger on the face of his leading man. The camera has always loved that face, but in later life, lined and weathered, almost eroded, it had become one of the great visions of modern cinema. As fierce as a clenched fist, but somehow more vulnerable and expressive. 'His facial bones, if anything, appear more finely chiselled than in his youth,'[14] noticed Taubin. The squint was deeper than ever. Shadows pooled over his eyelids. But the guardedness that once made him remote now spoke volumes.

Below: Eastwood's Frankie Dunn puts Hilary Swank's Maggie Fitzgerald through her paces – the actress was totally committed to the role, training for months to build up the necessary muscle.

Frankie writes long, imploring letters to his daughter, which are returned to sender. The sins of the past rear their head again as they had in *Unforgiven*, and so many Eastwood films. It's a theme he can't let go of. The flaws of the man make the part. We are left to ponder what Frankie could have done to lose a daughter. A staunch Irish Catholic, he heads to Mass every day in order to rail with God.

Frankie is another exercise in not only embracing age, but demythologizing his stardom, his eminence, out of which emerged a new status as teller of truths. Hollywood's father confessor. 'I am a slow learner,'[15] he said, but you can sense the body of work within these old men. He doesn't prescribe to anything Method, but the character is seated in his mind: you can take a meeting, have dinner, then pull yourself into it.

Asked what the film was about, Freeman raised his eyebrows and smiled. 'It's about life,'[16] he said. Scrap is the journeyman fighter who had one bout too many and lost an eye (Freeman wears a special contact lens), which, it is hinted, was down to Frankie's poor judgment. He should have thrown in the towel. Scrap's presence is another act of penance for the old man. He is street-wise but tender-hearted, watchful and centred. One of the film's great pleasures is the interplay between Frankie

Below: The Eastwood touch – continuing the director's knack for landing Oscars for his cast, Hilary Swank (as Maggie Fitzgerald) and Morgan Freeman (as Eddie Dupris) would win Best Actress and Best Supporting Actor respectively.

Above: Eastwood was particularly drawn to evoking the rundown boxing milieu depicted in F.X. Toole's short stories, which had the urgency of hardboiled crime fiction.

and Scrap, Eastwood and Freeman, trading barbs and affection like an old married couple. 'The lines are a duet for buzz saw and cello,'[17] was how David Denby described the effect in *The New Yorker*. Years of backstory flowing from between those lines.

Eastwood likes to have his cameras rolling when he rehearses a scene. He often uses that take, when the words are fresh and the actors more relaxed. When they weren't, he said, 'building up to something.'[18]

After *Unforgiven* (with *Invictus* to come, but less visibly only as director and actor), Eastwood and Freeman had an effortlessness with one another, something truly natural, as if they were trying to *underact* each other off the screen. 'He handles it differently,'[19] said Freeman, asked about what it was like to work with Eastwood. He meant everything: the fame, the process, the needs of actors. 'He assures you in your own work,'[20] he concluded. He made you feel comfortable.

Nervous but determined, already Maggie, Swank had arrived promptly at the famous adobe bungalow for her meeting with Eastwood. He hadn't turned up yet, so Swank was invited to head on into his office to wait. She was unsure if she should sit down. What if she took his favourite seat? She eventually chose a seat in the corner, and in he came. He was, she recalled happily, just a 'tall drink of water: so kind, refreshing. So… *Clint Eastwood*.'[21] Sandra Bullock had once been attached, but that was before Eastwood. Ashley Judd was also considered. He lowered himself onto the sofa, and put his feet up. 'So what do you think of the script?'[22] he asked. It wasn't what you would exactly call an audition. They talked about the part, and about their backgrounds. How growing up in Nebraska and Washington gave Swank few advantages. She had to work to get noticed as an actress. Going against the tide. An outsider in Hollywood, acting was a way of belonging, she

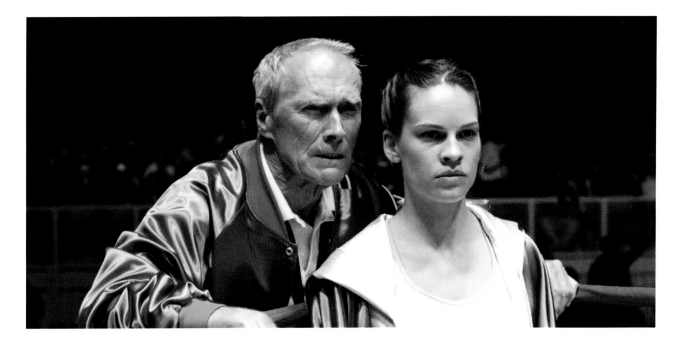

said. But she hadn't found the roles to capitalize on her Oscar win for the prescient transgender drama *Boys Don't Cry*. Eastwood could hear Maggie in her voice. As the conversation drew to an end, he got straight to the point. 'Well, you better learn how to box.'[23]

Swank had been a gymnast, and not only had the athleticism but the will required to train for four months with Dutch boxing champion Maureen Shea. If Eastwood had any qualms at all about casting her, it was her slight frame, but she put on eighteen pounds of muscle for the part (requiring her to eat every hour and a half). This was a perfect script, a perfect role. Not one word would be changed when they came to shoot. She wanted to live up to Maggie.

Life and art were exchanging notes. 'So I had that connection with her,' she said, 'and for me, working with Clint is a dream come true and for Maggie that relationship that she has with Frankie Dunn is so similar to my relationship with Clint.'[24] Swank didn't want the experience to end. To have to let go of Maggie.

She threatened to forget her lines just so to slow down Eastwood's spring-heeled production. After the broken men of *Mystic River*, Maggie is a welcome return of those strong female characters in Eastwood's films: a model of self-determination, his beloved grit, but stalked by tragedy. She is also the catalyst for a deeper reckoning.

We need to talk about the twist. How defenceless we are against the film's sucker punch. For two-thirds of its running time, *Million Dollar Baby* follows the well-worn structure – lyrically, authentically, powerfully – of the sports movie. The underdog making good under the grizzled old trainer. Then taking an illicit hit after the bell, Maggie topples onto the edge of a tipped-over stool and breaks her neck. And suddenly the film is charting darker waters. The rejuvenating father-daughter bond is brought to a bleak fruition as a bedbound Maggie asks Frankie to switch off her life-support. A devastating turn of events that had been kept carefully hidden during the rounds of publicity. It was as radical a turn as *The Sixth Sense*. Almost a switch in genre. The film was now

Above: Eastwood's Frankie Dunn soon realizes that Hilary Swank's Maggie has a shot at the title, but the director saw *Million Dollar Baby* as a complex relationship story between two broken people as much as a sports movie.

Above: A fistful of dollars - Eastwood directs Swank and Lucia Rijker, as opponent Billie 'The Blue Bear', through their moves. Despite the studio's lack of faith, *Million Dollar Baby* would be another surprise smash for the director, making over £200 million worldwide.

Left: Swank was devoted to Maggie to the point of obsession - she had come from a similarly humble background, and saw a reflection of the boxer's relationship with Frankie in her close bond with Eastwood.

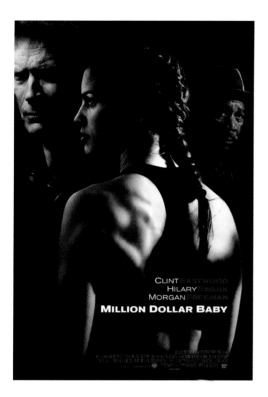

confronted by the morality of euthanasia, for which there was no easy answer. 'Nobody knows what they would do in that situation,'[25] said Eastwood. Is it another sin to add to Frankie's load?

We realize the most fundamental truth about *Million Dollar Baby* – that this was never a boxing movie, but a movie about a boxer. Or more to the point, her coach. This is what stirred the Academy: Eastwood had delivered a level-eyed dissertation on life and death, and another study in the wages of masculinity. There were inevitably critics who grumbled about archetypes and feel-good platitudes (at least, for the majority of the running time), but this was the fulfilment of a gravity and command of the medium laid down by *Bird*, *Unforgiven*, *A Perfect World*, *The Bridges of Madison County*, and *Mystic River*. After he makes his fatal decision, Frankie never returns to the gym. As with so many of Eastwood's films, he disappears at the end – we learn that the entire film is in

effect the contents of a letter written by Scrap to Frankie's unseen daughter. Telling her of the true nature of the father she has abandoned.

There is a finality to *Million Dollar Baby*, a summing-up equal to *Unforgiven*. What a capstone to see him into retirement. But no such thought ever occurred to Eastwood – he was off to the Second World War to try his hand at a war epic. Make that two epics made back to back.

Above left and right: Victory parade - Morgan Freeman, Eastwood, and Hilary Swank bask in the glory of winning the Directors Guild of America award for *Million Dollar Baby*, as their dark horse becomes a front runner for the Oscars.

Completing Clint

Rounding out a fifty-year career as filmmaker

Malpaso Productions: we should always bear in mind that from Western *Hang 'Em High* (1968) onwards, Clint Eastwood's personal production house was behind his star vehicles too. Which meant that while he didn't receive any greater credit, he was nonetheless always involved in developing the screenplay and finding the right director.

Amazing Stories: 'Vanessa in the Garden' (1985): something of a curio, and an early collaboration with Steven Spielberg, this is Eastwood's only episode of television as director. The fantasy short has artist Harvey Keitel discovering he can resurrect his dead wife (that regular Eastwood motif, and played by Sondra Locke) as long as he continues to paint her image.

Ratboy (1986): this oddball fantasy about a widow (Locke) who befriends a wildling boy was made at Malpaso as a favour to Locke, who was desperate to direct. Through Eastwood she secured an $8 million budget, but the result was an embarrassment for all concerned.

Thelonious Monk: Straight, No Chaser (1988): Eastwood serves as executive producer on Charlotte Zwerin's documentary about the great jazz pianist, using hours of unseen footage, and he put up the money to get the film completed. Released in the same year as *Bird*, it helped establish his credentials as a major jazz preservationist.

The Stars Fell on Henrietta (1995): this earnest period drama about the early days of the oil boom, starring Robert Duvall and Frances Fisher, is a Malpaso production where Eastwood serves only as producer, with James Keach calling the shots.

The Blues – 'Piano Blues' (2003): Eastwood's contribution to the Martin Scorsese-produced, seven-part series on the history of blues music (each film with its own director) is dedicated to his lifelong passion for blues on the piano. What he considers a true American art form.

Budd Boetticher: A Man Can Do That (2005): the rousing story of maverick Western director Budd Boetticher, to whom Eastwood pays tribute while sat beside Quentin Tarantino. Both have a ball. Eastwood also serves as executive producer, with Bruce Ricker directing.

Rails & Ties (2007): Eastwood remains uncredited on this well-acted Malpaso melodrama about a railroad engineer (Kevin Bacon) confronted by death, which may be because it is directed by his daughter Alison.

Johnny Mercer: The Dream's On Me (2009): a documentary on the life of Johnny Mercer, famed American lyricist, and favourite son of Savannah, Georgia (where Eastwood made *Midnight in the Garden of Good and Evil*). Threaded

Above: Eastwood and daughter Alison take a bow at the premiere of *Rails & Ties* in 2007.

through the film, directed by regular Ricker, we catch Eastwood arranging performances of the songs in a studio, and sitting beside the likes of John Williams to discuss Mercer's influence.

Dave Brubeck: In His Own Sweet Way (2010): another fine jazz documentary, this time covering the life of the eponymous pianist Brubeck, as directed by Ricker and executive produced by Eastwood.

Indian Horse (2017): a passion project of his regular camera operator Stephen S. Campanelli, Eastwood served as executive producer on this small, little-seen drama about a Native Canadian who becomes an ice hockey star.

A Star Is Born (2018): while he eventually took his name off the film, Eastwood nurtured the hit remake through its early stages, planning to direct Beyoncé in the lead role of a superstar discovery. When her pregnancy delayed production, Bradley Cooper took over as director and co-star, with Lady Gaga in the lead.

HOLLYWOOD NOBILITY

Flags of Our Fathers (2006), Letters from Iwo Jima (2006), Changeling (2008), Gran Torino (2008), Invictus (2009), Hereafter (2010)

In the afterglow of *Million Dollar Baby*, Clint Eastwood was Hollywood nobility, living proof there was still integrity to be found in the hyperactive studio system. Though he was no longer bound by commercial pressures, he was still capable of summoning up big hits alongside fine reviews. A commercial reliability not far off that of Steven Spielberg.

They make for a good comparison, Hollywood's untouchables. They are friends, of course, and had successfully partnered on *The Bridges of Madison County*. Spielberg had ploughed a more consciously crowd-pleasing furrow as filmmaker, though post-*Schindler's List* was drawn toward more mature, you might say Eastwoodian material. Eastwood was always a grown-up filmmaker, though far less strategic. As leading man, however, he had generated a popularity to match Spielberg's status as America's great showman. Both were bona fide icons.

Both too had been recognized by the Academy late in their careers, with two Best Director Oscars apiece. But it was at the post-ceremony Governor's Ball in 2004, the year *Mystic River* was bestowed with acting honours for Sean Penn and Tim Robbins, that they got talking. Spielberg had picked up the rights to *Flags of Our Fathers*, the best seller by James Bradley with Ron Powers, which told the story of the Second World War's most iconic photograph. Taken on 23 February 1945, Associated Press cameraman Joe Rosenthal's shot depicted soldiers straining to raise the American flag atop Mount Suribachi on the Japanese-held island of Iwo Jima, a strategic lynchpin in the Pacific. Silhouetted against the skyline, the six Marines embodied tenets of heroism, endurance, and toil. At least, that was as far as the U.S. government was concerned, who transformed a chance image into a patriotic symbol as the war dragged on in the East. Effectively, it was a PR spin.

It was a book Eastwood had read and coveted. He had tried to option it in 2000. Something he mentioned to Spielberg. Well, replied Spielberg, why don't you come over and direct it then? He would serve as producer. Most Hollywood deals take weeks if not months of back and forth, as lawyers and executives quibble over details, leaving eager artists hanging by a thread. Bar the paperwork, and Warner's willing commitment of a $70 million budget, the deal for *Flags of Our Fathers* was concluded in seconds.

Maybe Spielberg was concerned about repeating himself. What did he have left to say about war after *Saving Private Ryan*? Maybe he simply saw an opportunity. Who better to direct the material? A war film, yes, but also another study in the mechanisms of celebrity.

Opposite: Eastwood on the set of Nelson Mandela drama *Invictus* in 2009, aged seventy-nine, still following his instincts wherever they may take him.

With Eastwood already committed to *Million Dollar Baby*, there was ample time for screenwriter Paul Haggis to figure out a path through a complex book. What appealed to Eastwood was another opportunity to probe beneath the skin of a genre. The book examined the truth behind the picture. Co-author Bradley's father was John 'Doc' Bradley, long thought to be one of the very men immortalized in the picture (this has been latterly contested). Something he only found out after his father's death. Delving into the aftermath of the photograph, he discovered heroism, but also manipulation, spin, trauma, and a reality far removed from that presented by a snapshot in time.

For one thing, it was a second shot of flag-raising, after it is thought the Secretary of the Navy demanded the original flag. If not exactly staged, these were hardly men in the heat of battle. None of those involved ever considered it heroic. 'They just didn't think too much of it,'[1]

said Eastwood. Three of the six men were killed within a week. This was day five of a thirty-six-day struggle to secure Iwo Jima. Doc (Ryan Phillippe) was a Navy Corpsman – not a Marine at all – separated from his brothers in arms and brought home as a celebrity with his two fellow-survivors to tour America, be romanced by politicians, and raise war bonds. The bond drive pushed for investment from the people for the war effort as the country lent over the brink of bankruptcy. Alongside the stoic Doc were the more eager René Gagnon (Jesse Bradford), and Ira Hayes (Adam Beach), a Native American and the most conflicted of the three disorientated survivors, who sank into alcohol-fuelled destitution. Their story is structured as a tapestry of different timelines and locations, Iwo Jima and the home front, and present-day America, where Doc's son James (Tom McCarthy) interviews survivors, flashing back and forth like *Bird*, memories flowering into scenes. Cause and tragic effect.

Above left and right: Steven Spielberg had been planning to make *Flags of Our Fathers*, but hearing of Eastwood's interest he eagerly took the chance at another collaboration, after the success of *The Bridges of Madison County*.

2005 **Budd Boetticher: A Man Can Do That** (TV Movie)
Executive Producer

Below: Adam Beach, Ryan Phillippe, and Jesse Bradford play the three troops unwittingly shipped home as heroes to drum up support for the war. Their lives became a function of media spin.

'*Flags of Our Fathers* is about the Liberty-Valance-ism of warfare, the industrial production of myths and memories to sell war to the civilian population on the home front,'[2] noted Peter Bradshaw in the *Guardian*. This was not simply a war film, it was another demythification of a vainglorious genre, and another exploration of masculinity in extremis. Cutting to the core, Eastwood saw it as the story of 'just a bunch of kids sent off to fight for their country.'[3] Nineteen-year-olds who within two weeks looked forty-five.

Here, at age 76, said Manohla Dargis in *The New York Times*, 'is this great, gray battleship of a man and a movie icon saying something new and urgent about the uses of war and of the men who fight.'[4]

In simpler terms, those that made sense to Eastwood, he was testing himself against the scope and platitudes of a new genre. He had, of course, made war films as an actor: the entertaining, knowingly absurd adventure-style Second World War movies *Where Eagles Dare* and *Kelly's Heroes* (whose Vietnam corollary was lost in translation).

2005 **Budd Boetticher: An American Original** (Video)
Executive Producer

Heartbreak Ridge is more the tale of a man conditioned by the military. For the record, both *The Beguiled* (as actor) and *The Outlaw Josey Wales* (as actor-director), ostensibly Westerns, cohabit the ravages of the American Civil War. And curiously, one of those who auditioned but failed to get a part in the new film was Bradley Cooper, who would in a few years star in Eastwood's modern account of war's psychic toll, *American Sniper.*

A fifty-eight-day shoot was epic by Eastwood's standards, but this was a film of many moving parts. He had never orchestrated action sequences of this magnitude. The third act of *Heartbreak Ridge* counts as no more than a skirmish. In production terms, his great Westerns were closer, but the sheer numbers involved were dizzying: seventy thousand Marines poured onto that beach from over eight hundred ships. Something the director took in his unshakeable stride.

Iwo Jima was a tiny island, 650 miles south of Tokyo, just eight square miles of rock and scrub, limned by black, volcanic beaches. They might as well have been invading the Moon. But it was the perfect launchpad for a final assault on the Japanese capital. The enemy battalions, burrowed into caves in the cliff sides, were ordered to hold the island at all costs. It remains the toughest battle in Marine Corps history, a grinding process of gaining ground.

Inevitable comparisons were made with Spielberg's D-Day sequence in *Saving Private Ryan* (he was, after all, producer), which had set a new,

Opposite: In the famous beach landing on the island of Iwo Jima, Eastwood was determined to capture the chaos of battle, and its unspeakable cost, as the focus remains on men simply trying to survive.

Below: Prevented from shooting for sustained periods on Iwo Jima itself, Eastwood found a replacement in the black, volcanic sands of Iceland, where he mounted the largest-scale scenes of his career.

2006 **Flags of Our Fathers**
Producer/Director

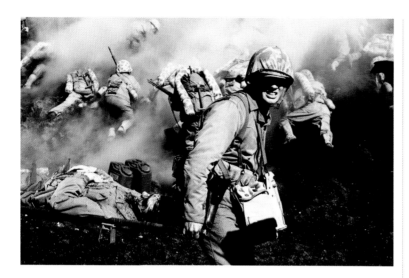

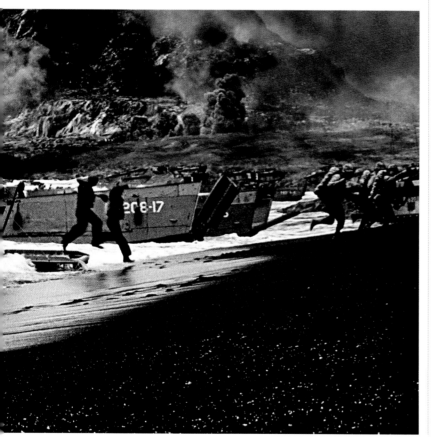

visceral idiom for war movies. And this was a post-*Unforgiven* Eastwood. All war films must be anti-war by default, he reasoned, as war comes with an 'unspeakable cost'[5] – even if that war is essential. Likewise *Flags of Our Fathers* opens with an overwhelming beach landing. Another battle scene to temper the old glorification of John Wayne sashaying up the beach in *Sands of Iwo Jima*.

With the real island off limits for anything but rudimentary establishing shots (it is the grave of 10,000 Japanese soldiers), a match was found in the black sands of Sandvík in Iceland. Even among Eastwood's cornucopia of monochromes, this is a world parched of colour. Only the orange-red bloom of an explosion, or the lick of cannon fire, or the great yellow breath of the flame throwers cut through the ashen imagery. It's all so messy. Men are chopped down by friendly bullets, or perish by pure accident, as the war machine heaves its way forwards.

To contain such anarchy required a new guile. Digital cameras were hidden in ammo cases, with the oblivious extras bounding past. Eastwood keeps the focus on the men with devastating intimacy, their bodies felled like straw dolls, order straining against chaos, a marvel of editing, physical filmmaking, and special effects that never draws attention to itself. Scenes infused with a trademark melancholy. Over the opening credits we hear a male voice singing, unaccompanied, a soft lament of death foretold.

During the intense, but swift-moving production, something peculiar began to occur. Another scene would be done, a different angle on events. Something unscripted. 'Oh, that's for the *other* picture,'[6] Eastwood would say with an enigmatic smile. His devoted team became increasingly aware that Eastwood was planning a second, companion film, which told the story of the same battle, the fight for Iwo Jima, from the perspective of the enemy. Something never taught in history classes either in American or Japanese schools.

Researching *Flags of Our Fathers* had led him to various biographies of General Kuribayashi,

who had commanded the Japanese army against insurmountable odds. 'I wondered who the tactician was,'[7] he explained. Kuribayashi and his men knew they were required to die to gain Tokyo time. A mindset utterly alien to the American troops. The biographies led him to Kuribayashi's letters. A thin volume of missives sent to his wife and children, offering real insight into this man, a husband and father wishing to be home with his family. Eastwood wanted to 'see war through different eyes.'[8] It was not about taking a side, he would iterate in prickly interviews, but mothers lost sons, wives lost husbands, and the pathos was just the same. These would be two films about sacrifice. About those who fought the war, not why. And visually speaking, two films designed to 'relate harmonically,'[9] according to cinematographer Tom Stern.

So Eastwood returned to Spielberg with an unexpected request. Having spent only $55 million of the $70 million budget on *Flags of Our Fathers* (care of his natural economy), he wished to use the remainder on a second, subtitled film with the working title of *Red Sun, Black Sand*. Again, the deal was concluded in seconds. And while the computer effects were being completed on his more elaborate opening salvo (for the great grey battleships, the fighters strafing cliffs like hornets, the wide shots of men swarming across the rocks), he and his team shot another film.

Above: Eastwood in command during the Iceland location shoot of *Flags of Our Fathers* – dressed for the occasion, the director upholds the old adage that a movie production is like a military campaign.

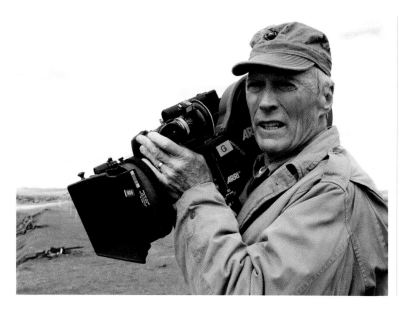

Left: *Flags of Our Fathers* is arguably the most complex shoot Eastwood has ever mounted: global locations, a cast of thousands, special effects, and a narrative that shifts in time and focus. Yet he still came in under budget, and was inspired to make a second, companion film…

Below: …*Letters from Iwo Jima* (2006) took the radical step of portraying the same conflict, indeed the same battle, from the perspective of the enemy. Ultimately, the two films were designed to reveal two contrasting military cultures, yet comparable human tragedies.

2006 **Letters from Iwo Jima**
Producer/Director

Eventually entitled *Letters from Iwo Jima*, it was written, at Haggis's recommendation, by Iris Yamashita, an American screenwriter of Japanese parentage. She was untried, but Haggis had liked her samples, and Eastwood just liked her. The more direct and in effect more emotionally assured plot is structured around Kuribayashi's unsent letters home, discovered buried in the excavated caves. Each film is built on the scaffolding of flashbacks from the present, historicizing events.

They shot on Leo Carillo State Beach in Malibu (trucking in volcanic ash), and in Odessa Canyon in Yermo, California, as well as using studio

"I wondered who the tactician was ... He [General Kuribayashi] believed that being a dead solider was not being effective at all, so he was a very practical guy."

Clint Eastwood

2007 **Rails & Ties**
Executive Producer (uncredited)

Opposite: One great difference between Eastwood's sister war films is that *Letters from Iwo Jima* was in part a portrait of the leadership of Ken Watanabe's General Kuribayashi (right) in what was knowingly a doomed campaign.

Below: A Samurai code – Shidô Nakamura as Lieutenant Ito defending the Japanese army's warren of caves on Iwo Jima to the death.

recreations of the caves in which the Japanese were embedded. Production designer James J. Murakami went to Iwo Jima and sketched the cave system first-hand, this warren carved out of the rock like something medieval, clammy with dysentery and starvation. The monochrome of *Flags of Our Fathers* gains a sepia wash like the old pictures of soldiers, frozen in formality, that gazed out at them from their research. One essential difference between the two films is rank. *Letters from Iwo Jima* explores the battle through the contained despair of a general, played with great expressiveness by Ken Watanabe, who forestalled the mighty American

army for over a month, yet never believed in the rituals of *seppuku* and *kamikaze*. 'He believed that being a dead solider was not being effective at all,' said Eastwood, 'so he was a very practical guy.'[10] Yamashita added fictional subplots, fixing on the lives of the demoralized Japanese infantry, who went unglorified back home, such as Saigo (Kazunari Ninomiya), a baker in civilian life, vainly struggling to survive.

Of the two, *Flags of Our Fathers* proved more divisive than expected with the critics. There was a suspicion that Eastwood had attempted to encompass too much. It has its advocates, but it

Left: Eastwood and star Ken Watanabe confer with Yuki Ishimaru, the Japanese-American writer who made her screenwriting debut with *Letters from Iwo Jima.* While the film would be shot in Japanese, the script was originally written in English and then translated.

was *Letters from Iwo Jima* that received the Best Picture nomination as the more nuanced of the two back-to-back films, released within months of one another. Here was the understated grace in tragedy of *Million Dollar Baby.* It is a study of nobility in the face of oblivion. There are those who argue that quietly it is Eastwood's finest hour. A.O. Scott of *The New York Times* called it 'one of the best war movies ever.'[11] Here was a tribute to the fatalism of his hero Kurosawa, of war's capacity to dehumanize and of humanity's endurance in the face of annihilation. What Eastwood viewed as the 'tough sell'[12] of *Letters from Iwo Jima* did better, certainly globally (it was a huge hit in Japan), making $68 million worldwide, with the more expensive *Flags of Our Fathers* a relative disappointment at $65 million.

Nonetheless, viewed together they serve as an astonishing eulogy, fuelled by the deep compassion of a singular artist. With every film it felt as if a lifetime of experience was being brought to bear.

Left: *Letters from Iwo Jima* would end up the more critically acclaimed of the Second World War diptych, landing Eastwood his fourth Best Picture nomination at the Oscars.

Above: John Malkovich, Angelina Jolie, and Geoff Pierson face down the injustice of the Los Angeles legal system in Eastwood's divisive period thriller *Changeling* (2008).

Changeling is the closest Eastwood has come to tackling a film noir head on. It is period Los Angeles, 1928 to be exact, placing it into a neo-noir bracket with *Chinatown* and *L.A. Confidential.* Eastwood had lived in Pacific Palisades in the early thirties while his father pumped gas on Sunset, and was determined to match memories of a patchwork of isolated districts connected by streetcars. Which made it expensive at $55 million, with historic buildings found in San Dimas and San Bernadino. It is also a dark tale of kidnapped children and a distraught mother. And it leans heavily into the theme of institutional corruption. In the background lurks something darker still, a serial killer preying on children.

In truth, *Changeling* is a film of many guises: noir, tragedy, courtroom drama; a quasi-horror, suffused with dread; a rich, emotional character piece in that Eastwood way; and a true story. The real case of single mother Christine Collins, whose son is kidnapped: in her torment,

the LAPD almost manage to intimidate her into believing a complete stranger they pick up is her missing child. They even get her committed to a psychiatric ward as delusional.

Angelina Jolie was already lined up when producer Brian Grazer called Eastwood. He had read the screenplay having no idea it was true. When he found out, he called the writer J. Michael Straczynski to gauge how much he had fictionalized events. Not at all, the writer replied. The newspaper archive revealed that statements given by the authorities in the script were virtually word for word. It was staggering. The fake boy turned out to be a Midwest runaway, who dreamed of being an actor like his hero Tom Mix, famed for his early Westerns! As he had with *Mystic River,* Eastwood connected with the material as a parent (of eight). He saw how the film was driven not by sensationalism, but by a 'mother's love.'[13]

His first true female lead (if we view Jessica Walter, Meryl Streep, and Hilary Swank as co-

2008 **Changeling**
Producer/Director

stars), there had never been any debate about Jolie. 'She reminds me a lot of the actresses from the Golden Age of movies in the forties – Katharine Hepburn, Ingrid Bergman, Bette Davis, Susan Hayward, all of them,'[14] he said. But it was an emotionally exacting journey for Jolie. As a mother, she had found the script distressing, but it wouldn't leave her alone. She was honoured to be have been drawn into Eastwood's orbit. But his pace and directness 'made her terribly nervous.'[15] She needed to remain constantly alert for when he gestured, almost invisibly, to his cameraman and filming began. That edginess translated into the character, who is brought startlingly to life. But after predictions of Oscar attention, *Changeling* was met by a surprisingly indifferent reception on its U.S. release (was it too sombre, too busy?) and never caught fire at the box office ($113 million in total), or with the Academy. Remarkably, Eastwood had a second film ready for release in 2008.

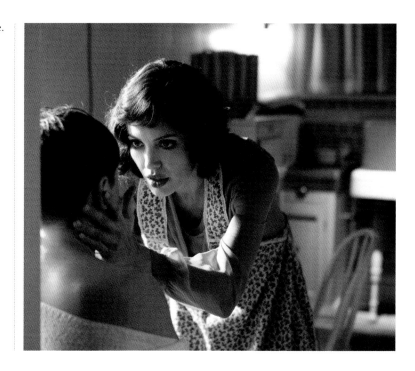

Above: One of the attractions of *Changeling* for Eastwood was the chance to direct a film centred on a powerful female performance. And in Angelina Jolie he saw a star who echoed the great actresses of the forties.

Left: Eastwood on the set of *Changeling* with cinematographer Tom Stern (centre) and actor Michael Kelly as a local detective. One of the themes of the film is the stark institutional corruption of the LAPD of that era.

2007–2008 **American Masters** (TV Series)
Executive Producer/Producer (4 episodes)

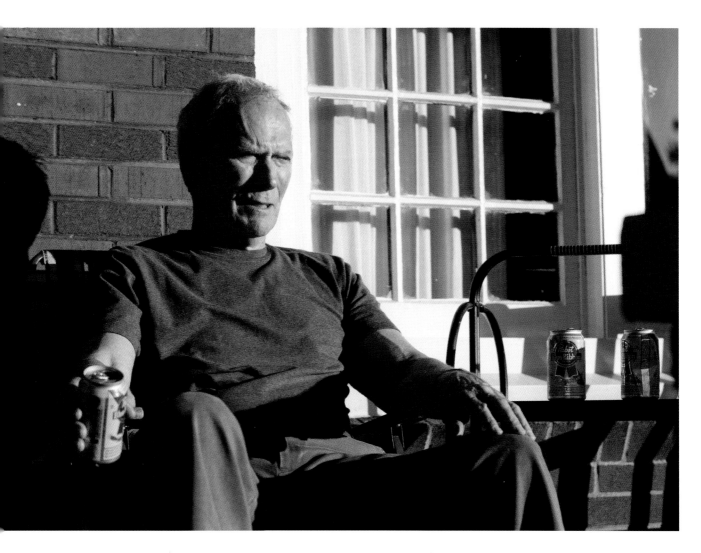

Above: Eastwood's bigoted Detroit widower Walt Kowalski in *Gran Torino* (2008) marked an unexpected return to leading man duty and a knowing echo of icons past. The question of what Dirty Harry Callahan might be like in retirement.

He had been adamant that he would never return to Detective Harry Callahan, but vituperative sourpuss Walt Kowalski in *Gran Torino* offers a glimpse of Harry in retirement. Rumours it *was* a belated *Dirty Harry* sequel had been swiftly quashed by Eastwood. The famous cop was at least back as a 'ghostly presence,'[16] sensed Manohla Dargis in *The New York Times*. Marketed on Eastwood's legendary scowl, this small film became the highest-grossing film of his career to date, with $270 million.

Bigoted Detroit widower Kowalski, a Korean War vet and retired auto worker, was a part good enough to draw Eastwood out of what he had assumed was acting retirement. Kowalski would have an invigorating effect, commencing an unofficial trilogy of late performances and old-timer odysseys with *The Mule* and *Cry Macho*. Age inevitably was on Eastwood's mind, he was seventy-eight. It was a self-deprecating joke, and a potent theme. There is something so resonantly Eastwood about a man who wants to be left alone

2008 **Gran Torino**
Actor/Director/Producer

to drink Pabst Blue Ribbon on his porch, or work on his prized Ford Gran Torino, but is dragged – begrudgingly, redemptively, iconically – into protecting the immigrant Hmong family next door from the predations of local gangs. 'Get off my lawn,'[17] he rasps at the hoods, another one-liner carved into stone.

First-time writer Nick Schenk had known guys like Kowalski from his days working construction. He wrote his screenplay in the local bar, trying out lines on the bartender. Every agent told him it would never sell. An ageing, racist antihero? Forget it. Through a friend, it landed on the desk of producer Bill Gerber, who wisely thought of Eastwood. Then good fortune: Eastwood's proposed biopic of Nelson Mandela, *The Human Factor* (later *Invictus*), had been delayed until 2009. Rather than go on vacation, he made another film.

Even by his standards, it flew: *Gran Torino* was green-lit by Warner in February 2008 (for $33 million), shot for thirty-three days on location around Detroit in June, and ready for cinemas by 12 December.

What appealed to Eastwood was that the script refused to compromise. Kowalski was a bigot, prone to vile outbursts. 'If you do something halfway then it becomes a Hollywood bailout,' said Eastwood. 'And if you're gonna play this kind of guy, you can't go soft. You gotta go all the way.'[18]

There were critics who saw an almighty step backwards, but Eastwood still knew the power of stardom, and the catharsis of Clint turning vigilante again. *Gran Torino* also possessed a big, beating heart. There is more to Kowalski than the ghost of *Dirty Harry*, there are trace elements of William Munny from *Unforgiven* and Frankie Dunn from *Million Dollar Baby* in the buzzsaw delivery, the lapsed Catholicism, and the sins of the past that weigh a man down. Kowalski is haunted and soured by what he witnessed in Korea, but he has a deeply embedded moral compass. Kowalski may be obsolete, the actor-director said, 'but he had the capacity to learn, to change.'[19] It is the ethos he embraces too. 'You're supposed to expand.'[20]

Above: *Gran Torino* was a stroke of good fortune – Eastwood had a gap in his schedule when the script landed on his desk, and he didn't think twice. Shot in just over a month, it would become one of his biggest hits.

Left: Street justice – Eastwood's Walt Kowalski will rediscover his moral compass when the Korean family next door fall prey to local gangs. There was a revival of Western principles in the idea of a man taking the law into his own hands.

Below: Thao (Bee Vang) and Walt (Eastwood) form a bond over the upkeep of the old man's prized 1970 Ford Gran Torino. This was the third time Eastwood had played a Korean war vet, after *Heartbreak Ridge* (1986) and *Absolute Power* (1997), and he had been enlisted during the time of war but never saw active duty.

2009 **Johnny Mercer: The Dream's on Me** (TV Movie)
Executive Producer

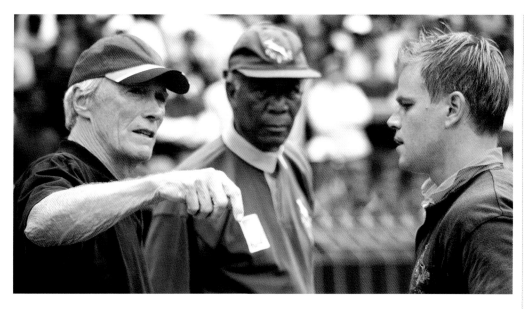

Left: Friends reunited – Nelson Mandela drama *Invictus* (2009) had been a passion project for Morgan Freeman, who brought it to Eastwood. The film centred on the great man's budding relationship with South African rugby captain François Pienaar (Matt Damon).

Morgan Freeman's passion project *Invictus* had tightened its focus from a life story of Nelson Mandela to a particular moment in history. Like Spielberg's *Lincoln*, the great man was to be found in a specific decision. In this case, also a specific relationship. Based on John Carlin's book, *Playing the Enemy: Nelson Mandela and the Game that made a Nation*, Freeman's Mandela (expertly mimicking his friend) attempts to unite a riven South Africa – or at least bring about a truce – around the forthcoming Rugby World Cup, and the possibility of their beloved Springboks winning. 'Don't address their brains, address their hearts,'[21] he insists, one of a lifelong store of credos. Crucial to this endeavour was a friendship with (and manipulation of) the team's captain François Pienaar (a beefed-up Matt Damon).

If anything, the pace of Eastwood's filmmaking had quickened. His thirtieth film was underway in South Africa two months after he had finished promoting *Gran Torino*. By autumn of 2009, he would be shooting his next in London and Paris.

Invictus is nobly intentioned, and nobly delivered, but falls flat as a triumphalist sports movie – rugby does not translate well to a cinema screen – and foreshortens Mandela's political guile. For the first time in a while, Eastwood is an outsider to the story. He had been persuaded to take it on by his friend. 'My first two choices were Clint Eastwood and Clint Eastwood,'[22] joked Freeman. He wanted that ease with actors. But as a director, Eastwood was better suited to American lives. 'The trouble with *Invictus* is that it is more monument than motion picture: handsome, reverent and heavy,'[23] concluded *The Guardian*. It did respectably at the box office ($122 million).

At first sight, *Hereafter* is an oddity. A supernatural story about three people touched by the afterlife? From Hollywood's great realist? But it fits. So many (if not all) of Eastwood's films and characters are haunted in some fashion. It is virtually an obsession. Dead wives hang over the lonely figures of Josey Wales, William Munny in *Unforgiven*, Frankie Dunn in *Million Dollar Baby*, and Walt Kowalski in *Gran Torino*. The past constantly stalks the present. The vengeful horsemen of *High Plains Drifter* and *Pale Rider* hover somewhere between life and myth, angels of death.

2009 **Invictus**
Director/Producer

Above: In the London-based chapter of Eastwood's portmanteau oddity *Hereafter* (2010), tragic twins Marcus and Jason are played by alternating mix of brothers Frankie and George McLaren.

Right: Eastwood saw *Hereafter* as a spiritual film rather than something supernatural – a film about the human need to believe in an afterlife. But this sombre meditation on death confounded both critics and audiences.

Nonetheless, this was a jolt. The three stories, which gradually intertwine, dispel any doubts over the existence of a non-denominational afterlife. Cécile de France's television journalist survives drowning in a tsunami (in the film's spectacular opening), only to be troubled by visions of blurry figures in a diffuse white light. Matt Damon's reluctant psychic can genuinely receive messages from the dead. And a small boy really senses the presence of his twin, killed in a car accident (played by non-actors Frankie and George McLaren).

'It's not about the occult,' insisted Eastwood, 'it's about the spiritual.'[24] He was reminded of *Million Dollar Baby*, and the question of assisted suicide. And certainly it was a prestige project. Spielberg was involved again, as executive producer, and it was based on a script by eminent British screenwriter Peter Morgan (*The Queen*). Eastwood was drawn to the way real events crossed paths with the uncanny. Nothing is resolved for the viewer. When reporters inevitably pressed to know if he believed in an afterlife, he was slyly vague: '…I approach it by not knowing.'[25]

Keeping the mood sombre and frank – not for Eastwood the atmospherics of *The Sixth Sense* or the harum-scarum impulses of horror – is a mixed blessing. The locations, London, Paris, San Francisco, and Switzerland, are sheathed in a steel-blue gloom. The mood is grave bordering on dour. Critics were polarized ('enthralling'[26] said *The Chicago Sun-Times*; 'a cosmic catastrophe,'[27] groaned *The Scotsman*). In the year of *Inception*, it played as a low-key meditation, though $106 million worldwide is not bad for a lament. And there are sharp, poignant notes in *Hereafter*. Subtle, humane scenes that illuminate Eastwood's sincerity. More than a ghost story, it is a portrait of grief. An eighty-year-old man staring death in the eye, then moving on to his next film.

THE UNQUENCHABLE FLAME

J. Edgar (2011), Jersey Boys (2014), American Sniper (2014), Sully (2016), The 15:17 to Paris (2018), The Mule (2018), Richard Jewell (2019), Cry Macho (2021)

Why does one star endure and another fade? Why does one director stay so sure in Hollywood's eye while another is forgotten? What was it that allowed Clint Eastwood to transcend fashion and fortune and still be working at the top of his game when so many of his peers were retired, or had been called home? Few directors have managed their careers so thoroughly, so economically, and without fuss – and the punk got lucky. No escaping that. To have a *Josey Wales*, an *Unforgiven*, a *Mystic River,* or a *Million Dollar Baby* in the wings for whenever it looked as if his popularity was waning.

Individuality, that word again, has much to do with it. Eastwood doesn't readily conform to any category. Confidence in his own talents, too. 'You can question what you're doing to death,' he said, 'or you can do things the way you want and know.'[1] And endurance – to treat flop and hit just the same. That forward motion is essential, to keep riding on to the next town. To have one eye on the horizon.

His powers have only rarely wavered; times when his choices looked uncertain. Not all the films work. But hindsight is easy. Eastwood is a monument to cut-the-crap directorial stamina. Why sit in a room talking about a movie, when you can be out there making it? He is known to get his hair cut while sitting in his director's chair.

'Making movies is easy when you have put sixty years into it,'[2] said Matt Damon.

Eastwood's long relationship with Warner is another factor. As CEOs come and go like the seasons, he remains an unshakeable part of the studio culture. Whatever the new regime has to say for itself, they leave Eastwood to go about his business. In 2011, that counted for Lola too. Lola was a local squirrel who happily waltzed in through the open front door of his bungalow to raid the bowl of peanuts he left out for her, entirely against studio health and safety regulations. 'If you do something long enough,' he smiled, 'people let you do your thing.'[3]

And why argue? That unquenchable fire still burns bright. Indeed, in 2011, Eastwood's biggest hit was still ahead of him. His later career, that is his eighties into his nineties, is defined by a fleet of biopics. Each wildly different from the next, but each, in its way, a study in the complexities of heroism, America, and reality versus mythological spin. Eastwood terrain. Some were embodied by A-list stars, some markedly not. And there were two more laconic turns for the A-lister closer to home.

Opposite: The gaze never falters – Eastwood in *Cry Macho* (2021), a leading man at ninety, and, while a little more frail, still a mighty presence on the big screen.

J. Edgar offered the gravitas of a big, political biopic, with Leonardo DiCaprio as J. Edgar Hoover, notorious director of the FBI for over thirty-seven years: a secretive, brilliant, tormented man (the film would have us believe) who traded in secrets. Hoover kept files on the rich and powerful, bugging innocent lives, building up his blacklist beyond the sanctions of the law. But this cloak-and-dagger figure also founded the FBI, empowering his crime fighters – the G-Men of the comic books Eastwood read as a kid – with a national database of fingerprints and forensic labs. He was a canny detective.

Writer Dustin Lance Black (*Milk*) moves through time via the convention of an aged Hoover recounting his life to a sanctioned biographer, allowing the film to roam within Hoover's uncensored memories, just as Eastwood had with *Bird*. In this case, exploring a clandestine soul. Though critics contested how frank the film was willing to get. Under the cloak of protecting America from itself, Hoover became warped by power and paranoia, driven by a storm of Freudian issues: his semi-repressed homosexuality, his devotion to his cold mother (Judi Dench), all the manifold insecurities of his inner world that burst into the outer one.

According to *New Yorker* critic David Denby, 'No stranger man – not even Nixon – has ever been at the centre of an American epic.'[4] Producer Brian Grazer had imagined something along the lines of Oliver Stone's storm-laden tragedies. But

Above: Eastwood's latter career is defined by a series of biopics, including *J. Edgar* (2011), an era-spanning dissection of notorious FBI chief J. Edgar Hoover, played by Leonardo DiCaprio, seen here with the director and screenwriter Dustin Lance Black (right).

2011 **J. Edgar**
Producer/Director

Below: Central to Eastwood's thesis on *J. Edgar* was the complex relationship and love affair between DiCaprio's troubled character and his number two at the FBI Clyde Tolson (Armie Hammer).

when Warner balked at the price tag, he turned to Eastwood to find a more restrained path through the Hoover enigma.

'The script intrigued me,' recalled Eastwood, 'because I lived through the time where people were constantly speaking of Hoover and his exploits.'[5] Back then Hoover was ever-present, and nowhere to be found. On a budget of $35 million and a thirty-nine-day shooting schedule, the past is faithfully restored in that trademark flinty noir. *J. Edgar* falters not in its execution,

but in its choices. It was so 'anxious to cling onto taste,'[6] sighed David Thomson in *The New Republic*. An opportunity is lost to examine how dangerous Hoover was: he wielded a whole state apparatus where *Dirty Harry* only had a badge and a gun. Eastwood's film remains an inconclusive flicker-book of Hoover and his three key relationships: with his mother; his devoted, tight-lipped secretary Helen Gandy (Naomi Watts); and his closeted love affair with FBI number two Clyde Tolson (Armie Hammer).

2012 **Trouble with the Curve**
Actor/Producer

Eager to stretch the limits of his stardom, DiCaprio had vigorously pursued the role. 'Anybody who wants the part that bad… is fine by me,'[7] said Eastwood. The star gives it his all, but he is hampered by both the puffy-looking make-up, ageing him into his sixties, and the lack of daring. Learning that the film contained a scene of Hoover kissing a man, the Society of Former Special Agents of the FBI fired off a letter to Eastwood, informing him that the scene 'caused us to reassess our tacit approval of the film.'[8] But Eastwood's film hardly summons up any great controversy. The legend that Hoover was a cross-dresser is dealt with by having DiCaprio, in a moment of grief, pressing his dead mother's dress against himself. The long talky scenes in shadowy offices never capture the idea of evil writhing unchecked at the centre of American justice. Stone would surely have been a better choice. He would have found the brimstone. As it was, the pale film made a wan $85 million at the box office.

The first third of *Jersey Boys* has a Scorsese-like thrust to it. A voice-over returns us to the neon-smeared New Jersey in 1951, where Tommy DeVito (Vincent Piazza) meets Frankie Castelluccio, later Frankie Valli (John Lloyd Young). They dally in petty crime, drawn into the circle of local gangsters, but these two have a different destiny. Together with Bob Gaudio (Erich Bergen) and Nick Massi (Michael Lomenda), this golden-voiced quartet become a doo-wop sensation. Based on the jukebox stage extravaganza, Eastwood's first musical (behind the camera – let us not forget *Paint Your Wagon*) tells the story of The

Below: As close as we have come to Eastwood directing a musical, *Jersey Boys* (2014) tells the embellished story of the rise of crooning quartet The Four Seasons. The director is pictured conversing with stars Michael Lomenda (as Nick) and Vincent Piazza (as Tommy).

2014 Jersey Boys
Producer/Director

"Everybody remembers it
how they need to."

JERSEY BOYS

JUNE 20

Above left and right:
The band find their voice
– Nick (Lomenda), Bob
(Erich Bergen), Frankie
(John Lloyd Young), and
Tommy (Vincent Piazza).
Jersey Boys worked well
enough in song, but
slipped into cliché as a
biopic.

Four Seasons, with the assistance of evergreen showstoppers such as *December, 1963 (Oh, What a Night)*, *Sherry*, and *Big Girls Don't Cry* (though the songs are carefully prescribed as performances).

It had been three years since *J. Edgar* – an unheard-of hiatus for Eastwood. There were familiar rumblings about retirement. He was far from idle: starring in baseball drama *Trouble with the Curve*, and becoming increasingly frustrated when a proposed remake of *A Star is Born* became mired in production delays (he would later produce the Bradley Cooper version). Proof that he didn't quite have carte blanche with Warner. When the script for *Jersey Boys* arrived at Malpaso, he was itching to get back behind a camera, instantly drawn to the anyone-can spirit of Frankie Valli rising from his humble, Newark beginnings. As the *New York Times* commented, it was a story 'about the American myth of success.'[9]

Eastwood stripped his $58 million Los Angeles-based production back to dramatic basics. If this

has been a hit stage musical the world over for ten years, he figured, it must be doing something right. So he unearthed an earlier script by the show's original writers, husband and wife Harry Julian and Rita M. Fink. 'Only in Hollywood do they take a play that's run for nine years on Broadway, six years in London, and five years in San Francisco, then go out and hire another writer,'[10] he sighed. Ignoring a nervous studio's hopes of bigger names, he plucked his cast from the pool of actor-singers well seasoned (if you will) from various stage productions. Young had won a Tony for his Valli on Broadway.

When the film bursts into song, it soars. But between the numbers, Eastwood doesn't trust his own intentions, striving to escape the crisp, up-tempo stage artifice by leaning into busted marriages, drug-addicted kids, and the old entanglements with the mob. Like *J. Edgar*, it is a film suffering from an identity crisis, a musical in disguise.

'Okay, whenever you feel like it,'[11] Eastwood would calmly inform Bradley Cooper, and the scene would begin. The cameras would already be rolling. There were plenty of pyrotechnics on what was officially the director's thirty-fourth film, but no one shouted. His methods were unchanged, though he was now using digital cameras (a practical switch augmented on *Jersey Boys*). Eastwood's second film in a year had recreated the ruins of Fallujah in Iraq on a Santa Clarita ranch.

American Sniper tells the true story of Christopher Kyle, the Navy SEAL sniper who recorded the highest number of lethal kills in American history. Kyle did four tours of duty in Iraq, amassing 161 confirmed kills. The insurgents dubbed him 'The Devil Of Ramadi.' And bit by bit, tour by tour, this true-blue patriot fell apart. At its heart, it is a portrait of trauma.

It came to Eastwood by a familiar channel. First, Warner optioned Kyle's book, *American Sniper: The Autobiography of the Most Lethal Sniper in U.S. Military History*, with Bradley Cooper attached to star and produce. Cooper had loved screenwriter Jason Hall's 'concept of framing it as a Western.'[12] That was when Steven Spielberg became interested, pushing Hall to emphasize Kyle's duel with a rival insurgent marksman. His ambitions curtailed by the limits of Warner's $60 million budget, Spielberg backed out, and the studio called Eastwood, who was literally finishing the book as he picked up the phone. Cooper was thrilled when Eastwood agreed; the actor had cited *Unforgiven* three or four times in his initial pitch to Warner.

Eastwood meanwhile put in a call to his old friend. 'Steven, I'm always doing your leftovers! Why'd you bail out of this thing?'[13] They met up and talked over the project for a couple of hours, and by April 2014 Eastwood was shooting in Morocco, before moving back to the Blue Cloud Ranch in California.

It looked like a risky project, a spate of Iraq films such as *Green Zone* and *In the Valley of Elah* had died at the box office. Which may have been

Above: American Sniper (2014), Eastwood's controversial depiction of the mental fragmentation of sharpshooter Christopher Kyle, became a box office sensation and Best Picture Oscar nominee.

"What we tried to do is show what a soldier goes through ... It's a character study. The hope is that people will understand the war in a way they didn't before."

Clint Eastwood

Above: Bradley Cooper takes aim as Kyle, who did four tours of duty in Iraq. One of the great draws of *American Sniper* was that writer Jason Hall had framed Kyle's story as a quasi-Western. Indeed, Cooper has likened it to *Unforgiven* (1992).

what limited Warner's investment. But this was different: like the similarly themed Oscar winner *The Hurt Locker* this was personal, and as the title suggests a deeply American story. Furthermore, there was a bitter, tragic coda to events. Even after Hall had begun his screenplay, Kyle was murdered at a gun range by an unstable veteran he was helping rehabilitate. Overnight the film became an elegy, though out of respect for the family Eastwood chooses to circumvent the darkly ironic outcome to Kyle's life – we cut straight to the funeral.

Responses to the finished film varied wildly. More cynically-minded commentators saw a jingoistic fairy tale about a racist killer. Kyle's unappealing comments on Arabs swiftly surfaced. On its release, Anti-Arab threats spiked. Was it

pro-Iraq? The filmmakers were forced to spring to their film's defence: 'The movie isn't about whether we should have been in Iraq or not,' said Hall. 'It's about how war is human.'[14]

'What we tried to do is show what a soldier goes through,' insisted Eastwood. 'It's not a political movie. It's a character study. The hope is that people will understand the war in a way they didn't before.'[15]

It was remarkable how unambiguously the different poles viewed the film: propaganda or psychoanalysis. As J. Hoberman wisely concluded in a lengthy, considered piece in the *New York Review of Books*: 'While *American Sniper* has drawn a large and diverse audience there is no consensus as to what the movie means.'[16] Which may be the point.

Away from the initial furore, in Eastwood terms, *American Sniper* is a return to a great thematic backbone of his work – the wages of violence. Kyle is a vivid, complex character who believes he is a simple man. There is excellent support from Sienna Miller as his wife, Taya, the prism through which we see Kyle unravel. Eastwood is perfectly content to cut straight from the bosom of the family to the embrace of combat in a heartbeat. He moves through time and space with great eloquence, and amid the controversy and vast success, it is easy to forget how well the film is directed. Yes, it has the cadence of a Western, but an *Eastwood* Western, where conclusions are uncertain. 'It's an existential critique of violent machismo,' commented Dana Stevens in *Slate*, 'that doubles as a celebration of violence.'[17]

Even the studio was blindsided by its success. On its four-day Christmas weekend, *American Sniper* scored $104 million, the biggest opening of Eastwood's career. It finished with $547 million worldwide; $350 million of which came from the USA.

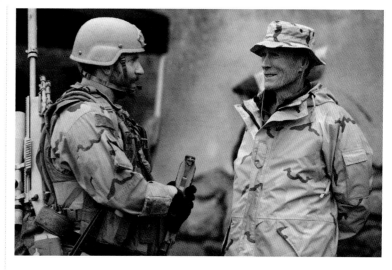

Top: Key to the film's emotional depth is that *American Sniper* is also a study of marriage, and we see Kyle unravelling through the eyes of his wife Taya (the excellent Sienna Miller).

Above: Eastwood and Cooper on set – the shell-shattered remains of Fallujah were artfully recreated on the grounds of the Blue Cloud Ranch in Santa Clarita, California.

Right: *Sully* (2016) was
another hit study in the
complexities of real-life
heroism, the story of
the captain who landed
his passenger jet on the
Hudson River, only to be
accused of error in the
later investigation.

Sully was another major hit ($240 million worldwide). And the study of another highly publicized American hero with his share of troubles. With another A-list star at its centre. A startlingly white-haired Tom Hanks took on the role of pilot Chesley 'Sully' Sullenberger, who famously landed US Airways Flight 1549 on the Hudson River after hitting a flock of birds and losing both engines. Not a single life was lost. However, subsequent investigations suspected that Sully may have been at error. It was another big, $60 million production, with a vivid crash sequence (a considerable step forward from the *Firefox* days). Sully is portrayed with a Howard Hawks-like firmness of a man tested and proved worthy (and this is Hanks!), whatever the cynical authorities had to say about it. Events Eastwood nimbly navigates with his predilection for a network of flashbacks ferrying us through the before, during, and after of the incident. Can we read Eastwood in the unflappable Sully, and the nit-picking safety board as studio interference? Think of it as a song to under-appreciated professionalism.

Below: Tom Hanks as
the eponymous hero
Sully with Aaron Eckhart
as co-pilot Jeff Skiles,
who defends the actions
of his beleaguered
captain as the drama
shifts back and forth
between disaster movie
and courtroom thriller.

2016 **Sully**
Producer/Director

Thriller *The 15:17 to Paris* is a well-meant companion piece to *American Sniper* hamstrung by a failed experiment. Eastwood attempted a little too much reality in telling the true story of three backpacking Americans, young men with military connections, who thwarted a terrorist attack on a French train. A topical and striking story. But after the usual rigmarole of auditions (not a process he enjoys), he elected to cast the actual guys to tell their own story: Anthony Sadler, Alek Skarlatos, and Spencer Stone. 'I had this great sense of pride,' he said. 'That was a great event they pulled off.'[18] The central action sequence is gripping enough, and mounted with familiar verisimilitude. And there is a frisson in knowing that these guys did this for real. But the laborious three-part backdrop, building up the characters, challenges their acting ability to breaking point. It produced among the worst reviews of Eastwood's career (certainly since *The Rookie*). *Film Comment* called

Left: *The 15:17 to Paris* (2018) took the idea of the biopic to an extreme, by casting the real-life men who foiled a terrorist attack on a French train to play themselves. Noble intentions with mixed results.

Left: Life and art – Eastwood advises two of his three leads, Spencer Stone and Anthony Sadler, but the performances would be mixed and the film might have fared better with real actors.

2017 **Indian Horse**
Executive Producer

Above: Eastwood's aged drug smuggler Earl Stone counts the ill-gotten rewards of his deal with a Mexican drug cartel in *The Mule* (2018), second in an unofficial trilogy of late performances after *Gran Torino* and before *Cry Macho*.

it 'aggressively incoherent.'[19] *The New Republic* really didn't mince their words: 'They're all handsome but just appalling actors.'[20] Life and art only cross over so far.

Proving the point, *The Mule* encouraged Eastwood out of acting retirement once more, now a sprightly 88-year-old. Naturally, it is a tale of age and misadventure, but never descends into self-parody. Remarkably, it is another true story. *Gran Torino's* Nick Schenk based the screenplay on a *New York Times* article about the genuine Detroit 90-year-old who became a drug mule for a Mexican cartel. 'All of a sudden I start thinking,' said Eastwood wryly. 'Well, it might be kind of fun to play a guy who was even older than me.'[21]

The character fits a profile. Eastwood's Earl Stone is another Korean war vet, but more of a lost cause than Walt Kowalski, like Frankie

Dunn he is estranged from his daughter (Alison Eastwood), and his horticulture business has gone under. Lured in by an enterprising cartel, he begins a risky late career shipping drugs across the American border. What could be less suspicious than an old man in a 1972 Ford pick-up truck?

Handsomely shot around Atlanta and New Mexico, another American heartland, for its first half *The Mule* has the laconic pleasures of the Eastwood school: wry, baffled confrontations with younger generations; Earl's rejuvenation through not only daring a life of crime, but finding somewhere to belong. There is a moving commentary on the disenfranchisement of old age. But once it shifts gears into a thriller, as the cartel turns on Earl and the Drug Enforcement Administration (led by Bradley Cooper) home in on this not-quite-perfect crime, the film sacrifices

Opposite: Eastwood enjoying life on the set of *The Mule* – there is a clear parallel to be drawn between Earl's irresistible urge to bring meaning to his life and the director's determination to keep working.

Right: Even in his late eighties, there was clearly still great appeal in seeing Eastwood on screen, and this modern day spin on Robin Hood would become a minor hit.

Below: The wages of sin – another Korean war vet, Earl's dalliance with crime would catch up with him, but *The Mule* worked better as a comic character piece than a thriller.

its lopsided Robin Hood charms (Earl is using his ill-gotten gains to fund his granddaughter's education) for conventions that never quite come to a boil. Reviews were muted. You can't put the old guy down, but was the familiar dance enough? *The Mule*, wrote Matt Brunson in *Film Frenzy*, was 'yet another portrait of a forgotten man keeping his identity and his wits in a world that continues to change around him.'[22] The routine – a line we can draw back to *In the Line of Fire* – clearly still spoke to people, with the film grossing $174 million worldwide.

Richard Jewell was another case of Eastwood giving life to an unloved project. It told the bizarre, yes, real-life story of the unassuming security guard (the excellent Paul Walter Hauser) at the 1996 summer Olympics in Atlanta, who discovered a bomb, alerted the authorities, saving lives, only to be accused of planting that bomb by the FBI. It was a matter of appearances. Jewell fitted a certain profile: living at home with his mother (Kathy Bates), an overzealous history in security, an

2018 **The Mule**
Actor/Director/Producer

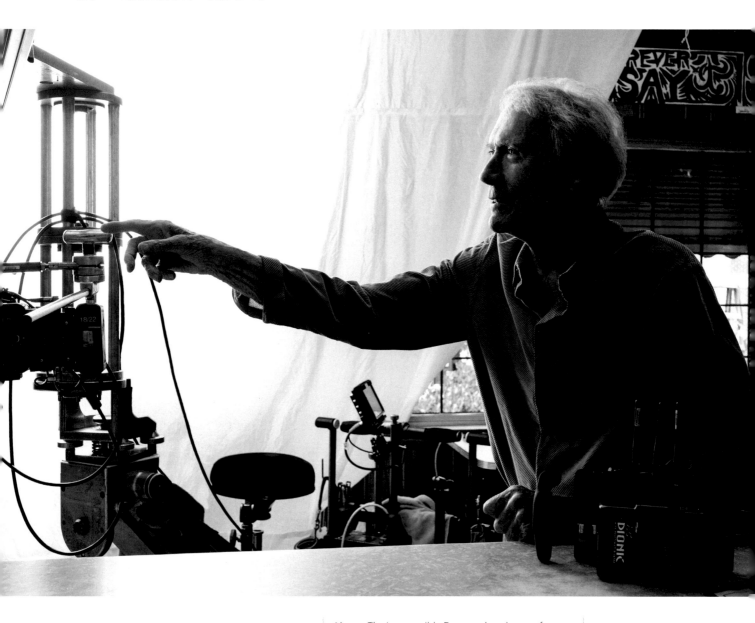

Above: The irrepressible Eastwood on the set of *Richard Jewell* (2019) – work and life are one and the same for the iconic director, who would rather be shooting than on any kind of vacation.

unhealthy interest in firearms. Eastwood classified it as a 'great American tragedy.'[23] Jewell was only exonerated by the efforts of local media. Though the film would come under fire for its distorted portrayal of Olivia Wilde's Kathy Scruggs as a reporter willing to sleep with an FBI source.

Jewell's story had been floating around Hollywood for years. Leonardo DiCaprio tried to produce a version with Jonah Hill starring. Directors Paul Greengrass and David O. Russell came and went. Then Eastwood simplified things, making it less of a thriller, or anti-establishment exposé (that old, persistent theme), and more of an open-to-interpretation character study – this lonely guy who didn't fit the bill of a hero. Like *Sully* it is a parable on the hounding of a good man, and Eastwood's documentary-like restraint serves the material well. 'Solid, dependable, very late period Eastwood,'[24] approved Ian Freer in *Empire*. But without stars, and with the relative obscurity of Jewell's story by 2019, the film fizzled on release.

Right: *Richard Jewell* (2019) was yet another portrait of an unconventional American hero, in this case the Atlanta Olympic Park security guard in 1996, who discovered a bomb and was later accused of planting it by the FBI.

Right: FBI agents Jon Hamm and Ian Gomez turn the screw on Richard, an outstanding performance from the then unknown Paul Walter Hauser, who didn't exactly fit the bill of a hero.

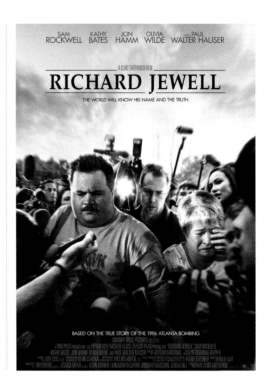

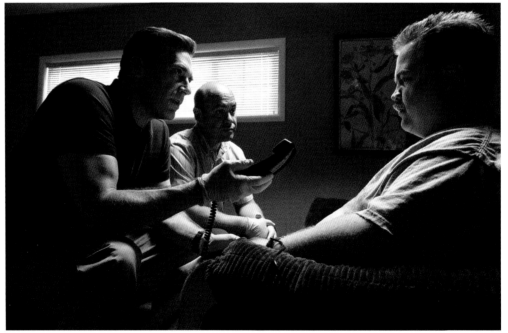

2019 **Richard Jewell**
Producer/Director

So finally to *Cry Macho*. If it is indeed to be Eastwood's last film then it's fitting that he was back before the cameras as well as behind. Fittingly too, perhaps, the script, by N. Richard Nash, had lingered since the seventies. It was pure fiction again. Eastwood had ironically turned it down in 1988, fearing he was too young. There was more of an ageing action-hero persona in the original draft: Schwarzenegger even tried it for size. With heavy rewrites from Schenk (Eastwood's go-to writer for octogenarian alter-egos), it follows washed-up Texan rodeo star Mike Milo (Eastwood), who takes a job of retrieving his old boss's teenage son from Mexico. The story is essentially mellowed into the meandering encounter between the old man and this wilful but sweet-natured kid (Eduardo Minett) and his feisty rooster Macho. Filming around New Mexico, recreating a 1980 that might as well be 1890, the film's ambitions were small, but charged with a knowing nostalgia, and something elegiac. Here are the soft, melancholy notes of *Breezy*, *Bronco Billy*, and *Honkytonk Man*, even *Rawhide*. There is a Western feel to things. We see the 90-year-old icon atop a horse for the first time since *Unforgiven*. He came in one day ahead of schedule.

Released during the pandemic in 2021, the film's success or failure is hard to judge. It did only $16 million at cinemas, but found an appreciative audience via streaming – such were the times. More than anything, and the film is slight, it is the simple pleasure of being in Eastwood's company that counts. As Donald Clarke appreciated in the *Irish Times*, 'his gift for expressing everything by doing almost nothing has become more impressive with the passing years.'[25]

So that is where we leave him, with that mighty face turned to the sun, the parched landscape rolling away behind him – a man in his element, at magic hour, when the shadows are long. More than a director, more than a star, Eastwood is a defining presence in American culture, a walking monument. He has shaped the world's perception of the country of his birth, and his great subject.

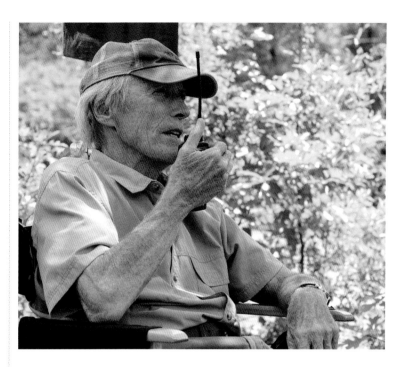

He has upheld a national mythology as he deconstructed it. And he stands alone. There has never been anyone like him. Eastwood would never see his achievements – stardom, Oscars, financial success, critical appreciation (eventually) – as anything more than a life well lived. Which, you sense, is also kind of the point. With the release of *Cry Macho*, the press wondered, would he now retire, after forty-five directing credits (all told), now 91 years old? Still impressive, but frail, the bones pressing through the parchment of his skin. Hell no, he responded in that weathered voice, smiling, a twinkle in those blue eyes, 'I'm still figuring out what to do next.'[26]

Above: On location with *Richard Jewell* – a film written as a straightforward thriller, which in Eastwood's hands became a rich and complex character piece.

Above: Still so at ease in the saddle – Eastwood strikes a classic pose alongside co-star Eduardo Minett in the charming neo-Western *Cry Macho*, his final Western. At least, at time of writing!

…And so to the inevitable postscript. As this book headed off to be printed, news broke of a new Eastwood movie potentially going into production: a legal thriller entitled *Juror #2*, set up at Warner, of course; written by Jonathan Abrams (*Escape Plan*), with production set to begin in June 2023, following Eastwood's ninety-third birthday on 31 May. In the style of the classic *12 Angry Men*, Nicholas Hoult's titular juror, realizing he may be responsible for the death of the victim at a murder trial, attempts to swing his fellow jurors into exonerating the accused without incriminating himself. With Toni Collette playing the prosecutor. It's not unheard-of terrain for Eastwood: *Midnight in the Garden of Good and Evil* and *Changeling* were, in part, courtroom thrillers. Another genre that has fallen out of fashion, as if such things matter to him.

SOURCES

BIBLIOGRAPHY

Eliot, Marc, *American Rebel: The Life of Clint Eastwood*, Three Rivers Press, 2009
Foote, John H., *Clint Eastwood: Evolution of a Filmmaker*, Paeger, 2009
Frayling, Christopher, *Clint Eastwood*, Virgin, 1992
Frayling, Christopher, *Sergio Leone: Something to Do with Death*,
 Faber & Faber, 2000
Frayling, Christopher, *Spaghetti Westerns*, Routledge & Kegan Paul, 1981
Goldman, Michael, *Clint Eastwood: Master Filmmaker at Work*, Abrams, 2012
Kapsis, Robert E. and Coblentz, Kathie (editors), *Clint Eastwood: Interviews*,
 The University Press of Mississippi, 2013
Kaminsky, Stuart M., *Clint Eastwood*, New American Library, 1974
McGilligan, Patrick, *Clint: The Life and Legend*, Harper Collins, 1999
Schickel, Richard, *Clint Eastwood: A Biography*, Vintage Books, 1997
Tarantino, Quentin, *Cinema Speculation*, Weidenfeld & Nicolson, 2022
Thomson, David, *A New Biographical Dictionary of Film*, Little, Brown, 2002

DOCUMENTARIES

A Cinematic Masterclass by Clint Eastwood, Festival de Cannes, 23 May 2017
Hell Hath No Fury: The Making of The Outlaw Josey Wales, Warner Home
 Entertainment, 2012
Inside the Actor's Studio: Clint Eastwood, Apple TV, 5 October 2003
An Old Fashioned Love Story: Making 'The Bridges of Madison County', Warner
 Home Video, 1995

INTRODUCTION

1. Shoard, Catherine, *Tom Hanks: Clint Eastwood 'Treats Actors Like Horses'*,
 Guardian, November 25 2016
2. Ibid
3. Junod, Tom, *The Eastwood Conundrum, Esquire*, 20 September 2012
4. Thomson, David, *A New Biographical Dictionary of Film*, Little, Brown, 2002
5. Nathan, Ian, *Clint Eastwood on Clint Eastwood, Empire*, July 2008
6. Ibid
7. Junod, Tom, *The Eastwood Conundrum, Esquire*, 20 September 2012

THE MAGNIFICENT STRANGER

1. Thompson, Richard and Hunter, Tim, *Clint Eastwood, Auteur, Film Comment*,
 January/February 1978
2. Ibid
3. Cahill, Tim, *Clint Eastwood: The Rolling Stone Interview, Rolling Stone*,
 4 July 1985
4. *Inside the Actor's Studio: Clint Eastwood*, Apple TV, 5 October 2003
5. Ibid
6. Ibid
7. Schickel, Richard, *Clint Eastwood: A Biography*, Vintage Books, 1997
8. Ibid
9. Ibid
10. Ibid
11. Ibid
12. Barron, James, *Remembering James Cagney, a Tough Guy With a Green
 Thumb, New York Times*, 17 July 2016
13. *Inside the Actor's Studio: Clint Eastwood*, Apple TV, 5 October 2003
14. Reed, Rex, *No Tumbleweed Ties for Clint, Los Angeles Times*, 4 April 1971
15. Schickel, Richard, *Clint Eastwood: A Biography*, Vintage Books, 1997
16. Kaminsky, Stuart M., *Clint Eastwood*, New American Library, 1974
17. Frayling, Christopher, *Sergio Leone: Something to Do with Death*,
 Faber & Faber, 2000

18. Cahill, Tim, *Clint Eastwood: The Rolling Stone Interview, Rolling Stone*,
 4 July 1985
19. Frayling, Christopher, *Sergio Leone: Something to do with Death*,
 Faber and Faber, 2000
20. Frayling, Christopher, *Spaghetti Westerns*, Routledge & Kegan Paul, 1981
21. Ibid
22. Cahill, Tim, *Clint Eastwood: The Rolling Stone Interview, Rolling Stone*,
 4 July 1985
23. Ibid
24. Schickel, Richard, *Clint Eastwood: A Biography*, Vintage Books, 1997
25. Reed, Rex, *No Tumbleweed Ties for Clint, Los Angeles Times*, 4 April 1971
26. Thomson, David, *Cop on a Hot Tightrope, Film Comment*,
 September/October 1984
27. Cahill, Tim, *Clint Eastwood: The Rolling Stone Interview, Rolling Stone*,
 4 July 1985
28. Champlin, Charles, *Eastwood: An Auteur to Reckon With, Los Angeles Times*,
 18 January 1981
29. Schickel, Richard, *Clint Eastwood: A Biography*, Vintage Books, 1997
30. Cahill, Tim, *Clint Eastwood: The Rolling Stone Interview, Rolling Stone*,
 4 July 1985
31. Thomson, David, *A New Biographical Dictionary of Film*, Little, Brown, 2002
32. Tarantino, Quentin, *Cinema Speculation*, Weidenfeld & Nicolson, 2022

THE DIRECTOR EMERGES

1. Cahill, Tim, *Clint Eastwood: The Rolling Stone Interview, Rolling Stone*,
 4 July 1985
2. McGilligan, Patrick, *Clint: The Life and Legend*, Harper Collins, 1999
3. Thompson, Richard and Hunter, Tim, *Clint Eastwood, Auteur, Film Comment*,
 January/February 1978
4. *Play Misty for Me DVD*, Final Cut Entertainment, 2020
5. Thompson, Richard and Hunter, Tim, *Clint Eastwood, Auteur, Film Comment*,
 January/February 1978
6. Kaminsky, Stuart M., *Clint Eastwood*, New American Library, 1974
7. Denby, David, *Out of the West, The New Yorker*, 28 February 2010
8. Cahill, Tim, *Clint Eastwood: The Rolling Stone Interview, Rolling Stone*,
 4 July 1985
9. Schickel, Richard, *Clint Eastwood: A Biography*, Vintage Books, 1997
10. Ibid
11. Unattributed, *Play Misty for Me review, TV Guide*, 1971
12. Junod, Tom, *The Eastwood Conundrum, Esquire*, 20 September 2012
13. Ibid
14. Ibid
15. Ibid
16. Kaminsky, Stuart M., *Clint Eastwood*, New American Library, 1974
17. Gelmis, Joseph, *Play Misty for Me, Newsday*, November 1971
18. Schickel, Richard, *Clint Eastwood: A Biography*, Vintage Books, 1997
19. Junod, Tom, *The Eastwood Conundrum, Esquire*, 20 September 2012
20. Tarantino, Quentin, *Cinema Speculation*, Weidenfeld & Nicolson, 2022
21. Thompson, Richard and Hunter, Tim, *Clint Eastwood, Auteur, Film Comment*,
 January/February 1978
22. Bowen, Chuck, *Review: Clint Eastwood's High Plains Drifter on Kino Lorber 4K
 UHD Blu-ray, Slant*, 28 October 2022
23. Thompson, Richard and Hunter, Tim, *Clint Eastwood, Auteur, Film Comment*,
 January/February 1978
24. Schickel, Richard, *Clint Eastwood: A Biography*, Vintage Books, 1997
25. Ibid
26. Thompson, Richard and Hunter, Tim, *Clint Eastwood, Auteur, Film Comment*,
 January/February 1978
27. Ebert, Roger, *The Eiger Sanction, Chicago Sun-Times*, 1 January 1975

WAY OUT WESTERN

1. Roberts, Jerry, *Q&A with a Western Icon, Daily Variety*, 27 March 1995
2. *Hell Hath No Fury: The Making of The Outlaw Josey Wales Blu-ray*, Warner Home Entertainment, 2012
3. Ibid
4. Ebert, Roger, *The Outlaw Josey Wales, Chicago Sun-Times*, 1 January 1976
5. Schickel, Richard, *Clint Eastwood: A Biography*, Vintage Books, 1997
6. Ibid
7. *Hell Hath No Fury: The Making of The Outlaw Josey Wales*, Warner Home Entertainment, 2012
8. Biskind, Peter, *Any Which Way He Can, Premiere*, April 1993
9. *Hell Hath No Fury: The Making of The Outlaw Josey Wales*, Warner Home Entertainment, 2012
10. Schickel, Richard, *Clint Eastwood: A Biography*, Vintage Books, 1997
11. *The Outlaw Josey Wales Blu-ray*, Warner Home Video, 2012
12. Schickel, Richard, *Clint Eastwood: A Biography*, Vintage Books, 1997
13. Thompson, Richard and Hunter, Tim, *Clint Eastwood, Auteur, Film Comment*, January/February 1978
14. McGilligan, Patrick, *Clint: The Life and Legend*, Harper Collins, 1999
15. Ibid
16. Thompson, Richard and Hunter, Tim, *Clint Eastwood, Auteur, Film Comment*, January/February 1978
17. Sloman, Tom, *The Outlaw Josey Wales, Radio Times*, 27 July 2016
18. Thompson, Richard and Hunter, Tim, *Clint Eastwood, Auteur, Film Comment*, January/February 1978
19. Ibid
20. Ibid
21. Corliss, Richard, *Kitsch kitsch bang bang, New Times*, 3 September 1976
22. *The Outlaw Josey Wales Blu-ray*, Warner Home Video, 2012
23. Ibid
24. Thompson, Richard and Hunter, Tim, *Clint Eastwood, Auteur, Film Comment*, January/February 1978
25. Ibid
26. Ebert, Roger, *The Outlaw Josey Wales, Chicago Sun-Times*, 1 January 1976
27. Eder, Richard, *Clint Eastwood Aims at War Epic in 'Josey Wales'*, *New York Times*, 5 August 1976
28. Schickel, Richard, *Clint Eastwood: A Biography*, Vintage Books, 1997
29. Thomas, Kevin, *The Outlaw Josey Wales, Los Angeles Times*, 30 June 1976

MAXIMUM MINIMALISM

1. Canby, Vincent, *Screen: Eastwood Gauntlet, New York Times*, 22 December 1977

AMERICAN STORYTELLER

1. Vincour, John, *Clint Eastwood Seriously, New York Times Magazine*, 24 February 1985
2. Cahill, Tim, *Clint Eastwood: The Rolling Stone Interview, Rolling Stone*, 4 July 1985
3. Wilson, Michael Henry, *'Whether I Succeed or Fail, I Don't Want to Owe It to Anyone but Myself': From Play Misty for Me to Honkytonk Man, Postif*, January 1985
4. Gentry, Ric, Director *Clint Eastwood: Attention to Detail and Involvement for the Audience, Millimeter*, December 1980
5. Mailer, Norman, *Norman Mailer Meets Clint Eastwood, Observer Magazine*, 29 January 1984
6. Thompson, Richard and Hunter, Tim, *Clint Eastwood, Auteur, Film Comment*, January/February 1978
7. Ibid
8. Allen Tom, *Clint: An American Icon, Newsweek*, 22 July 1985
9. Wilson, Michael Henry, *'Whether I Succeed or Fail, I Don't Want to Owe It to Anyone but Myself': From Play Misty for Me to Honkytonk Man, Postif*, January 1985

10. Wilson, Michael Henry, *'Whether I Succeed or Fail, I Don't Want to Owe It to Anyone but Myself': From Play Misty for Me to Honkytonk Man, Postif*, January 1985
11. Ebert, Roger, *The Gauntlet, Chicago Sun-Times*, 1 January 1977
12. Schickel, Richard, *Clint Eastwood: A Biography*, Vintage Books, 1997
13. Champlin, Charles, *Eastwood: An Auteur to Reckon With, Los Angeles Times*, 18 January 1981
14. Cahill, Tim, *Clint Eastwood: The Rolling Stone Interview, Rolling Stone*, 4 July 1985
15. *Bronco Billy DVD*, Warner Home Video, 1991
16. Schickel, Richard, *Clint Eastwood: A Biography*, Vintage Books, 1997
17. Wilson, Michael Henry, *'Whether I Succeed or Fail, I Don't Want to Owe It to Anyone but Myself': From Play Misty for Me to Honkytonk Man, Postif*, January 1985
18. Schickel, Richard, *Clint Eastwood: A Biography*, Vintage Books, 1997
19. Ibid
20. Ibid
21. *Firefox DVD*, Warner Home Video, 2003
22. Wilson, Michael Henry, *'Whether I Succeed or Fail, I Don't Want to Owe It to Anyone but Myself': From Play Misty for Me to Honkytonk Man, Postif*, January 1985
23. Canby, Vincent, *Stealing Firefox, New York Times*, 18 July 1982
24. Wilson, Michael Henry, *'Whether I Succeed or Fail, I Don't Want to Owe It to Anyone but Myself': From Play Misty for Me to Honkytonk Man, Postif*, January 1985
25. Mailer, Norman, *Norman Mailer Meets Clint Eastwood, Observer Magazine*, 29 January 1984
26. Cahill, Tim, *Clint Eastwood: The Rolling Stone Interview, Rolling Stone*, 4 July 1985
27. Henderson, Eric, *Review: Honkytonk Man, Slant*, 2 September 2003
28. *Sudden Impact Special Edition DVD*, Warner Home Video, 2008
29. Schickel, Richard, *Clint Eastwood: A Biography*, Vintage Books, 1997
30. Wilson, Michael Henry, *'Whether I Succeed or Fail, I Don't Want to Owe It to Anyone but Myself': From Play Misty for Me to Honkytonk Man, Postif*, January 1985
31. *Sudden Impact Special Edition DVD*, Warner Home Video, 2008
32. Unattributed, *Sudden Impact, Variety*, 31 December 1982

THE MAYOR

1. Weintraub, Bernard, *Clint Eastwood Interview, Playboy*, March 1997
2. Kroll, Jack, *Tightrope, Newsweek*, 17 August 1984
3. Ebert, Roger, *Tightrope, Chicago Sun-Times*, 1 January 1984
4. McGilligan, Patrick, *Clint: The Life and Legend*, Harper Collins, 1999
5. Frayling, Christopher, *Clint Eastwood, Virgin*, 1992
6. Ibid
7. Foote, John H., *Clint Eastwood: Evolution of a Filmmaker*, Paeger, 2009
8. Wilmington, Michael, *Westerns Return on a Pale Rider, Los Angeles Times*, 28 June 1985
9. Schickel, Richard, *Clint Eastwood: A Biography*, Vintage Books, 1997
10. Ibid
11. Ibid
12. McGilligan, Patrick, *Clint: The Life and Legend*, Harper Collins, 1999
13. Attanasio, Paul, *Heartbreak Ridge, Washington Post*, 5 December 1986
14. McGilligan, Patrick, *Clint: The Life and Legend*, Harper Collins, 1999
15. *Heartbreak Ridge DVD*, Warner Home Video, 2019
16. Kehr, David, *Eastwood Takes a Winning Risk in 'Heartbreak', Chicago Tribune*, 5 December 1986
17. Hentoff, Nat, *Flight of Fancy, American Film*, September 1988
18. Yanow, Scott, *Bird: The Movie, Down Beat*, September 1988
19. Hentoff, Nat, *Flight of Fancy, American Film*, September 1988
20. Jousse, Thierry and Nevers, Camille, *Interview with Clint Eastwood, Cahiers du Cinéma*, October 1992
21. Goldman, Michael, *Clint Eastwood: Master Filmmaker at Work*, Abrams, 2012
22. Hentoff, Nat, *Flight of Fancy, American Film*, September 1988

23. Yanow, Scott, *Bird: The Movie, DownBeat*, September 1988
24. Hinson, Hal, *Bird, Washington Post*, 14 October 1988
25. Kael, Pauline, *Bird, Movie Love, Plume*, 1991
26. Goldman, William, *Hype and Glory*, Villard Books, 1990
27. Ciment, Michel, *Interview with Clint Eastwood, Postif*, May 1990
28. Ibid
29. Ibid
30. Brody, Richard, *White Hunter Black Heart, New Yorker*, undated
31. Canby, Vincent, *Clint Eastwood with Fiends Bloodthirsty and Otherwise, New York Times*, 7 December 1990
32. Siskel, Gene, *Stock Characters Inhabit Eastwood's Rookie, Chicago Tribune*, 7 December 1990
33. Hinson, Hal, *The Rookie, Washington Post*, 7 December 1990

THE MAYOR OF CARMEL

1. Shelton, Jacob, *1986: Clint Eastwood was Elected Mayor of Carmel, California, Groovy History*, 9 April 2020
2. Schickel, Richard, *Clint Eastwood: A Biography*, Vintage Books, 1997
3. Eastwood, Clint, *Eastwood: In His Own Words*, American Film Institute, 1995
4. Shelton, Jacob, *1986: Clint Eastwood was Elected Mayor of Carmel, California, Groovy History*, 9 April 2020
5. Ibid
6. Mailer, Norman, *Norman Mailer Meets Clint Eastwood, Observer Magazine*, 29 January 1984

THE LAST RIDE

1. Schickel, Richard, *Clint Eastwood: A Biography*, Vintage Books, 1997
2. Ibid
3. Thomson, David, *A New Biographical Dictionary of Film*, Little, Brown, 2002
4. Unattributed, *Interview: David Webb Peoples, That Shelf*, 2 April 2014
5. Ibid
6. Biskind, Peter, *Any Which Way He Can, Premiere*, April 1993
7. Ibid
8. Ibid
9. Nathan, Ian, *Clint Eastwood on Clint Eastwood, Empire*, July 2008
10. *Unforgiven DVD*, Warner Home Video, 1993
11. Biskind, Peter, *Any Which Way He Can, Premiere*, April 1993
12. *Unforgiven DVD*, Warner Home Video, 1993
13. Ibid
14. Schickel, Richard, *Clint Eastwood: A Biography*, Vintage Books, 1997
15. Jousse, Thierry and Nevers, Camille, *Interview with Clint Eastwood, Cahiers du Cinéma*, October 1992
16. Ibid
17. Eliot, Marc, *American Rebel: The Life of Clint Eastwood*, Three Rivers Press, 2009
18. Schickel, Richard, *Clint Eastwood: A Biography*, Vintage Books, 1997
19. McGilligan, Patrick, *Clint: The Life and Legend*, Harper Collins, 1999
20. Whitty, Stephen, *Clint Eastwood on Jersey Boys, Taking Risks and a Life Well Lived, Inside Jersey*, 13 June 2014
21. Jousse, Thierry and Nevers, Camille, *Interview with Clint Eastwood, Cahiers du Cinéma*, October 1992
22. Schickel, Richard, *Clint Eastwood: A Biography*, Vintage Books, 1997
23. Ibid
24. Jousse, Thierry and Nevers, Camille, *Interview with Clint Eastwood, Cahiers du Cinéma*, October 1992
25. Ibid
26. *Unforgiven DVD*, Warner Home Video, 1993
27. Ibid
28. Ibid
29. Schneider, Wolf, *Clint Eastwood Tribute Book*, American Film Institute, 1996
30. Turan, Kenneth, *Clint is Back With a Vengeance, Los Angeles Times*, 7 August 1992
31. French, Philip, *Unforgiven – review, Observer*, 20 September 1992
32. Errigo, Angie, U*nforgiven, Empire*, December 1992
33. Lane, Anthony, *Here's Shooting at You Kid: Unforgiven; A League of Their Own, Independent On Sunday*, 19 September 1992
34. Schickel, Richard, *Clint Eastwood: A Biography*, Vintage Books, 1997
35. Corliss, Richard, *Unforgiven, Time*, 7 August 1992
36. Junod, Tom, *The Eastwood Conundrum, Esquire*, 20 September 2012
37. *Unforgiven DVD*, Warner Home Video, 1993
38. Schickel, Richard, *Clint Eastwood: A Biography*, Vintage Books, 1997
39. *Academy Awards 1973*, Oscars.org

THE INTREPID ICON

1. Wilson, Michael Henry, *'Truth, Like Art, Is in the Eye of the Beholder': Midnight in the Garden of Good and Evil and The Bridges of Madison Country, Postif*, March 1998
2. Schickel, Richard, *Clint Eastwood: A Biography*, Vintage Books, 1997
3. Behar, Henri, *America on the Brink of the Void, Le Monde*, 16 December 1993
4. Caddies, Kelvin, *Kevin Costner: Prince of Hollywood*, Plexus Publishing, 1996
5. Behar, Henri, *America on the Brink of the Void, Le Monde*, 16 December 1993
6. Schickel, Richard, *Clint Eastwood: A Biography*, Vintage Books, 1997
7. Ibid
8. Chow, Walter, *A Perfect World, Film Freak Central*, 25 November 2013
9. Thompson, Anne, *The Making of The Bridges of Madison County, Entertainment Weekly*, 16 June 1995
10. Wilson, Michael Henry, *'Truth, Like Art, Is in the Eye of the Beholder': Midnight in the Garden of Good and Evil and The Bridges of Madison Country, Postif*, March 1998
11. Eliot, Marc, *American Rebel: The Life of Clint Eastwood*, Three Rivers Press, 2009
12. Thompson, Anne, *The Making of The Bridges of Madison County, Entertainment Weekly*, 16 June 1995
13. Ibid
14. Ibid
15. *An Old Fashioned Love Story: Making 'The Bridges of Madison County'*, Warner Home Video, 1995
16. Ibid
17. Meza, Ed, *Berlin: Meryl Streep Talks Working With Clint Eastwood, Female Directors and Vanity, Variety*, 14 February 2016
18. Ibid
19. *An Old Fashioned Love Story: Making 'The Bridges of Madison County'*, Warner Home Video, 1995
20. Cole, Jake, *Review: Clint Eastwood's* The Bridges of Madison County *on Warner Blu-ray, Slant*, 5 May 2014
21. Ebert, Roger, *The Bridges of Madison County, Chicago Sun-Times*, 2 June 1995
22. McGilligan, Patrick, *Clint: The Life and Legend*, Harper Collins, 1999
23. Le Salle, Mike, *Eastwood Makes `Power' Flow/Slick, Dark Thriller Tense and Crafty, San Francisco Chronicle*, 14 February 1997
24. *Midnight in the Garden of Good and Evil: Clint Eastwood, Joe Leyden Show*, November 1997
25. Ebert, Roger, *Midnight in the Garden of Good and Evil, Chicago Sun-Times*, 21 November 1997
26. Phipps, Keith, *Space Cowboys, AV Club*, 1 August 2000
27. Foote, John H., *Clint Eastwood: Evolution of a Filmmaker*, Paeger, 2009
28. Ebert, Roger, *Space Cowboys, Chicago Sun-Times*, 4 August 2000
29. Foote, John H., *Clint Eastwood: Evolution of a Filmmaker*, Paeger, 2009
30. Chow, Walter, *Blood Work, Film Freak Central*, 8 July 2012
31. Blumenfeld, Samuel, *Mystic River: Eastwood without Anger or Forgiveness, Le Monde*, 15 October 2003
32. *Clint Eastwood Interview, Mystic River, The Charlie Rose Show*, 8 October 2003
33. French, Philip, *Take a Subtle Clint, Observer*, 19 October 2003
34. *Sean Penn Interview, Mystic River DVD*, Warner Home Video, 2003
35. Steyn, Mark, *Primal Truths, The Spectator*, 25 October 2003
36. *Academy Awards 2004*, Oscars.org

AMERICAN SOUL

1. Turan Kenneth, *Laid Bare in the Ring, Los Angeles Times*, 15 December 2004
2. *Academy Awards 2005*, Oscars.org
3. Ibid
4. Taubin, Amy, *Staying Power, Film Comment*, January/February 2005
5. *Clint Eastwood Interview, Million Dollar Baby, The Charlie Rose Show*, 15 December 2005
6. Orr, Christopher, *The Movie Review: Million Dollar Baby, The Atlantic*, 12 July 2005
7. *Clint Eastwood Interview, Million Dollar Baby, The Charlie Rose Show*, 15 December 2005
8. Ibid
9. Taubin, Amy, *Staying Power, Film Comment*, January/February 2005
10. Junod, Tom, *The Eastwood Conundrum, Esquire*, 20 September 2012
11. *Clint Eastwood Interview, Million Dollar Baby, The Charlie Rose Show*, 15 December 2005
12. Taubin, Amy, *Staying Power, Film Comment*, January/February 2005
13. Turan Kenneth, *Laid Bare in the Ring, Los Angeles Times*, 15 December 2004
14. Taubin, Amy, *Staying Power, Film Comment*, January/February 2005
15. *Clint Eastwood Interview, Million Dollar Baby, The Charlie Rose Show*, 15 December 2005
16. *Morgan Freeman Interview, Million Dollar Baby, The Charlie Rose Show*, 15 December 2005
17. Denby, David, *Out of the West, The New Yorker*, 28 February 2010
18. *Clint Eastwood Interview, Million Dollar Baby, The Charlie Rose Show*, 15 December 2005
19. *Morgan Freeman Interview, Million Dollar Baby, The Charlie Rose Show*, 15 December 2005
20. Ibid
21. *Hilary Swanks on Meeting Clint Eastwood, Landing Million Dollar Baby Role, Entertainment Weekly Radio – SiriusXM*, 19 October 2018
22. Ibid
23. Ibid
24. Ibid
25. Taubin, Amy, *Staying Power, Film Comment*, January/February 2005

HOLLYWOOD NOBILITY

1. Gross, Terry, *Eastwood's Letters from Iwo Jima, Fresh Air with Terry Gross*, 10 January 2007
2. Bradshaw, Peter, *Flags of Our Fathers, Guardian*, 22 December 2006
3. Foote, John H., *Clint Eastwood: Evolution of a Filmmaker*, Paeger, 2009
4. Dargis, Manohla, *A Ghastly Conflagration, a Tormented Aftermath, New York Times*, 20 October 2006
5. Ibid
6. *A Cinematic Masterclass by Clint Eastwood*, Festival de Cannes, 23 May 2017
7. *Red Sun, Black Sand: The Making of Letters from Iwo Jima*, Warner Home Video, 2007
8. Ibid
9. Ibid
10. Gross, Terry, *Eastwood's Letters from Iwo Jima, Fresh Air with Terry Gross*, 10 January 2007
11. Scott, A.O. *Blurring the Line in the Bleak Sands of Iwo Jima, New York Times*, 20 December 2006
12. *Interview with Clint Eastwood: Flags of Our Fathers, The Charlie Rose Show*, 20 December 2006
13. Foote, John H., *Clint Eastwood: Evolution of a Filmmaker*, Paeger, 2009
14. Changeling Production Notes, Universal Studios, 2008
15. Harris, Mark, *The Mommy Track, New York Times*, 15 October 2008
16. Dargis, Manhola, *Hope for a Racist, and Maybe a Country, New York Times*, 11 December 2008
17. *Gran Torino DVD*, Warner Home Video, 2009
18. Levy, Emanuel, *Gran Torino: Interview with Clint Eastwood, Emanuel Levy Cinema 24/7*, 4 December 2008

19. Brockes, Emma, *Eighty? It's Just a Number, Guardian*, 14 February 2009
20. Foundas, Scott, *Clint Eastwood, America's Director: The Searcher, LA Weekly*, 18 December 2008
21. *Invictus DVD*, Warner Home Video, 2010
22. Foundas, Scott, *Eastwood on the Pitch: At Seventy-Nine, Clint Tackles Mandela in Invictus, LA Weekly*, 10 December 2009
23. Brooks, Xan, *Review: Invictus, Guardian*, 31 January 2010
24. Wilson, Michael Henry, *Interview with Clint Eastwood: First, Believe in Yourself, Postif*, January 2011
25. Foundas, Scott, *Eastwood on the Pitch: At Seventy-Nine, Clint Tackles Mandela in Invictus, LA Weekly*, 10 December 2009
26. Ebert, Roger, *Hereafter, Chicago Sun-Times*, 19 October 2010
27. Harkness, Alistair, *Hereafter, Scotsman*, 31 January 2011

THE UNQUENCHABLE FLAME

1. Bowles, Scott, *With J. Edgar, Eastwood Again Flexes His Freedom, USA Today*, 9 November 2011
2. Goldman, Michael, *Clint Eastwood: Master Filmmaker at Work*, Abrams, 2012
3. Ibid
4. Denby, David, *Out of the West, The New Yorker*, 28 February 2010
5. Bowles, Scott, *With J. Edgar, Eastwood Again Flexes His Freedom, USA Today*, 9 November 2011
6. Thomson, David, *Thomson on Films: Clint Eastwood's Disappointingly Cautious Depiction of J. Edgar Hoover, The New Republic*, 15 November 2011
7. *Clint Eastwood Interview, Celebs.com*, November 2011
8. Bowles, Scott, *With J. Edgar, Eastwood Again Flexes His Freedom, USA Today*, 9 November 2011
9. Dargis, Manohla, *You're Just too Good to Be True, New York Times*, 19 June 2014
10. Foundas, Scott, *Clint Eastwood: Cowboy Led Jersey Boys Down a New Trail, Variety*, 10 June 2014
11. Ibid
12. Block, Alex Ben, *The Making of American Sniper: How an Unlikely Friendship Kickstarted the Clint Eastwood Film, Hollywood Reporter*, 2 January 2015
13. Foundas, Scott, *Clint Eastwood: Cowboy Led Jersey Boys Down a New Trail, Variety*, 10 June 2014
14. Dockterman, Eliana, *Clint Eastwood Says American Sniper is Anti-war, Time*, 17 March 2015
15. Block, Alex Ben, *The Making of American Sniper: How an Unlikely Friendship Kickstarted the Clint Eastwood Film, Hollywood Reporter*, 2 January 2015
16. Hoberman J., *The Great American Shooter, The New York Review of Books*, 13 February 2015
17. Stevens, Dana, *The Battle Over American Sniper, Slate*, 21 January 2015
18. Alexander, Bryan, *Why Clint Eastwood gambled (and won) using the real heroes to star in 15:17 to Paris, USA Today*, February 2018
19. Sragow, Michael, *Deep Focus: The 15:17 to Paris, Film Comment*, 9 February 2018
20. Livingstone, Jo, *The 15:17 to Paris Is a Strange, Strange Journey, The New Republic*, 14 February 2018
21. Truitt, Bryan, *Exclusive: Clint Eastwood plays a guy 'even older than me' in drug drama The Mule, USA Today*, December 2018
22. Brunson, Matt, *The Mule, Film Threat*, 12 April 2019
23. Isaza, Marcela, *Eastwood on Richard Jewell, Criticism and Finding Stories, AP News*, 12 December 2019
24. Freer, Ian, *Richard Jewell Review, Empire*, 27 January 2020
25. Clarke, Donald, *Cry Macho: Clint the Old Cowboy Sings One More Swansong, Irish Times*, 12 November 2021
26. Reinstein, Mara, *'I'm Not in It for the Dough!' Clint Eastwood Talks Cry Macho and Why He Has No Plans to Retire, Parade*, 10 September 2021

Acknowledgements

Clint Eastwood isn't a subject; he is part of who I am. Aged twelve, my dad allowed me and a friend to stay up and watch *The Good, The Bad and The Ugly* – he felt it would do us good. He can't have imagined how I would be changed by that late-night viewing. Films, I realized, could have personalities, style, a thrilling brio, and something profound under the cool veneer. More than just playing a part, stars could be icons. When it came to drinking in *The Outlaw Josey Wales* and *Unforgiven* and *Million Dollar Baby*, all the great works Eastwood directed – darker, more emotional, weightier in their own way than so much that pours out of Hollywood – he had become one of the standards by which I measured film. Taking this long, daunting, but still thrilling journey back through his directorial career has reminded me what greatness means. Thus foremost, I would like to give my thanks to Clint Eastwood for remaining Clint Eastwood for over fifty years. I would also like to thank my dad, Christopher Nathan, whose love of movies, particularly Westerns, particularly a Clint Western, I have inherited. You can rely on Eastwood, he told me. He was right. Eastwood speaks not of a crew, but a family. Taking a leaf from his book, I would like to give my thanks to my publishing family. To my editor, Jessica Axe, for her soothing emails and endless store of patience. To my copy editor Nick Freeth, so eagle-eyed for typos and brilliant at untangling sentences. To the magnificent Sue Pressley at Stonecastle Graphics, who with each of the books in this series has visualized a career as much as I have tried to explain it. Excellent advice has come from my old compadres Ian Freer, Simon Braund, Steve Hornby, Julian Alcantra, and Stephen Armstrong. Above all my thanks go to Wai for her love and support, and the restorative power of a great sense of humour.